28 DAY BOOK

8/04 2

GREAT NECK LIBRARY
GREAT NECK, N. Y. 11024

You must present your library card when borrowing library materials. You are responsible for everything drawn on your card.

Overdue charges must be paid on materials which are not returned on time.

As a courtesy and help to others, please return library materials promptly so that they are available for other borrowers.

JAN 2 7 2004

Route 66

Route 66

Images of America's Main Street

William Kaszynski

McFarland & Company, Inc., Publishers
Jefferson, North Carolina, and London

LIBRARY OF CONGRESS CATALOGUING-IN-PUBLICATION DATA

Kaszynski, William, 1953–
Route 66 : images of America's main street / William Kaszynski.
p. cm.
Includes bibliographical references and index.

ISBN 0-7864-1553-3 (library binding : 50# and 70# alkaline paper) ∞

1. Historic Sites— United States.
2. Historic sites— United States— Pictorial works.
3. United States— Description and travel.
4. United States Highway 66.
5. United States— Pictorial works.
6. United States Highway 66 — Pictorial works.
I. Title
E169.04.K38 2003 388.1'0973 — dc21 2003004125

British Library cataloguing data are available

On the cover (background): Tire tread image ©2003 PhotoSpin; Arroyo Seco Parkway,
Los Angeles, 1940s *(National Archives); (foreground):* Eisler Brothers' Riverton Store *(Scott Nelson);*
Coleman Theater Beautiful, Miami, Oklahoma, *Route 66 Magazine;*
Abandoned truck stop and cafe, Hinton Junction, *A Guide Book to Highway 66,*
Jack D. Rittenhouse, University of Oklahoma Press; Sixth Street Auto Company,
Amarillo Church at Laguna Pueblo, *A Guide Book to Highway 66;*
Rod's Steak House, Williams, Arizona; Meramec Caverns barns;
Ruins of Meteor Crater Observatory and Museum, *Route 66 Magazine*

Manufactured in the United States of America

 McFarland & Company, Inc., Publishers
Box 611, Jefferson, North Carolina 28640
www.mcfarlandpub.com

To Yvonne

Contents

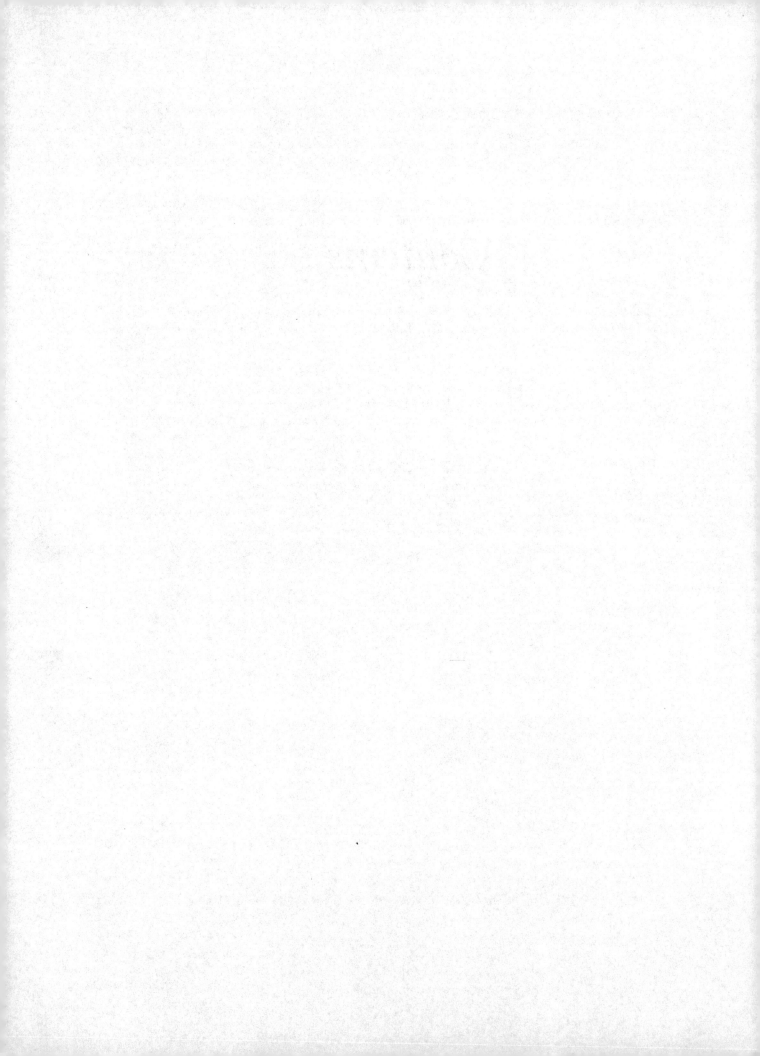

Introduction

Route 66: The name itself inspires visions of the bygone days of the American motoring experience. The road is a product of the twentieth century, conceived some 20 years after the "horseless carriage" made its appearance on city streets and country lanes across the United States. From Chicago to Los Angeles, the most famous highway in America has carried three generations of travelers, most heading toward the sunny west coast: people by the thousands, leaving the East just like the pioneer settlers of the Old West, searching for new opportunities or Hollywood stardom; refugees from the Midwest and elsewhere, seeking to escape the Dust Bowl and the Depression. Wartime traffic and rationing interrupted civilian life for only a few years; then followed the golden days of U.S. 66, when three decades of prosperity and tourism transformed the road into something special for millions of overland motorists. To truckers, traveling salesmen, family vacationers, and the people who lived along its route, Highway 66 was more than just a road. It will always have that certain mystique shared by only a handful of American legends.

At the end of the 1800s, roads were almost nonexistent in the United States, except for streets in the major cities. While urban areas had some hard-surfaced roads— paved with cobblestones, wooden blocks or planks, bricks, or new materials such as portland cement and bitumen — the hinterlands were served only by the occasional railroad or plain dirt paths.

By 1900, Chicago had become the nation's second-largest city, while Los Angeles counted only 102,000 inhabitants. Rail was the only mode of transportation between the two cities. From Chicago to Southern California was a trip of more than 2,000 miles; portions of that journey might follow pathways first traveled by Native Americans, then Spanish explorers and, later, white settlers. The route crossed the midwestern plains through Illinois, then followed the Osage Trail and the Federal Wire Road over the northern Ozark Mountains, just nicking the southeastern corner of Kansas. The desert Southwest was rarely visited by anyone, other than a few adventurous trailblazers and scouts like Kit Carson and Lieutenant Edward Beale. The state of Oklahoma was admitted to the Union in 1907, while New Mexico and Arizona were still territories until 1912. California's Mojave Desert was the final barrier confronting overland travelers, where it was every man (and beast) for himself.

Despite these harsh conditions, the advent of the motorcar prompted some hardy auto pioneers to head out on the nation's primitive pathways in search of the most passable routes. They recorded their travels for those to follow, copiously noting every stream and river, fence line, tree, rock and natural landmark. The most prolific of the early pathfinders was A. L. Westgard, who documented thousands of miles of routes, some of which were later used by highway planners and still carry traffic today.

Concurrent with the exploits of Westgard and others was a dramatic increase in the number of auto trails designated by groups of ordinary citizens for cross-country travel. These trail organizers, mainly auto clubs, tourist groups and businesses, charted interstate routes and assigned them descriptive names to differentiate them from other roads. In 1913, the Lincoln Highway Association was formed to build a 3,000-mile road from New York to San Francisco, still the longest highway in the United States. A wealthy entrepreneur named William Hope Harvey formed the Ozark Trails Association the same year to advance his own trail from St. Louis to Santa Fe, New Mexico. Other roads quickly followed, including the Atlantic Highway along the eastern seaboard and the Dixie Highway from Michigan to Florida. Each trail organization marked its chosen route with its own color scheme, which was painted on posts, rocks, or whatever was available along the roadside, to guide travelers. The Lincoln Highway used patriotic red-white-and-blue

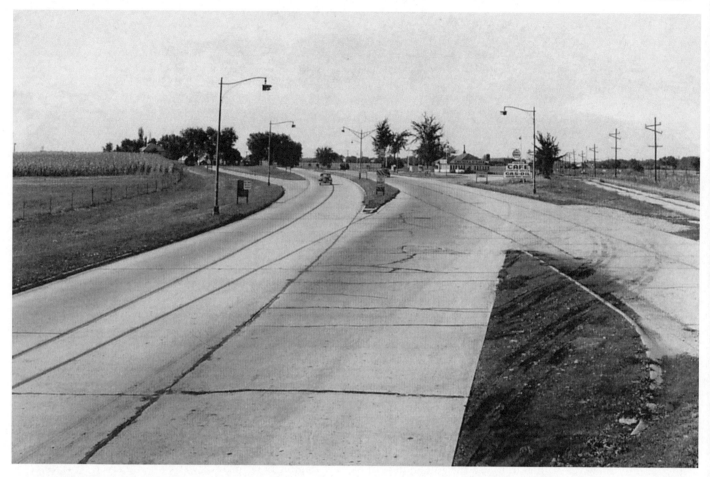

Four-lane bypass north of Lincoln, Illinois. The state of Illinois began a highway modernization program during the Second World War and began constructing a new four-lane freeway to bypass the cities along Route 66 on the congested corridor from Chicago to St. Louis. This view, taken in 1952 by the Illinois Division of Highways, is looking north one mile outside of Lincoln, with an original alignment following the line of telephone poles at the right of the photograph. Courtesy Illinois Department of Transportation.

bands with the letter "L," while the Dixie Highway chose red and white and the initials "DH."

Auto production outstripped the nation's ability to construct new roads during the second decade of the twentieth century, and citizens and businesses petitioned the state and federal governments for assistance. Public pressure pushed Congress into passing the Federal Aid Highway Act of 1916, which proposed a nationwide system of highways but provided very little funding. By the 1920s, the country's transportation problems had become acute, as postwar prosperity resulted in a surge in motor vehicle registrations across the United States. To make matters worse, the haphazard system of named trails had grown into a bewildering maze, with the trails numbering more than 250.

Necessity prompted action, and the American Association of State Highway Officials (formed in 1914) held meetings during 1925 and 1926 to develop the nation's first highway system. The AASHO appointed a Joint Board of Interstate Highways and agreed on a 50,100-mile system, which was pared down to just under 40,000 miles after months of rancorous debate.

The board's next task was to agree on an acceptable system of route marking to replace the named trails. Following Wisconsin's example of using numerals for state roads, which was being copied by other states, AASHO's "Committee of Five" agreed on a proposal submitted by board member E. W. James calling for even-numbered east–west routes and odd-numbered north–south routes. To make the numbering scheme easier for motorists to remember, numbering of routes would increase from north to south for highways traveling east–west and east to west for the north–south routes. Most states pushed for the major or "naught" routes (those ending with the numbers five or zero), since these traveled through larger cities and would carry more traffic than minor routes. Some established trails managed to preserve their routes—the Lincoln Highway, for example, was retained and assigned number 30—while others lost out.

Proponents of a route from Chicago to Los Angeles

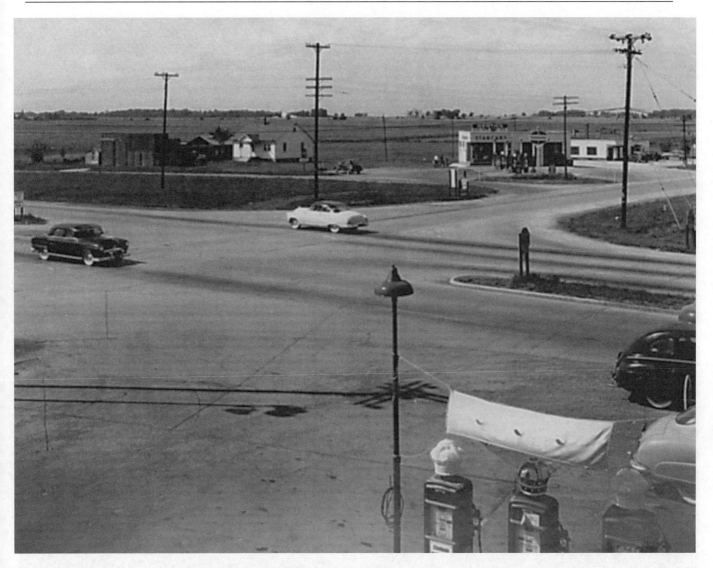

Junction of Route 66 and Illinois State 121. A photograph taken in 1952 of the intersection of Illinois 121 and four-lane U.S. 66. The state's Division of Highways shot this photograph to demonstrate the added safety of lanes separated by medians and frontage roads to carry slower traffic to businesses adjacent to the highway. This scene, showing Werth's Standard station and Looby's Inn across Route 66, is a half mile northwest of Lincoln. Courtesy Illinois Department of Transportation.

made their pitch as well, aided by joint board member Cyrus Avery of Oklahoma, who had been advocating a highway between the two cities and through his state. Avery and his allies' proposed highway would travel southwest from Chicago to Oklahoma City, then west to California, bypassing the Rocky Mountains.

Politics and the fact that the Chicago–Oklahoma City portion was neither north–south nor east–west created problems when it came to agreeing on a number for the new road. Kentucky Governor W. J. Fields wanted a naught route for his state and demanded that U.S. 60 pass through Kentucky. In the end, a compromise was reached, and Kentucky got its U.S. 60 while Avery's backers were rewarded with their Chicago-to-Los Angeles route. The new route was not a transcontinental highway, however, and therefore could not given a naught number. Other

east–west naught routes were in the process of getting their plans finalized, and since Avery's road was roughly in the vicinity of U.S. 60, the new highway number was a six followed by another six, both even numbers in accordance with the AASHO numerical scheme.

Even if the new Chicago-to-Los Angeles highway had not been assigned its catchy double sixes, it was destined to become the nation's main thoroughfare. Although the Lincoln Highway was the first to call itself the "Main Street of America," it had to compete with other routes such as U.S. 6 and U.S. 20. U.S. 66 quickly usurped the title and became the only major highway from the Midwest to southern California. Any road between the industrial states of the Great Lakes and the West Coast was bound to carry a considerable number of cars, trucks and vacationers. By the late 1920s, the popular Chicago-to-

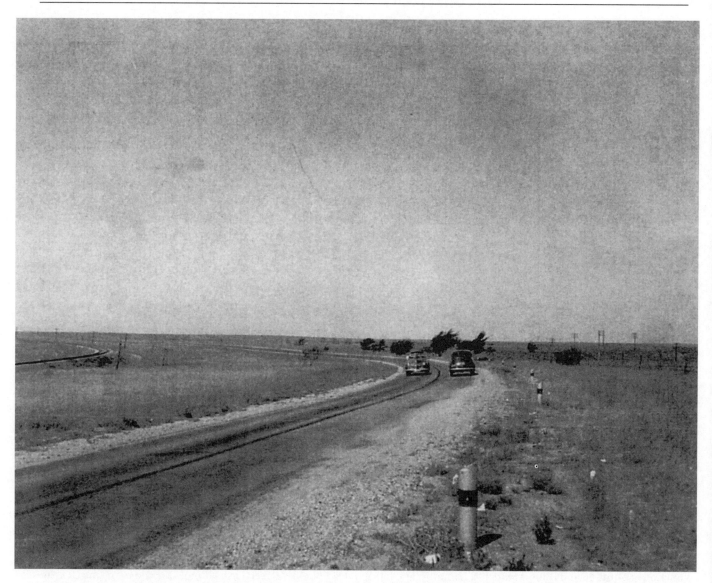

Open stretch of U.S. 66 near Alanreed, Texas. A view of Route 66 taken two years after Jack Rittenhouse wrote his pioneering *A Guide Book to Highway 66*. The Texas portion of U.S. 66 was paved by the early 1930s and Rittenhouse describes the road through the Texas panhandle as "wide, with excellent shoulders." The area shown in this photograph is six miles west of Alanreed in the vicinity of Jericho Gap, the last section of Route 66 to be paved in the state. Courtesy National Archives.

Los Angeles highway was starting to receive national attention. Palm trees, a fabulous climate and dreams of Hollywood stardom were luring Americans to the West Coast. Although Florida was also becoming a favorite destination for northerners eager to escape the cold winters, the Golden State called to anyone willing to pull up stakes and take a chance.

For the majority of Americans living east of the Mississippi, the only route to southern California was U.S. 66. The public had pretty much forgotten the old named trails and accepted the new federal highway numbering system, and "sixty-six" stood out in folks' minds; it had a certain rhythm that other highway numbers lacked. Even the Phillips Petroleum Company named its gasoline after the new highway in 1929, partly because U.S. 66 passed near its corporate headquarters in Bartlesville, Oklahoma. A road with Al Capone's Chicago at one end and Tinseltown at the other was intriguing, and the highway soon attained a quirky sort of sex appeal.

During the Depression, the road became a highway of despair for many, carrying displaced farmers and the unemployed in search of work and a better life in the lush farms and orchards of southern California. Author John Steinbeck immortalized the highway in this role in his Pulitzer Prize–winning novel *The Grapes of Wrath*. U.S. 66 became an escape route for many; for some, from the small-time hoodlum to Clyde Barrow and Bonnie Parker, it was a route to escape the law.

The highway was empty during World War II except for occasional military convoys and necessary civilian

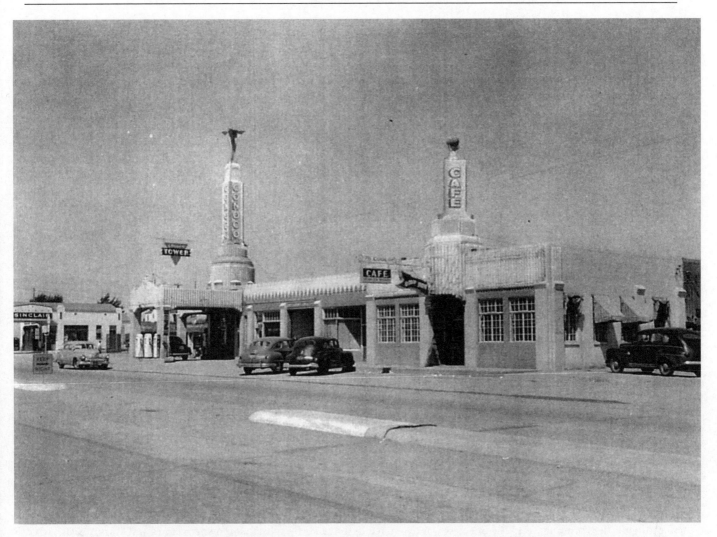

Tower Conoco and U Drop Inn Café, Shamrock, Texas. The most well-known surviving landmark on U.S. 66 is the Tower station and U Drop Inn Café, located at the junction of U.S. 66 and U.S. 83. The station was designed by its first owner, John Nunn, and constructed by J. M. Tindall in 1936. Nunn and his wife Bebe ran the business, sold it and repurchased it in 1950, restoring its original name of "Nunn's Café." The filling station and café are now closed, but the state of Texas has plans to use the site for a tourist center. Courtesy National Archives.

traffic, but it sprang to life again following the war. As if to celebrate the return of the famous highway, a little-known songwriter named Bobby Troup penned a song about the road while driving west with his wife Cynthia to Los Angeles in 1946. Cynthia first suggested that Bobby write a song about U.S. 40; Bobby suggested Route 66 instead, since they were taking it on their trip. As the couple arrived in St. Louis and began traveling on U.S. 66, Cynthia came up with the title and Bobby wrote half of the lyrics, using the names of some of the cities along the way. When they arrived in Los Angeles, Troup put the finishing touches on the song and gave it to singer Nat King Cole, who was then performing at the Trocadero Restaurant on Sunset Boulevard. Cole recorded the song that same year and it became an instant hit. "Get Your Kicks on Route 66" became the anthem for decades of Route 66 travelers.[1]

In the 1950s, the road was renamed the Will Rogers Highway in honor of one of America's most beloved humorists, a native son of Oklahoma. The tourism industry saw explosive growth during the postwar era and traffic on 66 was often bumper-to-bumper, even through the desert regions. The highway hosted an eclectic mix of colorful roadside establishments—diners and cafés, gas stations and truck terminals, the tourist camps and motels. Route 66 even inspired an eponymous early 1960s television show, featuring two young men driving a Corvette from town to town across the United States. The highway had its own organization whose job was to promote the highway, distributing travel brochures using the "Main Street of America" theme.

And yet by the mid–1970s, interstate freeways had bypassed all of Highway 66, and the road was quickly forgotten. On January 1, 1977, Illinois and Missouri began

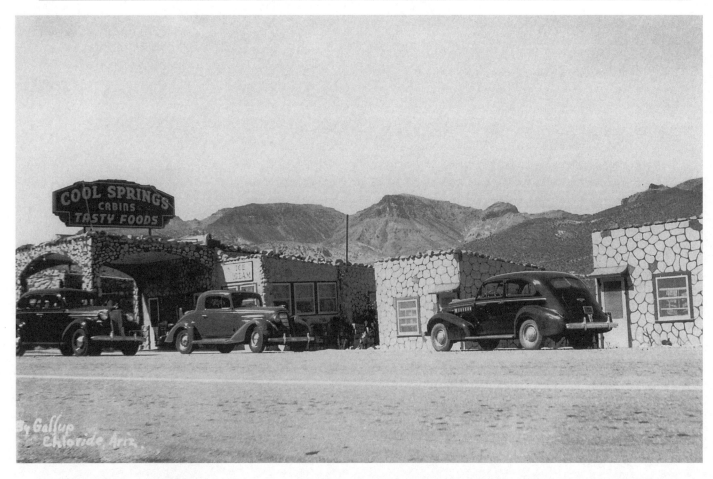

Cool Springs Camp, Gold Hill Road, Arizona (1927). One year after the official creation of U.S. 66, an Arizona trucker named N. R. Dunton built a gasoline station on the east side of Sitgreves Pass on Gold Hill Road. This was one of the most difficult sections of Route 66 for early travelers, built on the National Old Trails Road used in the late 1800s as a stage coach line and by migrating settlers heading west. The business was expanded in the 1930s by subsequent owners James and Mary Walker, who improved the cabins and added a restaurant and bar. Cool Springs Camp was abandoned a decade after the new alignment for U.S. 66 was completed in 1951, and almost completely destroyed in a movie sequence for the Jean Claude Van Damme film *Universal Soldier*. Courtesy Mojave Museum of History and Arts.

removing the once familiar U.S. 66 highway signs, and in 1985, AASHTO permanently "decommissioned" the highway because much of its route had already been assigned state and county road designations. Within just a few years, all "66" shields were quietly taken down and auctioned off to fans of the great highway.

Today, the interstate highway has effectively replaced the old federal aid system and is the quintessential American driving experience, where exit 29 in Oregon looks the same as exit 29 in Maine. The Eisenhower system of interstate and defense highways is a homogeneous blend of the "Big Three" of the freeway exit commercial scene: motels, filling stations, and fast-food franchises. While our interstates constitute only 1 percent of the nation's highways, they carry one-fifth of all vehicular traffic, safely and efficiently. However, interstate highways' broad right-of-ways lack the visual appeal and romance of the old roads, which is why Route 66 winds forever through

Opposite, top: Route 66 east of Lebanon, Missouri. Highway 66 came back to life after World War II as millions of Americans packed their bags and set out on the nation's highways in search of roadside adventure. The post-war years saw tremendous growth for the tourism industry and a new generation of travel-related businesses appeared along the country's busy thoroughfares. This is a stretch of U.S. 66 in the Missouri Ozarks west of Lebanon, Missouri. Courtesy National Archives. *Bottom:* Arroyo Seco Parkway, Los Angeles California, 1940s. The West Coast's first "free-way," opened for traffic in December 1940, was a nine-mile parkway named for a local city park. A joint project of the cities of Los Angeles, Pasadena and South Pasadena, the California Highway Department and the U.S. Bureau of Public Roads, the parkway became a vital link between the city of Pasadena and downtown Los Angeles. During World War II, additional freeway sprawl that the nation experienced during the the prosperous post-war decades. Shortly after its completion, the Arroyo Seco Parkway became part of U.S. 66, and it was renamed the Pasadena Freeway in 1954. Courtesy National Archives.

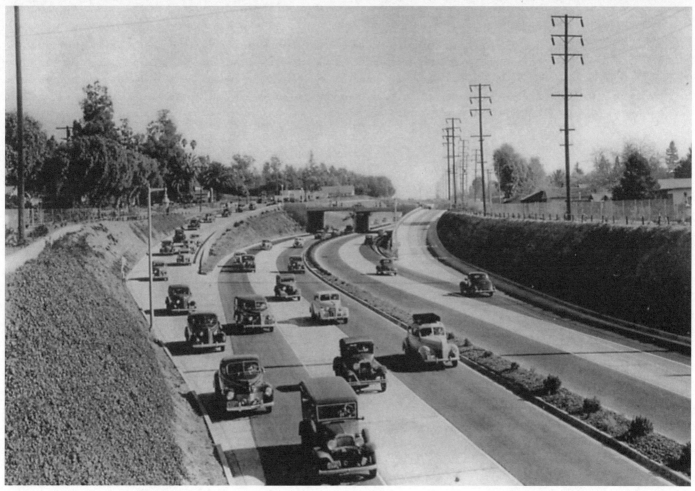

the nation's psyche. The highway has become a place to return to, like one's old neighborhood or home town. While the people along its route may change with the passing years, the road itself remains a permanent fixture on the nation's cultural landscape.

As a new century begins, the Mother Road remains, and it has now seen its seventy-fifth year. Despite time, neglect, and progress, the road has endured. Almost all of its 2,448 miles are still intact and driveable. Although the road no longer exists on highway maps and has been re-assigned various state and county road designations, highway archeologists can still explore early alignments and those bypassed by later improvements to Route 66. What's even more remarkable are the many surviving businesses and landmarks that still line its route, although more are lost as each year passes by. All eight states crossed by U.S. 66 have organizations which have marked some of the route with standard white-and-brown signs to help guide travelers. Ordinary citizens like Angel Delgadillo of Seligman, Arizona (founder of the first state Route 66 organization), who single-handedly started a grass-roots movement to preserve the old highway in 1987, have combined their talents and made their own contributions towards reviving interest in Route 66. After years of lobbying by citizen groups and others interested in the old road, Congress passed the National Preserva-tion Act of 1999, which includes the Route 66 Corridor Act, appropriating $10 million to study and preserve the highway and sites along its route over the next ten years. This new initiative will help raise public awareness of the unique role that highways have played in United States history and the need to preserve their character for the future.

This book is a photographic record of some of the historic landmarks and longtime businesses which have become roadside institutions for generations of Route 66 travelers, plus some features that are relatively anony-mous to the average tourist, like early segments of the old road. It is a salute to those who supported the highway over the years, including Cyrus Avery, Jack Cutberth ("Mr. 66"), Lucille Hamon and Campbell's 66 Express. The highway and its people are a complex study. Over seventy-five years of history, nearly 2,500 miles of high-way, and thousands of individuals cannot be completely captured in a single work. Although this book is by no means an exhaustive account of U.S. 66, nearly all of the photographs are of places that still exist and can be vis-ited today. Although much has been lost with the passage of time, interesting people and historical sites still re-main, although a single journey on Highway 66 won't guarantee that you will see everything on the route. It normally takes several journeys down the great road to see its main attractions and drive all of the old alignments. While reading about Route 66 is insightful and enter-taining, it is best to see it first-hand, and retrace the foot-steps of the Native Americans, pioneers and millions of motorists who have used the route over the past several centuries. Whether one travels the highway through the Central Plains, the Ozark Mountains, or the desert South-west, Highway 66's surviving artifacts and landmarks are sure to make a lasting impression.

Route 66

Our journey begins in Chicago, the City of Big Shoulders that sprawls for miles along the shores of Lake Michigan, and ends at another great metropolis, Los Angeles, and another body of water, the Pacific. Although many travelers drove east on U.S. Federal-Aid Route Number 66 during the road's history, millions more Americans traveled west from Chicago to southern California, so Chicago is the point of departure.

The highway officially starts in Chicago's downtown loop at the intersection of Jackson Boulevard and Michigan Avenue and begins the trip west on Jackson. However, the highway's terminus did not remain long at this intersection and the route was moved two blocks east toward Lake Michigan to the corner of Jackson and Lake

(SEE COLOR SECTION C-1.) Intersection of Michigan Avenue and Jackson Boulevard, Chicago. This is the original terminus for U.S. 66 when the highway was first designated as a federal-aid highway by AASHO in 1926. The starting point for Route 66 was short-lived, however, and was relocated two blocks east from this location to the corner of Jackson and Lake Shore Drive (U.S. 41). By the mid–1950s, the highway had been moved again after Jackson was made into a one-way street, and followed Adams Street west to leave Chicago.

Shore Drive (U.S. 41) sometime in the mid–1930s. In the mid–1950s, Jackson Boulevard was made into a one-way street heading east toward the lake, so East Adams Street, two blocks north of Jackson, became the current Route 66.

After proceeding west on East Adams Street for several blocks, drivers can find the first landmarks on Route 66 by making a U-turn and doubling back onto Jackson. At 565 Jackson (the street sign reads "South" Jackson, which is a bit confusing) is Lou Mitchell's Restaurant, with its brightly lit red neon sign. Lou's has been owned by the Thanas family since first opening in 1923. The original restaurant was across the street and relocated to its present site. The restaurant was named "Lou Mitchell's" in the 1950s and is known in Chicago for its bakery goods and superb service.[2]

Back on Adams Street, the route continues west approximately two miles, then turns left at Ogden Avenue. Several blocks farther southwest on Ogden Avenue at Taylor Avenue is a more recent Route 66 establishment, Lu Lu's (circa 1968), where the most expensive item on the menu of over sixty food choices is just $8.95.

The route continues southwest through the suburb of Cicero to the junction of Ogden and Harlem avenues in the city of Riverside, where 66 makes a left turn south on Harlem for several blocks to Joliet Road. Farther down the road is Snuffy's 24 Hour Grille, still visited by truckers on this neglected stretch of Highway 66.

The route turns right at Joliet Road and continues southeast until it reaches a freeway interchange at Indian Head Park. At this point, Interstate 55 replaces Joliet Road, so drivers must follow the interstate approximately eight miles to the Joliet Road exit (Illinois state highways 7 and 53). This is the 1926–40 alignment leading to Joliet.

An alternate route, built by World War II, is farther down the interstate and begins at the exit for Illinois State Highway 126, heading west to the city of Plainfield. In the center of Plainfield, this route crosses the famous Lincoln

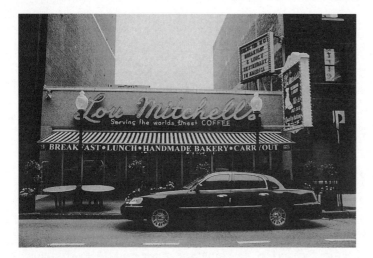

(SEE COLOR SECTION C-1.) **Lou Mitchell's, Jackson Boulevard, Chicago. Originally opened in 1923 across the street from its present location, Lou Mitchell's is one of the oldest continuously operating eating establishments on U.S. 66. Lou's is run by the descendants of founder Bill Thanas, who passed away in 1999. The business adopted the surname "Mitchell" after son, Lou (who still owns the restaurant) and added the red neon sign in the 1950s. Lou Mitchell's is open seven days a week and still does a brisk business despite the highway's rerouting off of Jackson Boulevard.**

Highway (U.S. 30); turns south and passes the west side of Joliet; and finally rejoins the older U.S. 66. By approximately 1940, the Plainfield bypass was officially designated as U.S. 66, with the Joliet alignment from Lamont to Elwood (south of Joliet) marked as "Alt 66" on roadmaps of the period. However, Alt 66 carried the most traffic despite traveling through the city of Joliet, so the state upgraded it to a four-lane highway in the early 1950s. Prior to this project, the state built small sections of some of the nation's first "super-highways" during the 1940s under a bill passed by the Illinois legislature in 1943. Eventually, the legislation resulted in U.S. 66 being improved into a four-lane, limited-access freeway from Chicago to St. Louis by the mid–1950s. However, the Joliet Road alignment is the more scenic of the two, so it is the preferred route.[3]

Proceeding south from I-55, Joliet Road passes a rural area that has seen little change in the decades since the interstate diverted most traffic away from Joliet. The highway approaches the northern outskirts of Romeoville and curves past the White Fence Farm Restaurant. The White Fence Farm has been operating alongside this four-lane version of U.S. 66 since 1954 and is still run by its original owner, Doris Hastert (her husband Robert passed away in 1998).[4] The business's sign out front features a rooster, a tip-off that chicken is the specialty here.

The highway enters the north end of Joliet as Broadway, then makes a left turn at Granite Street, which becomes Ruby Street. Route 66 crosses the Des Plaines River

on the Ruby Street Bridge, one of a series of lift bridges in Joliet. The bridge itself is of sturdy steel construction and painted green, as are its sister bridges just a few blocks away. On the east side of the bridge is its art deco-styled concrete control tower. A small plaque mounted on the tower dates the bridge to 1935.

The road makes a sharp right turn after crossing the bridge and heads south on a series of local streets: Chicago, North Washington, and Ottawa. The route continues past two larger lift bridges, both built the same year as the Ruby Street Bridge. The Cass Street Bridge carries U.S. 30, better known as the Lincoln Highway, one of the few original named trails that became federal-aid highways in the 1920s. The Jackson Street Bridge is just a short distance away and is the route for U.S. 6, another major trans-continental federal-aid highway, so this stretch of 66 was extremely congested years ago. Joliet is also the crossroads for U.S. 52, which begins at the North Dakota-Canadian border and runs diagonally southeasterly to Charleston, South Carolina, so veterans of travel on U.S. 66 can well remember how traffic inched along through downtown Joliet. The city route is still marked as Illinois State 53 and becomes a four-lane road after leaving Joliet's south side. This stretch was widened during World War II to accommodate increased traffic near ordnance facilities in Kankakee and Elwood.[5]

Route 66 finally leaves the outer fringe of the Chicago metropolitan area and traverses prime American farmland to St. Louis, Missouri, some 250 miles away. The cities of Chicago and St. Louis experienced rapid growth during the 1800s and became the major population and trade centers of the Midwest. Gradually, a crude road developed, called the Chicago-to-St. Louis Road, which served as the main route between the two cities for almost 200 years. Springfield, the state's capital, is situated midway between the two cities, so it was only natural that U.S. 66 would follow this path.

During the early decades of the twentieth century, the states established highway departments to plan and construct new state roads to accommodate the steady increase in vehicular traffic. When Congress passed the Federal Aid Road Act in 1916, the route from Chicago to Morris consisted of 60 miles of stone and gravel, with short sections of concrete road at Morris, Pontiac, Funk's Grove, Lincoln and Springfield. Illinois received approximately $12 million in federal matching funds under the act and the Illinois State Highway Commission immediately utilized its share to plan a 4,000-mile state-wide system of hard-surfaced roads. In 1918, a state bond issue approved $50 million to fund the new system and the Illinois State Highway Department assigned Illinois State Route 4 to the Chicago-to-St. Louis Road (named the Pontiac Trail by trail organizers in 1915). On February 1, 1921, the state

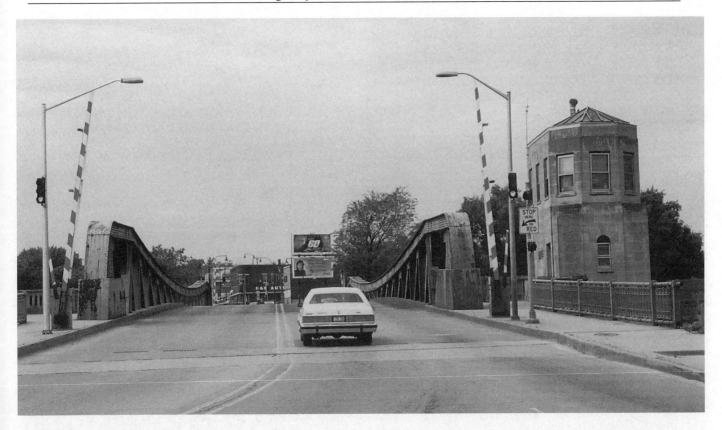

Ruby Street Bridge, Joliet, Illinois (1935). A view facing west on the Ruby Street drawbridge over the Des Plaines River in Joliet, Illinois. Two larger bridges, also built in 1935, are several blocks south of this location, and carry two other major transcontinental routes, U.S. 30 (the Lincoln Highway) and U.S. 6.

took construction bids for the new highway system, and built an 18-foot-wide concrete roadway at a cost of $30,000 to $40,000 per mile. By 1924, the entire route from Chicago to St. Louis was completely paved. In 1926, the American Association of State Highway Officials (AASHO) designated Illinois State 4 as U.S. 66, after the AASHO approved the route numbering scheme for the new federal-aid highway system.[6, 7]

After leaving Joliet, U.S. 66 (Illinois State 53) heads southwest across basically flat terrain. Just north of Elwood, a 1926–30 alignment continues straight ahead, then makes a 90-degree turn west toward Elwood, while the 1940–77 route curves off to the right and takes a more direct path into town. Just outside of Wilmington is Jim Gorman's Vegetables, a throwback from the good old days when local farmers sold crops and other agricultural products at homemade roadside stands. In Wilmington, Illinois 53 enters town as Water Street, then takes a right turn at Baltimore Street. The road crosses the Kankakee River on a concrete bridge that was refurbished in 1998. An old dam is visible from the bridge, and opposite the dam is the Van Duyne Motel, which advertises itself as the "Best Motel by a Dam Site."

Leaving Wilmington, the highway continues five miles to Braidwood. Travelers can bypass the town and

continue south on State 53, or enter Braidwood by exiting to the right. Just beyond the railroad tracks that parallel U.S. 66 is Peter Rossi's service station (circa 1939), currently Lucenta Tire, next to an aging motel that was once a part of Peter Rossi's business. The old station has survived over 60 years of changes on the old road. Its current owners have photographs of the building in its earlier days on display, before it became a tire dealership.[8] The main street continues into Braidwood, while the 1930–40 alignment (now IL 129) runs past Lucenta Tire and the motel toward Plainfield. This route soon ends at Interstate 55, but another section of the route between Plainfield and Shorewood remains and is currently designated as Illinois State 59. The Plainfield alignment is referred to as the official Route 66 on many 1940s and '50s highway maps, while the old route through Joliet was usually called Alt 66.

Highway 66 heads southwest on the modern 1940–77 route (Illinois 53) just east of the railroad tracks and the 1930–40 alignment. The road passes through a string of small villages — Godley, Braceville, and Gardner — all once thriving towns until the area coal mines gave out. A few slag heaps of mining waste can be still be seen in the vicinity. Nothing notable is left in Braceville, and the 1930–40 alignment continues southwest on the west side

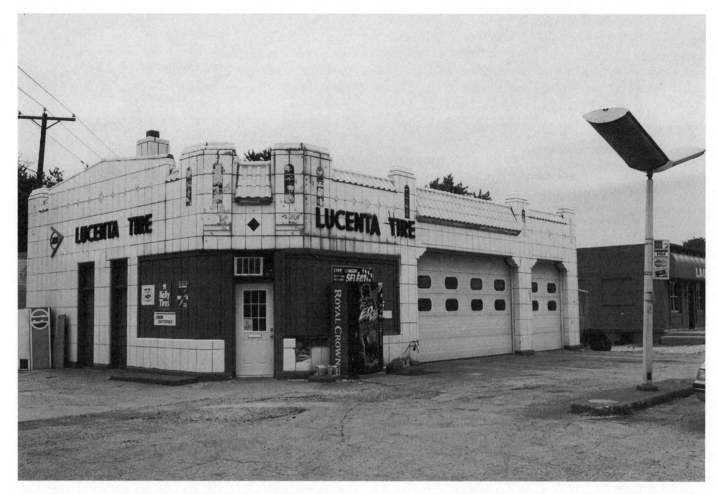

Rossi's Service Station, Braidwood, Illinois (1939). Originally an outlet for the Sinclair Oil Company, the Rossi family opened this art deco service station in the late 1930s just a few years before Route 66 was bypassed by a four-lane highway. The Rossis later added a restaurant, laundry and motel; only the motel next door remains today. Currently, the station is occupied by Lucenta Tire, a regional chain which purchased the site in the 1980s.

of the railroad tracks. The 1930–40 route is closed to traffic approximately a mile south of town and posted signs warn of the road's closure ahead. However, just beyond the barricaded roadway is a steel suspension bridge over a set of railroad tracks, built in 1939. The Braceville Bridge, also called the Illinois Route 129 Bridge, looms above the old alignment for 66. It is slated for restoration by the Illinois Department of Transportation, along with other historic landmarks on the historic highway, including businesses, billboards, grain elevators, and other structures.[9]

Route 66 enters Gardner and makes a 90-degree turn in the center of town. The road leaves town heading west and rejoins the 1930–40 alignment. Illinois 53 soon meets up with Interstate 55, but Old U.S. 66 makes a sharp left turn that is easy to miss. Next is Dwight, which was bypassed by a modern four-lane built in the 1940s. The road enters town as Waupansie Street and continues past the site of the Carefree Motel, now gone, and a closed Marathon filling station, both dating from the 1930s.

The northern half of the Chicago–St. Louis section of Route 66 contains other fine examples of early limited-access super-highways built in urbanized states like Illinois in the 1940s. In 1941, the first sections of bypasses around the cities Bloomington and Lincoln were completed. These new alignments for U.S. 66 are on the western perimeter of both cities and are narrower than today's interstate freeways. Construction continued through the war, as the state highway department anticipated a return to normal traffic patterns. By 1946, all of the major towns from Lincoln to Dwight were bypassed and by the early 50s, Route 66 became a non-stop four-lane highway all the way from Chicago to St. Louis.[10] The towns bypassed by the new U.S. 66 can be seen to the east and can be investigated by exiting off four-lane 66 (a left-hand turn if heading south). These original alignments are easy to spot; they are parallel to the railroad tracks and pass through the center of each town along the route. As soon as they were finished, however, each became a focal point for traffic slow-downs as vehicular traffic steadily mounted

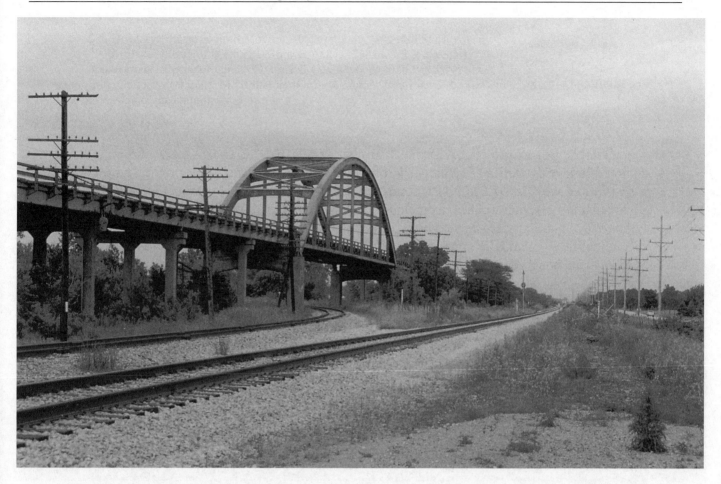

Braceville Bridge (1939). A view looking north of the Braceville Bridge (also called the Illinois Route 129 Bridge), constructed in 1939 for the new lanes for U.S. 66 to bypass the old route at right. The bridge is currently closed to traffic. The Illinois Department of Transportation is undertaking a new program to save many structures and landmarks on U.S. 66 and plans to preserve this historic bridge.

following World War II. Despite the careful planning, congestion continued to outpace new highway construction and Highway 66 remained a crowded thoroughfare up to its final days.

Four-lane 66 continues south from Dwight and curves past the western edge of Odell. The city route predates U.S. 66; this was once Illinois State 4. On the south side of town is a recently-restored Standard filling station built in 1932. Sometime in the 1940s, the station stopped selling Standard Oil products and was converted to an outlet for Sinclair Oil, then went out of business after U.S. 66 was decertified as a federal aid highway and traffic deserted 66 for the interstate. In the late 1990s, the station was restored as a Standard gas station, like it was in the 1930s. A sign on the property states that the structure has been listed as a national historic site.

After leaving Odell, the road runs parallel to I-55 to the tiny town of Cayuga, marked by a grain elevator and several Quonset huts. To the west and across I-55 is another rare find: a barn painted with an advertisement for Meramec Caverns. This popular Midwest tourist attraction,

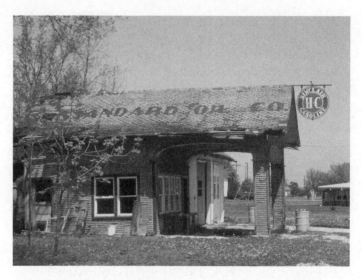

(SEE COLOR SECTION C-2.) Sinclair Station, Odell (1932). This Sinclair gas station is one of the oldest on the Illinois portion of Highway 66. It stayed in business for only a short time after it was bypassed by the construction of I-55 in the 1960s. Originally a Standard outlet featuring double garage bays, the building was recently refurbished.

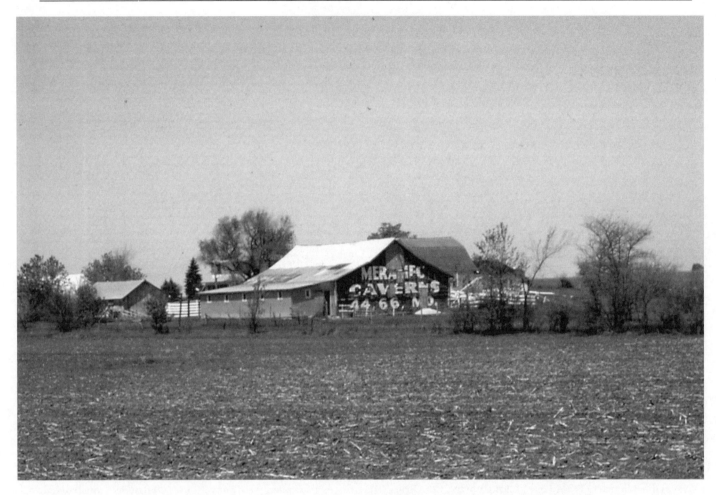

Meramec Caverns barn, Cayuga, Illinois. This is the last barn on the Illinois portion of Route 66 advertising Missouri's Meramec Caverns. The early barns used a basic black and white color scheme from the 1930s until an updated version appeared in the 1950s. This barn is west of Cayuga and is visible from Interstate 55 and the old alignment of Route 66.

located on U.S. 66 in the foothills of the Missouri Ozarks, was discovered by cave explorer Lester Dill in 1933 and opened to the public two years later. Advertisements for all sorts of consumer products, local businesses and tourist stops were once painted on barns as a cheap alternative to billboards. The Cayuga barn is unique, the only barn advertisement still standing on the Illinois section of Highway 66.

Beyond Cayuga is Pontiac, named for an Indian chief. Four-lane 66 takes its usual wide sweep past the west side of town, while the 1926–30 route through town passes some historic sites. On Pontiac's north side is the Old Log Cabin Inn, which once fronted on Illinois State 4. In the 1930s, the entire structure was moved 180 degrees to face the newer U.S. 66.[11] In Pontiac, a spur off to the left crosses a small creek. Drivers will find a short concrete bridge here, the Van Der Kar Young Bridge, dating to 1933 according to commemorative metal plaques. A few miles south of Pontiac is the old District 6 headquarters for the Illinois State Highway Patrol, built during the Second World War, as was four-lane U.S. 66. For decades, District

6's state troopers have maintained a constant presence on U.S. 66, keeping watch over the changing traffic patterns and discouraging speeders, particularly before speed limits were instituted in the 1950s.

The highway curves past several more towns— Ocoyo, Chenoa, Lexington, and Towanda — before it enters the twin cities of Bloomington-Normal, home of Illinois State University. The original 1926–30 route follows a crooked path through Normal, first on Pine Street, then Linden Avenue, and finally Willow Street, where the route enters the town's north side. At the intersection of Willow and Main Street, Route 66 makes a left turn south onto Main, currently designated as Business Route U.S. 51. Normal was the site of the first Steak and Shake drive-in (a chain of restaurants found mainly in the Midwest). City 66 continues on Main Street through Bloomington, then turns right at Oakland, left at Morris, and finally south on Beich to leave town.

Heading southwest from Bloomington, the highway crosses to the west side of I-55 at Shirley. An abandoned section of 66 lies to the east of the newer alignment, just

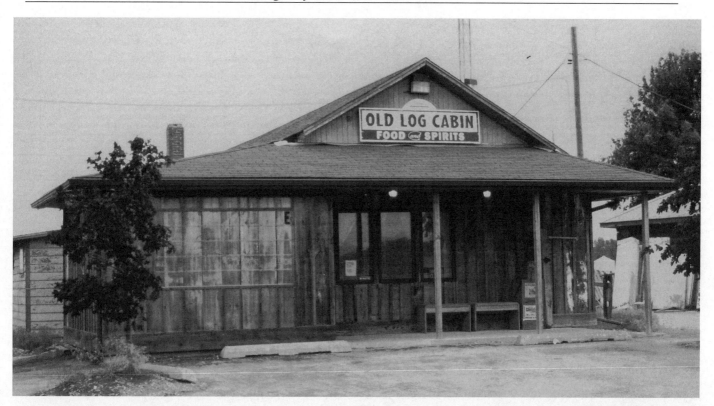

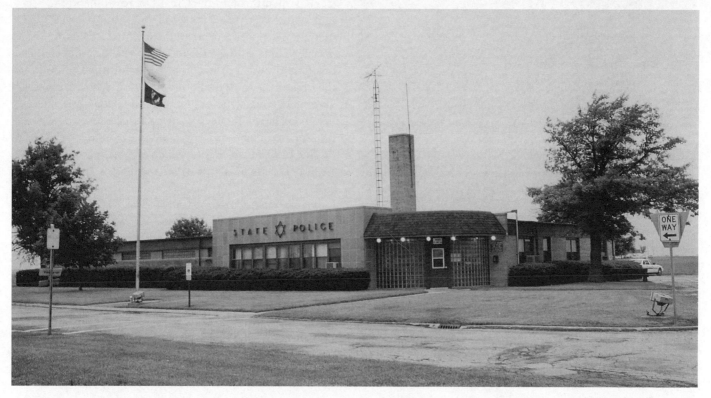

Top: Old Log Cabin Inn, Pontiac, Illinois. Constructed by the Seloti brothers, the Old Log Cabin Inn originally faced east on Illinois Route 4 and has been operating since the early 1920s on the north side of Pontiac, Illinois. In 1930, the second alignment for U.S. 66 was built to bypass Pontiac and most of the towns along the route from Chicago to St. Louis, and the building was moved 180 degrees to face the new highway. Ownership of the Old Log Cabin Inn has changed hands several times during the ensuing decades, but it remains open. *Bottom:* District 6 Headquarters for Illinois State Police. Built at the conclusion of World War II, this building still serves as the headquarters for District 6 of the Illinois highway patrol. The state built the facility as part of its post-war highway program to modernize U.S. 66 into a four-lane limited-access freeway.

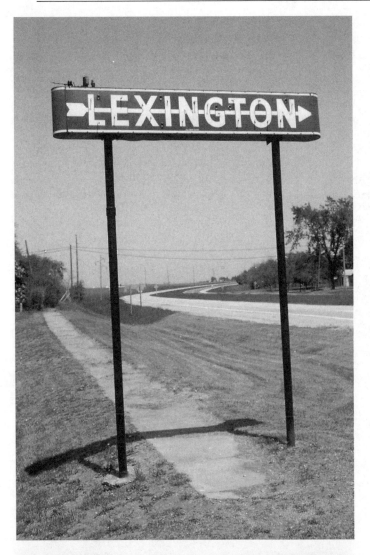

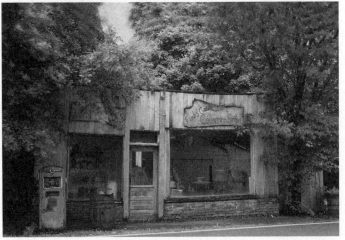

outside of town. The only landmark is the local maple syrup factory, located off of Route 66. Beyond Shirley is Funk's Grove, famous for its maple syrup. A right-hand turn leading to the tiny village is marked by an arrow-shaped sign reading "Maple Sirup" (not a misspelling!) pointing farther down the highway. The turn-off heads west through a quiet wooded area known as Funk's Grove. The road leads to a clearing and the Funk's Grove Country Store and Antiques, closed for years, with one aging red gas pump. Funk's Grove's original railroad depot is just yards away. It escaped demolition and moved to its present site after the railroad discontinued service to the tiny burg. Returning to the main road and heading south a short distance, drivers will find the home of the Funk family, who have been making and selling maple syrup here since the 1820s.[12]

Next is McLean, the location of the Dixie Truckers Home truck stop, one of the few original truck terminals remaining on Highway 66. Since 1926, the Dixie Truckers Home has been a favorite stop for wildcat truckers and American families on summer vacation, and the building itself grew along with its reputation. The die-hard establishment has never closed, not even for one day, staying open through the Great Depression and the Second World War. The Truckers Home almost met its fate in 1965 when a fire destroyed the entire structure. The disaster didn't stop the Dixie; as soon as the ashes cooled, business resumed as loyal patrons continued to pull off the highway. A new brick building replaced the original, and the current structure has recently been given a face-lift. The Dixie Truckers Home is still a must-see attraction for anyone driving Highway 66. It houses the "Route 66 Hall of Fame Museum," which exhibits vintage menus from original cafés and other mementos from the old road.[13]

Leaving McLean, the route follows U.S. 136 for a mile or so, then continues on to Atlanta and then Lawndale. This is Abe Lincoln country, and several historic sites honoring the great president can be visited in this part of central Illinois. The city of Lincoln comes next, where motorists have a choice of three routes. The town was named for Abraham Lincoln, who practiced law here in the late 1850s after he prepared the necessary legal papers to incorporate the city.[14] The original 1926–30 alignment zig-zags through town, first on Kickapoo Street, a right turn onto Keokuk Street, then left onto Logan Street. A

Top: Sign for Lexington. At the outset of World War II, Illinois began building a four-lane "freeway" parallel to U.S. 66. Bloomington and Lincoln were the first cities to be by-passed, in 1941; by 1946, the towns between Dwight and Lincoln were bypassed, including Lexington. This inoperable neon sign along four-lane 66 points east toward town, where the first alignment dating from the early 1920s is located. *Bottom:* (SEE COLOR SECTION C-2.) Funk's Grove Country Store and Antiques. This old store is just east of U.S. 66 and has been closed for many years; the old road became neglected after it was bypassed by the interstate in the 1960s. A well-preserved railroad depot was moved west from the tracks next to Route 66 and now lies a short distance away. The store is part of the small town of Funk's Grove, named for a local family.

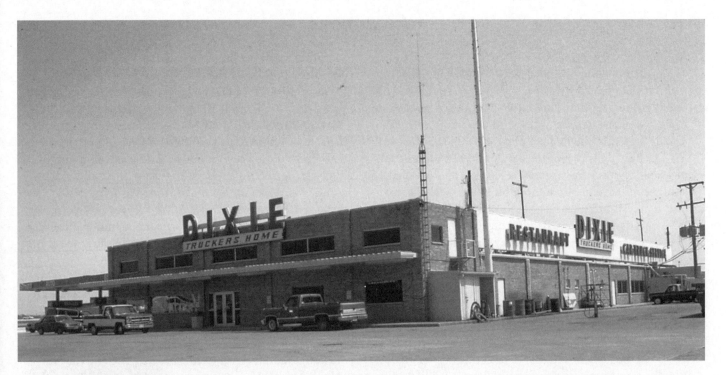

Top: Dixie Truckers Home, McLean, Illinois. In 1928. J. P. Walters and his son-in-law John Geske bought a garage at this location in McLean, Illinois and it has operated as the Shirley Oil and Supply Company ever since. The business served basic country-style cuisine and operated under the name "Dixie Truckers Home" to conform with Walters' personal style of southern hospitality, which became legendary among over-the-road truckers. The dining room was expanded in the 1930s and the business stayed open 24 hours a day. The present structure was built in May 1967, after a major fire two years earlier. Walters left the business in 1950 and John and Viola Geske took over; some years later, the Geskes' daughter Charlotte and son-in-law Charles Beeler took over. The Dixie Truckers Home was purchased in 1996 by the Beelers' son Mark and his wife Kathy. *Bottom:* Modern cement bridge on four-lane U.S. 66 near Atlanta, Illinois (1954). An example of one of the many small cement bridges that still remain on the post-war alignment of Route 66 in Illinois. Most of these bridges on four-lane 66 were built in 1954 and are marked with date plaques. A rusting plaque on the railroad bridge in the background is dated 1901. This has been the main route between Chicago and St. Louis for over 200 years.

few blocks farther, the route follows Fifth Street, taking a diagonal heading to the right. As the road leaves Lincoln, it rounds a curve past the Mill Inn restaurant, originally the Dutch Mill. The Dutch Mill opened in 1931 and was a popular roadside dining and drinking spot until it finally closed in the 1990s.[15] The road through the south side of Lincoln is one of the best-preserved pieces of the original highway, its original cement with sloped curbs still intact. Several old outdoor billboards are still standing here, visible to drivers heading north into Lincoln. These signs are among a handful on Highway 66 and elsewhere that survived the Highway Beautification Act of 1965, a federal law that mandated the removal of over 600,000 highway billboards across the United States. During the 1930s, a bypass diverted traffic around the west side of Lincoln, then a more modern four-lane was built farther west in 1941. The roadway for the 1941 bypass later became I-55.

The post–1940 four-lane 66 continues southwest, skirting the towns of Broadwell, Elkhart, Williamsville, and Sherman. Broadwell is the site of the Pig's Hip Restaurant, famous since 1937 for its "Pig's Hip Special" and other pork sandwiches. The unique cuisine plus its location made it a magnet for travelers for 50 years. As Broadwell came into view on the horizon, a sign spelling out the word "RESTAURANT" in red neon atop a building told motorists that this was the place to pull over for real food. Route 66 goes thorough Broadwell non-stop, but passing the Pig's Hip was not so easy, as travelers could not resist the smokey aroma drifting from the restaurant.[16] Unfortunately, the restaurant closed in the early 1990s. After Williamsville, the road dead ends at I-55, so the freeway must be crossed at the tiny town of Sherman to return to the old alignment.

From Sherman, the route enters the state capital of Springfield from the north at the Peoria Road exit, also called Loop 55. Local landmarks and references to Abraham Lincoln abound in the Illinois state capital, as he made Springfield his home from 1837 until he left for Washington to take office just before the Civil War. Lincoln and his family are buried at the Lincoln Tomb on the north side of town near the state fairgrounds, and the

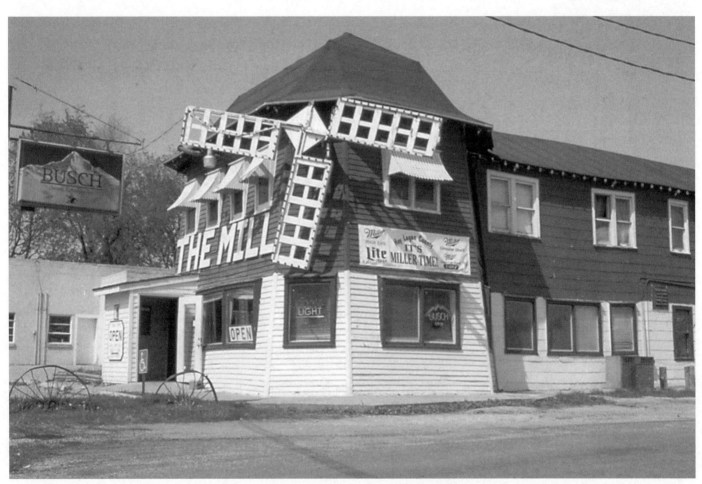

Dutch Mill Restaurant, Lincoln, Illinois (1931). A fixture on the south side of Lincoln, Illinois since the early '30s, the Dutch Mill attracted a steady clientele for many years. The Dutch Mill (later called simply "The Mill") closed in the 1990s after over 60 years of service. The building is situated on a curve on the original 1926–30 alignment on the south side of town.

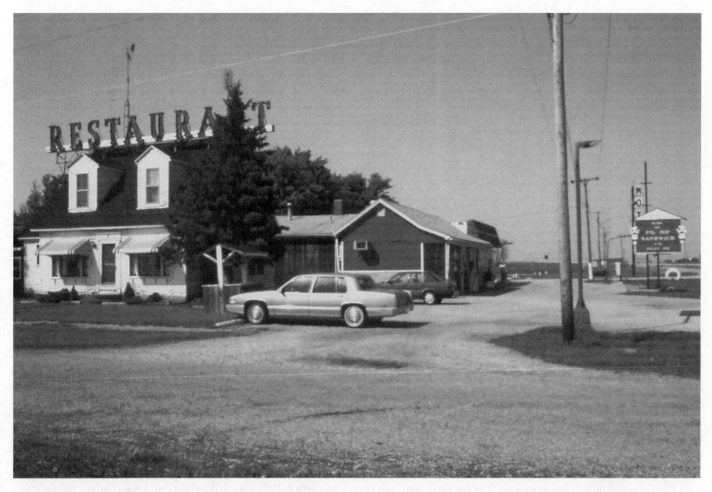

Pig's Hip Restaurant, Broadwell, Illinois (1937). Opened in the late 1930s, the Pig's Hip Restaurant was named after its pork sandwiches and other pork menu items, the invention of its owner, Ernie Edwards. Located in Broadwell, the business flourished for many years even after being bypassed by Interstate 55. The Pig's Hip closed for good in the 1990s.

Lincoln residence on Ninth Street is a national historic site open for public tours. Highway archeologists have three alignments through Springfield to choose from. The routes are marked by standard brown-and-white signs erected by the Illinois Route 66 Association and used by Route 66 associations in other states to mark the route. The Illinois versions are inscribed with the dates when each route was designated as U.S. 66. Just before the city limit, a 1940–77 alignment leaves Peoria Road to the left at Dirksen Parkway and continues south along the east side of Springfield, with I-55 farther to the east. This route turns west on Stevenson Drive, then south (left) onto Sixth Street, after which Sixth becomes I-55 just south of the city limits. The 1930–40 alignment continues south on Peoria Road from the intersection with Dirksen Parkway, becoming Ninth Street. Many of Springfield's main historical sites are near the Ninth Street alignment, just a few blocks to the west, including the old and new state capitol buildings and the Lincoln Home National Historic Site. The route took a right turn at Myrtle Street, then continued south on Sixth Street and left

town, but Sixth was made into a one-way street heading north. To see the old alignment, drivers must take Fifth Street south to Stanford Avenue (near the southernmost section of Springfield) and double back north on Sixth Street. The alternate route via Fifth Street can be picked up by turning right on Spruce Street (just before Myrtle Street) and heading south on Fifth Street, also a one-way. After turning north onto Sixth Street, drivers will find the Cozy Dog Drive-In at 2935 South Sixth Street.

The Cozy Dog is famous as the birthplace of the corn dog. During World War II, a local man named Edwin Waldmire II, while stationed at the U.S. Air Force base in Amarillo, Texas, invented a recipe that he called the "crusty cur"—a frankfurter covered in corn batter, which was then deep-fried. In 1946 Waldmire began selling his crusty curs from a small shack on Route 66. His wife, Virginia, convinced him early on to change the name of his food treat to "cozy dog," and the business naturally became the Cozy Dog. In 1950, Waldmire collaborated with the original owner of Dairy Queen, which was already becoming a household name synonymous with ice cream

(SEE COLOR SECTION C-3.) Cozy Dog Drive In, Springfield. A roadside institution on Route 66 since 1950, the Cozy Dog Drive In was started by Edwin Waldmire II, who invented a recipe consisting of a hot dog coated in corn batter and then deep-fried while he was in the service during the Second World War. Waldmire initially called it a "crusty cur," but his wife convinced him to call them a more marketable name, "cozy dogs." While others may lay claim to the invention of the "corn dog," the Cozy Dog remains a true original.

(the first Dairy Queen opened in Kankakee, Illinois in 1938). The Dairy Queen was built as a separate structure and customers could sit and eat in the area between the two buildings. Waldmire built a new building called a "drive-in," a roadside eating sensation that started on the west coast in the 1930s and began sweeping the country following the war. On September 27, 1950, the joint venture officially kicked off. A breezeway was built between the two buildings a few years later. After the Dairy Queen left, Waldmire remodeled the breezeway and built a single structure.

The Cozy Dog Drive-In remained a fixture on Route 66 on Springfield's south side into the 1970s, and Waldmire retired in 1975 (he passed away in 1993). The wood in the old building rotted over the years and became infested with termites, so the entire structure was torn down in 1976. The vintage Lincoln Motel next door was likewise demolished the same year and a new Cozy Dog was built on the property of the motel, while a Walgreens drug store was built on the former site of the original Cozy Dog. Waldimire's son, Edwin "Buzz" Waldmire III, and wife Sue ran the Cozy Dog until Sue became sole owner in 2001. During the 1980s and 1990s, the Cozy Dog maintained a relaxed atmosphere, where customers could make their own coffee and otherwise help themselves if Buzz was away on an errand. Today, the Cozy Dog is a meeting place for Route 66–seekers and, despite dozens of regional imitators, is a true original.[17] The 1940–77 alignment of U.S. 66 leaves town and becomes I-55, so the interstate must be rejoined to continue south.

The third and most interesting of the three Springfield alignments is the 1926–30 route, which begins by turning right (west) at Taintor Road just after the 1940–77 alignment branches off of Peoria Road at Dirksen Parkway. After turning onto Taintor Road, this early route passes the Illinois State Fair Grounds and bears south onto Fifth Street, jogs west at North Grand Avenue onto Second Street past the state capitol building, then continues west at South Grand Avenue onto Mac Arthur Boulevard. Proceeding south on Mac Arthur, the route turns west (right) onto Wabash Avenue, then south at Chatham Road, finally crossing U.S. 36 and joining Illinois State Route 4.

The history of the final segment of Route 66 between Springfield and St. Louis is markedly different than the stretch between Springfield and Chicago. Prior to 1930, Illinois State 4 from Springfield south to Staunton was the forerunner of U.S. 66. State highway records show this routing as temporary only. Illinois 4 follows a crooked path, in sharp contrast to the federal aid highway system's practice of planning the most direct routes whenever possible to save mileage. The state searched for a better route early on, and by 1930 Route 66 was moved east from Illinois Route 4 to the 1930–40 alignment, which follows Sixth Street due south out of Springfield. The first 55 miles (Springfield to Staunton) offer two alignments for highway exploration. Illinois State 4 is the oldest, making many 90-degree turns as it winds its way toward Staunton. Following Illinois 4 from Springfield, Route 66 passes first through the town of Chatham, with the original route angling off to the left through town. Several miles past Chatham is a rare piece of vintage Route 66, a ten-foot-wide brick section marked by a Route 66 Association sign next to a farmstead. This old road, only a mile or two long, passes over two small concrete bridges with memorial plaques dating them to 1920 as it gently winds its way back to Illinois State 4. At Thayer, the old alignment is a narrow path into town. Next is Virden, where old 66 follows Springfield Street, one block off the main route through the town's center. Illinois 4 zig-zags further south through Girard and Nilwood. Short stretches of this 1920s-era road can be seen between the small hamlets along the way, all driveable although a bit bumpy in places, some marked by the Illinois Route 66 Association's standard brown-and-white signs. In Carlinville, the county seat of Macoupin County, 66 follows a traffic circle, then heads east between the ornate courthouse and an old jail dating to 1869. The highway continues past Illinois farm country and through Gillespie, Mount Clare, Benld, Sawyerville, and finally, Staunton. The road winds through town, with the 1926–30 alignment bearing right and Staunton's classic old Main Street to the left. The 1926–30/Illinois 4 route heads west and

(SEE COLOR SECTION C-3.) **Brick pavement on Illinois State Route 4. Following a state bonding initiative in 1918, Illinois embarked on an ambitious statewide highway program to meet its growing transportation needs. Beginning in 1920, Illinois constructed a system of paved state roads, among them, State Route 4, which ran north–south the length of the state. In 1926, the portion of Illinois Route 4 from Springfield to Staunton was designated as U.S. Federal Aid Highway 66. Only a few vintage brick sections remain, such as this example located several miles south of Chatham.**

leaves town but is joined a mile or so away by the 1930–40 alignment. Several miles farther south, the two combined routes lead to I-55 and turn right to follow the interstate southwest; Illinois 4 continues south and passes under I-55.

The alternate route from Springfield to Staunton is east of the 1926–30 Illinois State 4 alignment and was completed by 1930. Although the new highway was a definite improvement, it quickly became a nightmare for travelers as traffic volume and accidents escalated as the 1930s came to a close. During the 1940s, the state responded by rebuilding Route 66 as a four-lane highway and constructing safer by-passes around cities such as Litchfield, Mount Olive, and Staunton. Although the old Route 66 is cut off by I-55 in a few places, there are at least three long uninterrupted stretches of roadway to explore. The route leaves Springfield on Sixth Street and follows I-55 south, since 66 was replaced by the interstate for the first several miles. The old road first appears on the west side of the freeway, at the town of Glenarm on the west side of I-55. Route 66 hugs the interstate for the next 20 miles or so, passing through Divernon, Thomasville, Farmersville and Waggoner. All four towns are connected by a road running parallel to U.S. 66 that existed prior to 66's construction in the late 1930s.

Approximately one mile south of Waggoner is Francis Marten's home, location of the "Our Lady of the Highways" shrine. This site consists of a simple statue of the Blessed Virgin Mary standing on a cement and brick base,

all made by Marten himself, next to a garage adjacent to the Marten home. A dedication plaque inscribed with the words "Protect Us On The Highway" was added in 1959. Marten also put up a series of small signs spelling out the prayer, the "Hail Mary," along the highway just south of the shrine. Today, a newer set of such signs line the same stretch of road. Countless travelers have stopped and visited Marten's shrine for inspiration or silent worship for a safe journey along what was once called "Bloody 66" by veteran motorists. (As of the writing of this book, Francis Marten is age 90 and in ill health. His son, Lee Marten, still resides in the area).[18]

South of Waggoner, a modern freeway bridge takes 66 over I-55. The 1930–40 and 1940–77 routes can be driven from here to Litchfield, where the 1930–40 alignment leaves the 1940–77 four-lane segment to the east. The route first passes under a concrete railroad bridge dating to approximately 1940, when this modern stretch of Route 66 was completed. A bit farther down the road, the 1930–40 portion exits to the left just north of Litchfield and passes the last operating outdoor movie theater on Route 66 in Illinois, the Frisina Sky View Drive-In Theatre, where the adult admission is only $1.00 and children get in free. The two alignments pass through Litchfield separated by only one city block. Just east of the junction of the older two-lane segment of Highway 66 and Illinois State 16 is the site of the 66 Motel Court, which was unfortunately demolished in 1999. The 66 Motel Court's familiar red neon sign is gone, now only a chapter in the history of Route 66. Only a blue-and-white sign reading "66 Hotel Court," its neon tubing missing, marks the spot of the old motel.

Just across the intersection of U.S. 66 and IL 16 is the Ariston Café, in business since 1935. The original restaurant was opened by Pete Adam in 1924 in Carlinville, approximately 13 miles northwest on the Illinois Route 4 alignment, and is named for the Greek word *aristos*, meaning "the best." When it was announced in 1929 that Route 66 was being moved east from Illinois Route 4, Adam opened a second location in Litchfield just kitty-corner from the current café to be on the new highway. The hard times of the Depression years wreaked havoc with countless businesses, both large and small, and forced Adam to close his Carlinville restaurant. In 1935, he left the leased location in Litchfield and built the current structure, now approaching its seventieth year of operation. An addition was built onto the east side of the café, but the Ariston Café's overall appearance has not changed, with wooden booths on the left side of the restaurant and red vinyl and chrome bar stools lining the counter on the right. In 1954, the state built a new four-lane alignment for U.S. 66 behind the restaurant, and a neon sign was added to the rear of the building so travel-

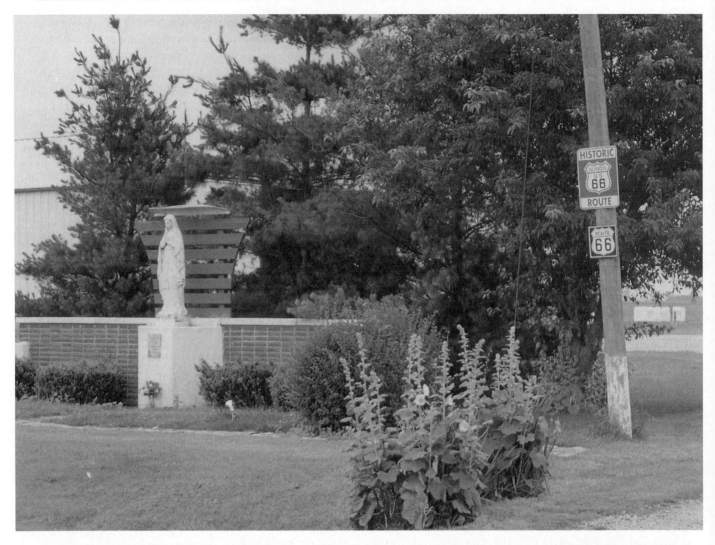

Our Lady of the Highways, Waggoner, Illinois. This shrine was erected on the 1940–1977 alignment of U.S. 66 south of Springfield by Francis Marten. The statue was visited by countless motorists who prayed for a safe journey on Route 66. The shrine is in front of Marten's home on the west side of Route 66, one mile south of Waggoner, Illinois.

ers wouldn't miss the café. In 1966, Adam's son Nick took over the café and still operates it along with his wife, Demi.[19] Across the old alignment from the Ariston is the only remnant of Vic Suhling's filling station: a vintage sign advertising "Gas for Less." A bit farther south is the Route 66 Café, a more recent business which took over an existing structure and adopted the name of the old highway to capitalize on the mystique of Highway 66.

Heading south from Litchfield, both routes converge but the two alignments diverge again before reaching Mount Olive. The 1940–77 route bypasses Mount Olive to the west while the older 1930–40 alignment passes through the center of town. The original route through Mount Olive crosses a set of railroad tracks and passes the Mount Olive Milling Company, founded in 1876. As the road starts to leave town, it comes to an intersection. Straight ahead is the newer alignment; 66 turns left

(south). A right turn at this junction leads to a cemetery notable for being the final resting place of Mother Jones, an early labor organizer of U.S. coal miners in the 1800s. A red-and-yellow Shell sign (circa 1960s) is visible from the intersection on the 1930–40 path of old 66. Next to the Shell sign is a modest filling station with a small carport, its gas pumps missing, and a sign announcing this as "Soulsby's Service." Opened in 1926, this vintage Shell station was owned and operated by Russell and Ola Soulsby (brother and sister) since the inception of Highway 66 and closed only recently. Even in his elder years Russell Soulsby kept the business open six days a week, and the station witnessed countless scenes on the moving pictorama that is Route 66. Ola passed away, followed by Russell in 1999, after which the station was auctioned off.[20] The building's appearance is unaltered except that the two glass "Shell" globes attached to the carport pillars have been removed. The road passing Soulsby's Shell

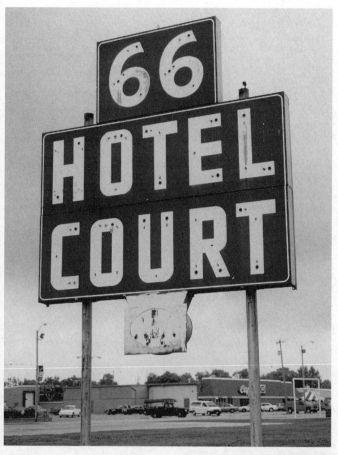

leaves town and rejoins the 1940–77 alignment. The road splits again after a short distance, the 1930–40 route heading toward Staunton to the left and the 1940–77 segment continuing straight ahead to Williamson and Livingston. The 1940–77 alignment was replaced by I-55.

Just north of Staunton on I-55 is the site of 66 Terminal, one of the largest truck stops on Route 66. The 66 Terminal was opened in 1940 when the four-lane alignment came through to bypass Staunton.[21] The station grew steadily over the years, adding a café, motel, and a steel derrick topped by giant neon "66 Cafe" lettering that was visible for several miles. The 66 Terminal was a busy stop for truckers and others traveling the congested St. Louis–Chicago section of U.S. 66 but eventually lost out to competition from newer establishments. The entire business was torn down recently and replaced by a used car dealership. A newer Phillips 66 station is just down the

Left: (SEE COLOR SECTION C-4.) **66 Hotel Court, Litchfield. This sign is all that remains of the 66 Motel Court, located in Litchfield, Illinois. A larger red neon sign reading "66 Motel Court" was taken down in 1999 when the motel was demolished.** *Bottom:* Ariston Café, Litchfield (1935). The Ariston Café was opened by Pete Adam during the Depression on the new 1930 alignment for U.S. 66 after the route was officially moved from Illinois State Route 4. Since 1966, the Ariston Café has been operated by the founder's son, Nicholas Adam, and his wife Demi.

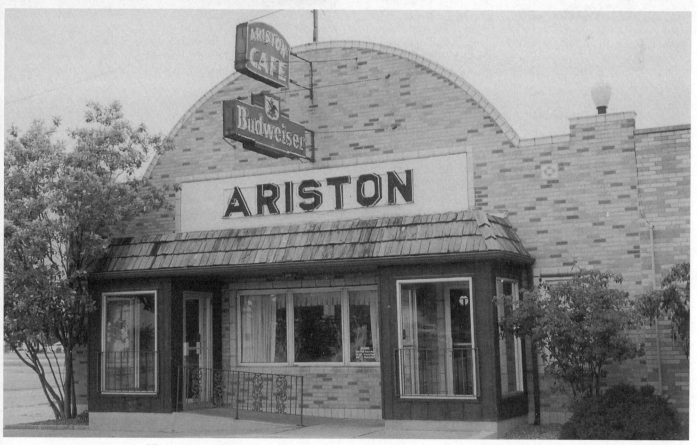

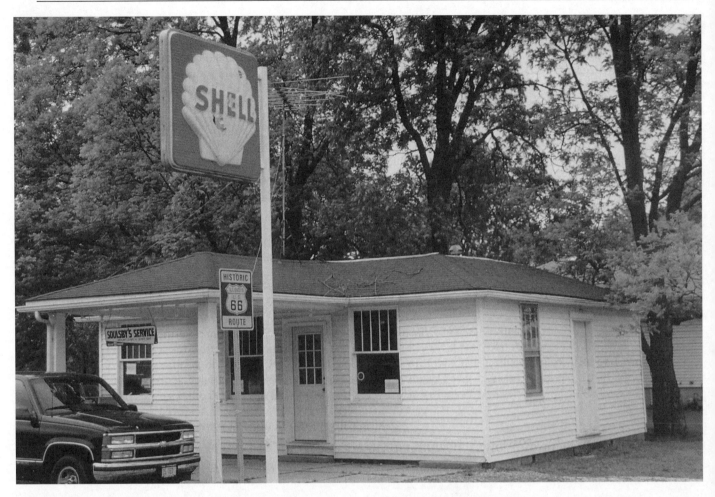

Soulsby Shell, Mount Olive (1926). Owned and operated by Russell and Ola Soulsby from 1926 until recently, this gas station is on the 1940–1977 alignment on the south side of Mount Olive, Illinois. Some of the station's original contents, including two glass "Shell" globe lights that hung from the pillars of the carport, are now in Shell Oil Company's museum in nearby Wood River, Illinois.

freeway off Exit 41 for Staunton, and includes Diamond's Restaurant, where the proprietors will gladly direct motorists to the former site of 66 Terminal.

The road continues southwest as Illinois State 157, just west of I-55 for a few miles and arrives at Hamel. The 1940–77 route was replaced from Staunton all the way to St. Louis, so IL 157 is the only historic link remaining in this part of southern Illinois. The road crosses Illinois State 140 and arrives at Earnie's Restaurant, owned by Bob and Joy Earnhart since 1982. The original build-

ing dates to the late 1920s and was first called the Village Inn. Hamel's village hall has an excellent collection of historic photos of Route 66 for curious travelers to browse through.[22] Next is Edwardsville, a town which has seen little change since U.S. 66 went through here before the

(SEE COLOR SECTION C-5.) Earnie's Restaurant, Hamel. Situated just west of the junction of Route 66 and Illinois State Route 140, Earnie's has been at the same location since the late 1920s, when Route 66 was a brick-paved highway. The original building was a small white structure called the "Village Inn," built by the Cassen family. The business was later known as the "Tourist Haven" and included sleep rooms upstairs. In the 1930s, the present brick structure was built around the original building. Earnie's Restaurant has been owned by Bob and Joy Earnhart since 1982.

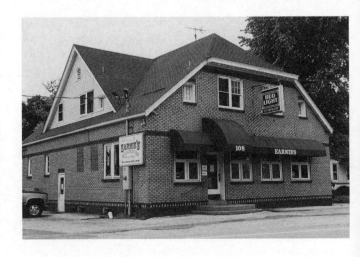

Second World War. Illinois 157 winds through town and leaves as Vandalia Street, passing a well-made brick billboard advertising the First Federal Savings and Loan ("Since 1921"), then under a viaduct for the old Electric Railroad.

Route 66 continues south, with the Southern Illinois University—Edwardsville campus west of the highway. The road becomes a four-lane for a short distance as the route is joined by a road leading south from the university. As this four-lane segment approaches Interstate 55, Illinois 157 continues south while U.S. 66 heads due west along the north side of the interstate. This junction, just north of freeway Exit 9, is where U.S. 66 met another great transcontinental highway, U.S. 40, before the construction of the interstate. This area was once teeming with traffic and activity and a roadside park with picnic tables and a gasoline station were located adjacent to this once-busy intersection.[23] The combined route of U.S. 66 and U.S. 40 continues west along the north side of the I-55 as they ap-

proach Mitchell, where several old motels can still be found along the route. The Bel Air Drive-In is closed now and the Town and Country Motel looks as if it hasn't seen any customers for quite some time. Luckily, the Luna Café is still open, its classic neon sign advertising "Steaks, Chicken, Sea Food" plus "Fine Drinks" and "Pkg. Goods." Currently, the Luna Café's specialties include burgers, steak, a monster-sized 12-inch taco, and fish deep-fried at a high temperature and recognized for miles around as a taste sensation unique to the Mitchell area.[24]

After Mitchell, the road heads south and crosses underneath I-55 as Illinois 203. A short distance away, Route 66 divides into two alignments. The early route, used only between 1926 and 1930, heads into St. Louis on Illinois State 3, while the newer alignment bypassed the city on its northern and western sides. If time is short, drivers should take I-270 west and cross the Mississippi River into Missouri, rejoining the post–1930 alignment that took traffic around the St. Louis metropolitan area. The

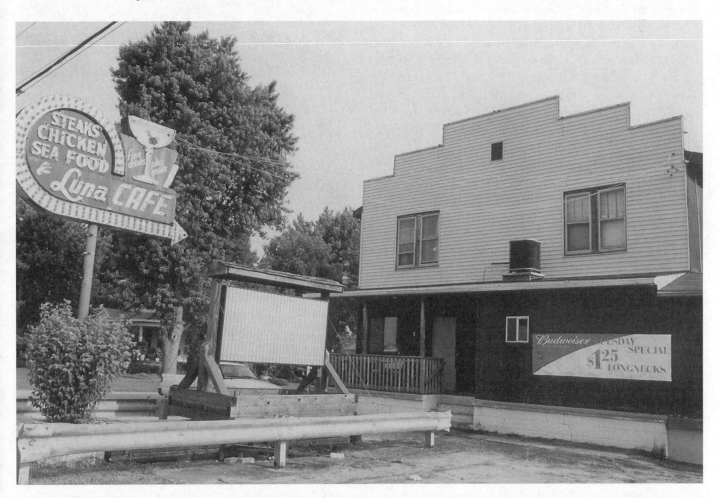

Luna Café, Mitchell, Illinois (1924). One of the oldest continuously-operating businesses on U.S. 66 is the Luna Café, built two years before there was a Route 66. The business has a colorful past; it operated for a time as a "cat house" and is rumored to have hosted the likes of Al Capone. A giant neon sign with a crescent moon on the roof of the building was taken down after it was badly damaged in a recent storm. Its current owners, Allen Young and Larry Wofford, are attempting to raise the $5,000 needed to repair the sign.

old route into St. Louis is by far the more interesting, following Illinois 203 south from Mitchell to Granite City, Venice, and across the McKinley Bridge into St. Louis. A great monument to Route 66's past stands a short distance away on a bypass route that was constructed in the late 1920s.

Route 66 was heavily traveled since its inception in 1926 and motorists badly needed an alternate route to avoid the congestion of the St. Louis metro area. In the late 1920s, planning began for a by-pass route to take traffic north of St. Louis. The bypass would share the same route as U.S. 40 until the two highways divided at Pattonville, northwest of St. Louis. This route was called "Bypass 66" on most road maps, while the original road through St. Louis was named "City 66." Bypass 66 begins at Mitchell and heads west on Chain of Rocks Road toward the Mississippi River; the route is well-marked by "Route 66 Historic Route" signs put up by the Illinois Route 66 Association. The road passes the Land of Lincoln and the Chain of Rocks motels, both in aging condition but with their original post-war-era neon advertising signs. The intersection with Illinois State 3 was called the St. Thomas Junction years ago, and I-270 is visible just to the right (north). Straight ahead through the intersection, a "Historic Route 66" sign reads "Spur," meaning that this is a dead-end side-road for U.S. 66. On the left shoulder is the Canal Motel and Café, still open. A bit farther is an abandoned gas station with an old metal sign advertising "Twin Oaks—Gas for Less." The road then climbs a long incline towards a steel truss bridge. At the crest of the hill is a steel truss bridge crossing a made-made river channel onto Chouteau Island. The bridge is marked by a metal plaque on the right bridge abutment identifying this as the Chain of Rocks Canal Highway Bridge, with dates of construction from 1946 to 1949. Chain of Rocks Road from this point east to Mitchell dates to 1929, but was rebuilt in the late 1940s when the bridge was finished. The plaque further commemorates this bridge as a project commissioned by the U.S. Army Corp of Engineers, which also dredged the barge canal beneath the bridge in the late 1950s to ease river traffic around the perilous waters on the western side of the island. The bridge was once in poor condition and speeds were limited to ten miles per hour due to the deteriorated steel-mesh bridge deck. The Canal Highway Bridge was recently repainted and the bridge deck and roadway repaired. The route continues west beyond the bridge and finally leads to a major landmark in Route 66 history, the now-closed Chain of Rocks Bridge.

To veteran travelers and road buffs, the Chain of Rocks Bridge remains an icon of 66 lore. Even today, admirers and curious tourists still make a pilgrimage to this almost-sacred site. Opened in 1929, the bridge was a major breakthrough for travelers seeking a route around St. Louis. Although there is some disagreement over when the bridge became a part of Route 66, the Illinois Highway Department records that it was designated as U.S. 66 in 1936. Drivers were charged a toll to pay for the bridge's unkeep, as with many other major bridges in the United States. Also known as the "Kings-Highway Chain of Rocks Bridge," the 5,350-foot long structure spans a shallow stretch of the Mississippi River strewn with large

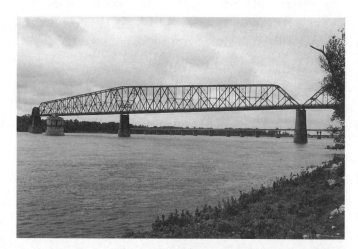

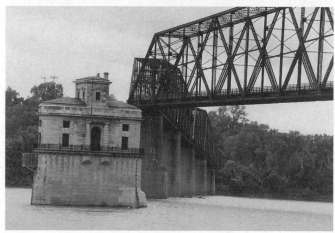

Top: (See color section C-5.) Chain of Rocks Bridge over the Mississippi River. Completed in 1929, the Chain of Rocks Bridge's continuous steel truss design is still the 12th longest of its kind in the world. The bridge officially became part of Route 66 in 1936 and carried over 11,000 vehicles per day during its peak years. In September 1966, the I-270 bridge was opened 1800 feet upstream, reducing traffic on the Chain of Rocks Bridge to only 100 vehicles per day. The bridge was closed in 1968. *Bottom:* (See color section C-6.) Chain of Rocks Bridge and #2 intake tower. This view shows the water intake tower built in 1913 near the Chain of Rocks Bridge's infamous 24-degree bend. Built at a cost of $2,000,000, the 5,350-foot bridge included a radical angle near the middle to satisfy river-boat operators who wanted a safer passage through the channel. By positioning a pier close to the water intake tower, a wider channel for river boats passing near the island was created.

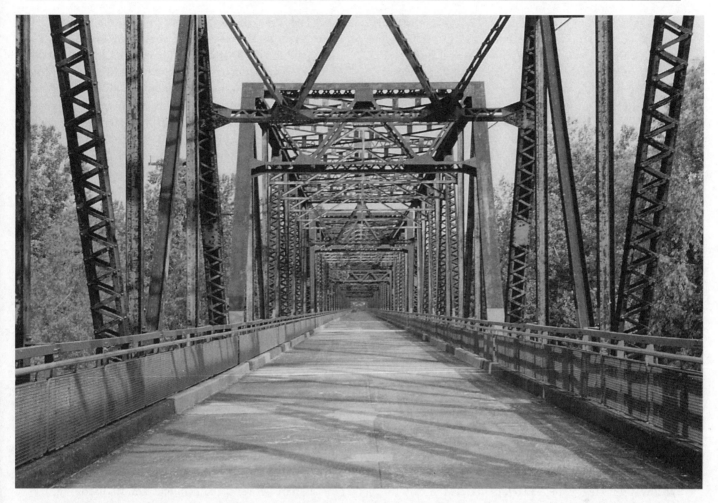

Looking west on Chain of Rocks Bridge from Chouteau Island. The Chain of Rocks Bridge opened on June 25, 1929, and became the fifth bridge to cross the Mississippi in the St. Louis area. The original plan called for a four-lane bridge 40 feet in width but was scaled back to only two lanes with a roadway width of 21.8 feet. The Illinois approach to the bridge was once lined with 400 elm trees, while the Missouri side had a small park and pond near a brick toll house. A joint effort by the city of Madison and the states of Illinois and Missouri has reopened the bridge for pedestrian and bicycle traffic as part of a system of bike trails called TrailNet.

boulders, which ensnared countless riverboat vessels since the days of Mark Twain. Riverboat captains dreaded this portion of the Mighty Mississippi well into the twentieth century, until the barge canal was built just after World War II. Planning for the bridge began as soon as Route 66 became a U.S. highway, and construction began simultaneously from both sides of the river in 1927. The new bridge was built during the early years of the federal-aid highway system, during the late 1920s and '30s, as were most major bridges in the Midwest. Others dating to this period include the Lewis and Clark bridges near Alton, Illinois (1929; both razed); the Mark Twain Bridge at Hannibal, Missouri (1935); the Champ Clark Bridge at Louisiana, Missouri (1928); and the Mississippi River bridge (1929) and the Ohio River bridge (1938), both near Cairo, Illinois. Work was temporarily delayed due to flooding on the eastern approach on the Illinois side in early 1929. The Chain of Rocks Bridge opened for traffic

on July 29, 1929, and travelers soon began using the new route, bypassing St. Louis.

The Chain of Rocks Bridge is a continuous steel truss design, with 17 concrete piers forming 16 spans, each 350 feet long. Planners were so proud of the new bridge that they planted 400 elm trees along the road approaching the bridge on the Illinois side, while Missouri constructed a landscaped water pond on the western river bank. The original plans called for a four-lane highway leading to the bridge at both ends, but a two-lane was built instead. The bridge's trademark is a sharp 24-degree bend at its midpoint, next to a midstream water intake building built in 1913 by the Chain of Rocks Water Company. The odd design originates from the objections of riverboat captains, who believed that placement of the bridge piers for a straighter bridge would be hazardous for boats to navigate. Placing a pier next to the water intake building provided a wider, safer passage for river traffic. A few hundred

yards downstream is a smaller intake tower (circa 1889) rising like an island from the swift current. A third, less-ornate building was added on the Missouri shore in 1932 to keep sand and ice from clogging the other towers.

The two intake buildings are made of heavy stone-work and have a medieval appearance. The 1913 tower is 98 feet above water level, with a foundation made of concrete and Georgia gray granite with buff Bedford limestone facing, and interior walls of white enameled brick. The building has a balcony, and its roof is made of green slate. The building's architectural style is classified as Imperial Roman. The lower level housed the control room for the gates that moved water via an underwater pipeline toward the city of St. Louis, while the upper story was used as sleeping quarters for the operators. Tower #2 is southwest of the larger 1913 intake tower, only 1,400 feet from the Missouri side. This stretch of the Mississippi was known as "Homer's Dike" and Native Americans once crossed the river at this location during dry seasons. Tower #2 is almost as tall as Tower #1 at 92 feet above river level; its foundation is made of Missouri red granite with limestone facing, while the upper portion is made of brick. Like the newer tower, the first floor was used as the control room while the second floor provided the living area for the operators.

Although the Chain of Rocks Bridge was an engineering marvel for its time, its design destined the bridge to a short lifespan. The bridge is only two lanes and its roadway 24.8 feet wide. Travelers first had to stop for the tolls at either end, then proceed single-file across the mile-long bridge. Traffic had to slow considerably while crossing, especially when vehicles met tractor trailers at the bridge's sharp bend. It was not unusual for traffic to come to a complete halt as vehicles were forced to back up to negotiate the corner at the bridge's mid-point. The journey across the bridge often seemed endless, especially at night, when the bridge was a surreal scene of noisy trucks, headlights and street lamps, and the omnipresent whine of vehicles snaking their way across. The bridge was originally owned by the Kingshighway Bridge Company, which collected a toll of five cents per person at toll houses at either end. Stricter federal regulations made operation unprofitable, and the bridge was sold to the city of Madison in 1939 for $2.3 million. Travel nationwide was greatly curtailed by World War II, and revenues fell by 50 percent. Tolls were increased to 35 cents per vehicle, and five cents for each additional passenger. By the late 1950s, tolls were reduced to just 15 cents per vehicle. The toll houses were handsome structures made of sturdy masonry, with carports on either side where motorists stopped to pay tolls. Today, both toll houses are gone and the west approach to the bridge has been fenced off along Riverside Drive.

The Chain of Rocks Bridge proved to be an excellent investment for the city of Madison, since the bridge more than paid for itself with revenue generated from toll collection. However, a new bridge over the Mississippi River for Interstate 270 was completed just 1,800 feet upstream in 1966, diverting most traffic away from the Chain of Rocks Bridge. Traffic dropped from over 11,000 vehicles per day during the bridge's peak years, to an average of only 180 per day following completion of the I-270 bridge. The bridge was dealt a second major blow that same year when a dispute erupted between the city and the federal government over toll collection. Legal action ensued and the issue was settled when Illinois governor Warren Hearnes ordered a suspension of tolls. The loss of revenue meant that Madison could no longer afford the bridge's maintenance costs of $50,000 per year, so the city closed the Chain of Rocks Bridge in 1968.[25]

The bridge sat idle for several years and plans to demolish it and sell it for scrap metal were abandoned when the price of scrap metal plummeted in the mid–1970s. Other proposals, such as building a restaurant on the bridge or converting the area on the Illinois side into industrial or recreational zones, never made it past the drawing board. Too costly to dismantle, the old bridge lingered into the 1980s, gaining a bit of notoriety when a scene from the movie *Escape from New York,* starring Curt Russell, Andrienne Barbeau, and Ernest Borgnine was filmed there. The bridge's accesses on both banks of the Mississippi were eventually blocked off to discourage trespassing. On the Illinois side, weeds grew in the roadway and the bridge became obscured, entangled in vines. In 1999, the Chain of Rocks Bridge became part of a new recreational area connected by bike paths which will eventually stretch from Alton, Illinois to St. Louis. By 2000, the bridge and the east approach area were cleared of decades of overgrowth. The bridge is now secured by an iron gate at night but is open during the daytime for foot-traffic and bicycles. The famous bridge looks better than it has in years. Visitors may view the bridge by taking a gravel road to the left, just a few hundred feet from the bridge. The road leads to a city park on the west shore of Chouteau Island with a full view of the historic bridge. The two-mile portion of concrete pavement leading to the bridge dates to 1949, the year the Chain of Rocks Canal Bridge was completed.[26]

To return to U.S. 66, motorists must backtrack east to the junction with Illinois State 3. The bypass route heads north at I-270, just to the north, and follows the I-270 freeway bridge across the Mississippi River into Missouri. However, City 66 is by far the more interesting alignment, and begins at I-270 Exit 4 for Mitchell and proceeds south on four-lane Illinois 203 (Nameoki Road) to Granite City. The route turns right onto Madison

Avenue, and becomes Broadway Avenue on Granite City's south side. After leaving the city limits, Broadway continues through the town of Madison and into Venice, passing neglected neighborhoods and industrial areas. Here, the road approaches the Mississippi River and the McKinley Bridge.

The McKinley Bridge, built in 1910, is the second-oldest in the St. Louis area (after the Eads Bridge, completed in 1874) and has been rumored for years to be targeted for demolition, due to its advanced age. Corroding plaques at either end date its construction to a time when the motor-cars were just beginning to replace horse power. The bridge was actually built for trains and livestock, and was the largest electric bridge at the time. Later, additional lanes for motor vehicles were added to the sides of the bridge.[27] The ancient structure still carries traffic across the Mississippi north of downtown St. Louis and collects a toll on the Illinois side at an equally-ancient toll plaza. The toll is only 50 cents, and the bridge runs parallel to an old railroad bridge. Here, City 66 enters St. Louis, a city famous for the blues.

If time is a factor, travelers can bypass the McKinley Bridge by continuing south on Illinois State 3 to the I-55/I-64 bridge across the Mississippi into St. Louis. This is Route 66's final alignment, from 1940 until 1977, the year the Missouri and Illinois Departments of Transportation took down all U.S. Route 66 road signs because the highway had been completely bypassed by interstate freeways. While crossing the river on the interstate, drivers can see an immense railroad bridge, now closed, to the left.

During its early decades, U.S. 66 followed many routes through downtown St. Louis. While all have some historical value, tracing all of them is time-consuming. City 66 was rerouted after the opening of the Chain of Rocks Bridge in 1929. It followed Riverview Drive south from the Missouri side of the bridge until it became Broadway, after which it turned left onto Florissant Avenue, to Carter Avenue, then onto North Florissant Avenue to the western end of the McKinley Bridge. From there, City 66 continued southeast on North Florissant, becoming Mullanphy (an earlier route continued west

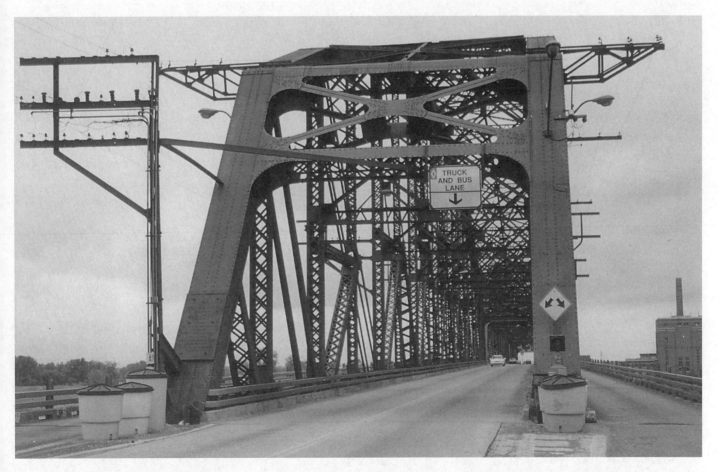

McKinley Bridge, St. Louis (1910). Reputed to be the largest electric bridge in the world when it was completed, the McKinley Bridge was actually built for trains and livestock. The rising number of motor vehicles prompted engineers to add additional lanes for autos on each side of the bridge a few years later. The McKinley Bridge became "City 66" after the Chain of Rocks Bridge opened in 1929; it is currently closed.

from McKinley Bridge on Salisbury Street, west on Natural Bridge Avenue, south on Vandeventer Avenue, and finally west on Manchester Road.) The route turns right onto 13th Street and becomes Tucker Boulevard (formerly 12th Street), with the old bus terminal on the left. City 66 bypasses the central St. Louis business district. The city's famed Gateway Arch and Busch Memorial Stadium are visible to the east. Tucker Boulevard passes under I-64, crosses a bridge over the city's main railroad yard, and bends southwest and over I-55, becoming Gravois Avenue.

Route 66 continues on Gravois Avenue (marked as Missouri State Road 30) and enters St. Louis' south side. This alignment was used in the 1930s, when the route was moved from Manchester Road on the western fringe of St. Louis. After Grand Avenue, drivers pass the art deco Bank of St. Louis and arrive at the intersection with Chippewa Avenue. Route 66 turns right onto Chippewa Avenue, passing under the Union Pacific Railroad viaduct. After the intersection with Kingshighway Boulevard, the route

passes through a quiet residential area with neat brick homes and manicured lawns. The road here is called Missouri State 366 and passes the Keller Drug store, with its cylindrical art deco neon sign. The road leaves the St. Louis city limits, crosses the Des Peres Drainage Channel, and enters the suburbs of Mackenzie, Shrewsbury, and Marlborough as Watson Road. At 6525 Watson Road is the Do-nut Drive-In, circa 1950, beyond which the road makes a slight bend to the left and reapproaches the St. Louis city limits. Ahead on the south side of Watson Road is Ted Drewes Frozen-Custard, which started as a roadside stand in 1929. Ted Drewes came up with his own frozen custard food treat that, so far, no one has successfully copied. Like many other Route 66 success stories, it is still open, and is on City 66. The building was added onto in the 1980s and is presently owned by Ted Drewes, Jr. Ted's sister and four of Ted Sr.'s grandchildren and other relatives work at the restaurant, so a third generation is continuing the family tradition.[28]

The road continues past an area that still has a few

Do-nut-Drive-In, St. Louis (1950). The Do-nut Drive-In began as a joint venture of two brothers and has been on City 66 in St. Lois since 1950. After 30 years of operating the Drive-In, they sold it to another proprietor, who ran the business for 15 more years. Kay Schwarz is the third and current owner and keeps the Do-nut Drive-In open seven days a week.

Ted Drewes Frozen-Custard (1929). A short distance west of the Do-Nut Drive-In is the location of Ted Drewes' original road-side stand, which has been expanded since its debut on the new Route 66 in 1929. Ted Drewes passed away in 1968; his son, Ted Drewes, Jr. and a third generation of Dreweses are keeping the family tradition alive.

old motels. This was the edge of the St. Louis metropolitan area before World War II. The Coral Court, perhaps the highway's finest example of "streamline moderne" architecture popular from the 1920s through the 1940s, is gone now, a victim of progress. The Coral Court's motel units had rounded corners with attached garages (a luxury in those days) and its exterior was of yellow glazed brick with glass block windows. The Coral Court did a steady business from the day it opened in 1946, but was too far away from the interstates and other major thoroughfares. The motel became run-down as business declined. In the spring of 1995, the property was sold and all of the buildings were demolished, except for one motel unit that was saved and is now on display at the Museum of Transportation in St. Louis.[29] The motel had a colorful history, and the loss of the Coral Court is another reminder of the tenuousness of the remaining relics on Route 66. The La Casa Grande Motel has survived, however, its units forming an intimate inner courtyard, a common configuration designed to prevent highway noise from disturbing the sleep of motel guests. The motel

is for sale, along with its nice neon sign bearing the slogan "Like a Fine Hotel." The route continues west, passing the Crestwood Bowl and Cocktail Lounge, also with a vintage neon sign. Watson Road passes Kirkwood Road (U.S. 61 and U.S. 67) and eventually merges onto I-44, so drivers must take I-44 to proceed west.

Drivers can follow an earlier alignment for Route 66 by leaving Watson Road and taking Kirkwood Road north through the suburb of Kirkwood for approximately three miles, then west (left) at Manchester Road (Missouri State 100). Manchester Road crosses under I-270 and eventually leaves the St. Louis suburbs. This route was replaced in 1932 by Watson Road.[30] It meets the post–1932 alignment near I-44 at Grey Summit, approximately 26 miles west of the junction of I-270 and Manchester Road. However, thanks to the Chain of Rocks Bridge, Bypass 66 was used by most motorists to avoid the city of St. Louis altogether.

Bypass 66 skirts St. Louis on its north and western perimeter, then rejoins the old City 66 at Watson Road in the southwestern edge of the metropolitan area. Starting

north of the Chain of Rocks Bridge at the I-270 bridge over the Mississippi River, the old alignment was replaced by the interstate for the first six miles west to Lindbergh Boulevard. After leaving the freeway onto Lindbergh Boulevard (also U.S. 67), Bypass 66 follows it south to the city of Kirkwood. This is the original four-lane "belt-line" route built before World War II. Jack Rittenhouse's 1946 book *A Guide Book to Highway 66* described numerous auto courts for overnight lodging along Lindbergh Boulevard, among them the King Brothers Motel (at the corner of Lindbergh and Clayton), the 66 Auto Court, and the Blue-bonnet.[31] Lindbergh Boulevard reaches the intersection with Manchester Road approximately eight miles south of I-270 at the northern edge of the suburb of Kirkwood, where two alignments can be taken. The pre–1932 Manchester Road alignment mentioned above can be taken west until it ends at Grey Summit. Manchester Road is a four-lane commercial strip lined with businesses, which gradually give way to the Missouri countryside as the road leaves the St. Louis area. The later alignment continues south on Lindbergh through Kirkwood, where Lindbergh is renamed Kirkwood Road, and heads west on Watson Road.

West of the cloverleaf with I-270, I-44 replaces U.S. 66 for the next 15 miles to Allenton. The interstate crosses the Meramec River into Fenton, passing a strip of nationally-known motels, restaurants and businesses. Until the mid–1990s, the Siesta Motel, the Sunset Ranch, and a few other run-down motels sat on the service road on the south side of I-44, but they were demolished to make way for new development. U.S. 50 shares this route with U.S. 66 and Interstate 44 for the next 25 miles, until 50 leaves the freeway at Exit 247 for Union. The route passes a giant Daimler-Chrysler assembly plant; Lone Elk County Park; Washington University Tyson Research Center; and West Tyson County Park. A surviving piece or two of Old 66 can be seen near the north side of the interstate and a short section can be found by taking Exit 266 (Lewis Road), which leads to the new Route 66 State Park, established in 1999. The road takes an old bridge (circa 1931) across the Meramec River, a winding tributary of the Mississippi that crosses the path of the Mother Road several times as she proceeds west toward the Ozark Mountains. The Route 66 State Park is a 409-acre park, its serene setting masking a somewhat checkered past.

The story begins in 1926, when the St. Louis Times newspaper purchased the land next to the sleepy Meramec River. The newspaper began a daring yet innovative publicity campaign designed to increase its readership: selling small parcels of land for $26.50 to anyone who subscribed to the Times for at least six months. Soon, the area became a small tourist attraction and came to be called "Times Beach." Small trailers and rudimentary

structures of all types appeared, then people began living at Times Beach year-round. Gradually, Times Beach evolved into a community of over 4,000 permanent residents. However, the town's fortunes changed suddenly in 1982, after flooding of the Meramec River revealed high levels of dioxin in the soil. The federal and state governments declared the area unsafe for habitation, forcing all residents to abandon their homes permanently. Times Beach became a ghost town, and all of its buildings were demolished and 265,000 tons of contaminated soil was removed. Today, Times Beach no longer exists, not even on road maps.[32]

Leaving Route 66 State Park, the old road merges right onto westbound I-44. A small piece of the old road appears, then disappears again. Drivers must follow Interstate 44 for the next six miles, to Exit 161 for Allenton, where U.S. 66 is called Business Loop 44. The road swings away from the interstate, running parallel to the Burlington Northern–Santa Fe railroad and crossing a deteriorating concrete bridge. On the north side of the highway is the V-shaped sign for the Al-Pac Motel (1942), which has been remodeled in recent years. In its prime, the Al-Pac's cedarwood dining room served meals from dawn to dusk.[33] At Pacific, a few abandoned businesses remain on this four-lane stretch of Route 66, including the Beacon Motel (1946).[34] Closed since the early 1980s, the Beacon Motel (originally Beacon Court) was named for its eye-catching sign with a flashing light atop an old windmill derrick salvaged from a farmstead. Also in Pacific is the Red Cedar Inn, a family restaurant in operation since 1934.[35] The road crosses over to the north side of I-44 at Grey Summit, joining the earlier alignment. The Gardenway Motel, a large motel complex, still does business here after many decades on Highway 66 (off of Exit 253, south of the freeway). The Gardenway is named for the nearby Henry Shaw Garden Way, a 2,400-acre arboretum planted with native trees, shrubs and plants in the 1930s.[36]

The next landmark is "The Diamonds," a truck stop owned by Spencer Goff, which claimed to have the world's largest restaurant. The Diamonds had something for practically everyone, and included a filling station with a gift shop, a truck stop, a restaurant and a motel perched on a high bluff overlooking Interstate 44. Goff moved the business to this location from a site farther to the west, which was bypassed when I-44 was built in the late 1960s. The giant enterprise survived through the mid–1990s. The restaurant and truck stop finally closed, but the Diamonds Best Western Motel behind the main building is still open. Farther down the road past Villa Ridge, U.S. 50 leaves U.S. 66, bound for Jefferson City and points west. A short distance past the junction with U.S. 50 is the 1930s-era Tri County Truck Stop and Restaurant, the location of The Diamonds before Spencer Goff moved the business east to

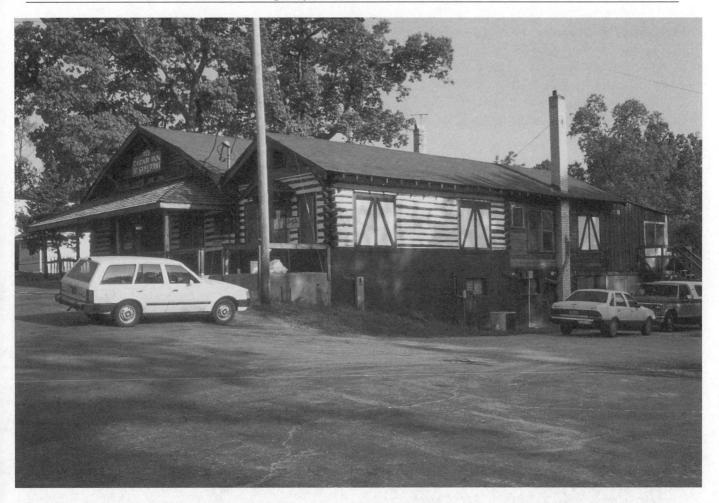

Red Cedar Inn, Pacific, Missouri (1934). The Red Cedar Inn was opened in 1934 by James and William Smith in Pacific, Missouri. In 1935, the Smith brothers added a restaurant, bar and later a few pumps for Mobil gasoline, and the business quickly became a popular roadside haven for motorists heading into and out of the St. Louis metropolitan area. Today, Wes Karna leases the business from the daughter of the original founders, and the Red Cedar Inn's southern recipes are now enjoyed by a new generation of Route 66 travelers.

be closer to the interstate. The sleek structure that today houses the restaurant was built in 1927 and originally included a motel with 25 cottages in the rear. The buildings and the grounds were arranged in the shape of a baseball diamond, hence its name.[37] This area was once a bustling center crammed with travelers and tourists, particularly over-the-road truckers who stopped here to refuel before making their way across the Ozark Mountains. Ironically, while the newer Diamonds is now out of business, the older location is still serving customers.

The foothills of the Ozark Mountains lie ahead. Highway 66 begins a slow southwesterly ascent across the northern edge of the mountain range. The Ozarks are honeycombed with over 1,000 caves, and Missouri, which claims to have over 6,000, once billed itself as the Cave State. The road runs parallel to the interstate as North Outer Road, then crosses I-44 at County Road AH, where it follows South Outer Road (Missouri State 47) and enters the town of St. Clair. From here to Springfield, U.S.

66 follows an Indian path known as the Indian Trail, the Osage Trail, and also the Kickapoo Trail. White settlers began using the route in the 1830s and as wagon trains widened the path into a dirt road, it became known as the St. Louis–Springfield Road or sometimes the Old Springfield Road. Following the Civil War, it was referred to as the Federal Wire Road (or simply "The Wire Road") because the U.S. Army erected a telegraph line along its route.

Leaving St. Clair, the highway crosses I-44 (as Missouri State 30) to the north side of the freeway, then becomes County Road WW and finally North Outer Road. Stanton comes next and is hard to miss since it is so heavily advertised. Stanton is the location of Lester Dill's Meramec Caverns, approximately two miles south of I-44, a popular attraction on U.S. 66 since 1935. In the days before television and other modern forms of media and advertising, Dill copied other entrepreneurs and began his own advertising campaign, painting barns throughout the

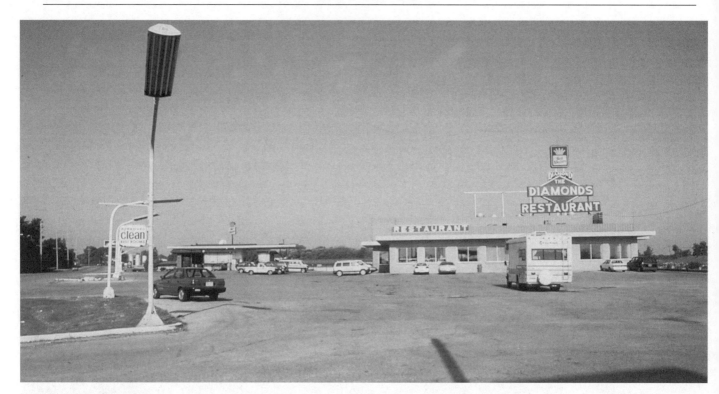

Top: The Diamonds Restaurant and Truck Stop, Villa Ridge. Owned by Spencer Goff since the 1930s, The Diamonds was a busy stopping place for vacationers and truckers for years. The business moved to this location in 1967 after the interstate diverted traffic away its original site several miles to the west. The original sign was taken from the first location and placed on the new-Diamonds. This 1992 photograph was taken shortly before The Diamonds permanently closed its doors in the mid–1990s. *Bottom:* Sign for The Diamonds. An old billboard for The Diamonds still sits on the north shoulder of Route 66 across the highway from another famous Route 66 establishment, the Gardenway Motel. This location is off the freeway exit for Villa Ridge, near some vintage neon signs advertising for The Diamonds and the Gardenway. This area overlooks I-44, seen in the background.

Roadside tavern and resort on Route 66. This abandoned tavern and resort is located at the point where U.S. 50 leaves Route 66 and heads west toward Missouri's capital, Jefferson City. The mint-condition sign advertising Falstaff beer was recently removed, but the buildings for this tourist spot still remain.

Dill also made bumper stickers (first paper, later vinyl-backed) which he attached to his customers' rear bumpers while they took his cave tour or browsed in the gift shop. Meramec Caverns' major claim to notoriety is as a hideout for bandits such as Quantrill's Guerrillas and Jesse James and his gang during the 1870s. Area roadside businesses still hawk "authentic" Indian souvenirs, native woven baskets, and other curios.[38] The road south of Stanton to Meramec Caverns passes an archtypical tourist stop: the Jesse James Trading Post and Riverside Reptile Ranch.

U.S. 66 is never more than a stone's throw from I-44, with only yards separating the two highways in some places. The old road vanishes, then reappears, as the interstate was built directly over it. Like many of our nation's highways, U.S. 66 follows Indians paths and trails blazed by early settlers for much of its route, so the old road had several centuries of history before today's highways were built. The fact that I-44 and other interstates roughly follow these ancient routes is a testament to the ingenuity of our forebearers in charting the optimum routes for overland travel.

During the first several decades of the 20th century, the road in this vicinity was unpaved, and the first generation of auto tourists encountered harsh conditions. The nation's infant auto industry was producing millions of new cars annually and traffic on the dirt road increased significantly. In 1915, the Ozarks Trails Association (one of many such groups

Midwest with the simple slogan "Meramec Caverns, U.S. 66, Stanton, Missouri." The original ads used plain black and white lettering on barns as well as billboards. In the 1950s Dill began using a brighter black, white, red, and yellow color scheme. Recently, Meramec Caverns has been re-painting some barns and billboards with new colors.

formed around that time), led by William H. "Coin" Harvey, proposed a highway from St. Louis to Las Vegas, New Mexico following the Wire Road, and the route through Missouri became known as the Ozark Trail. By the early 1920s, many states were beginning to hard-surface their many miles of new federal-aid and state highways, but

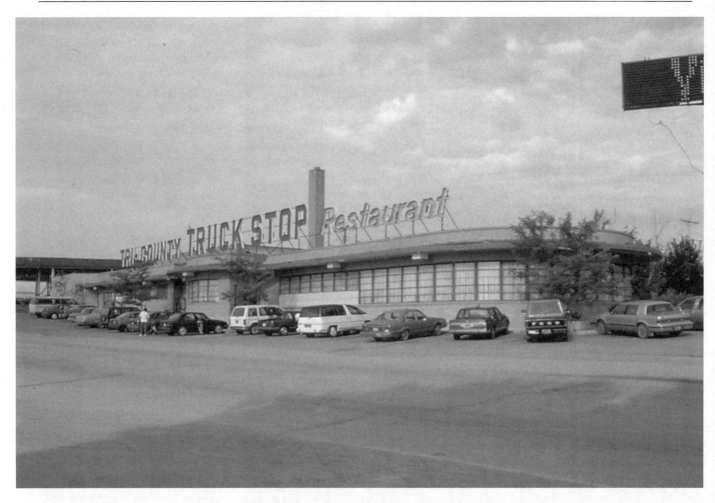

Tri County Truck Stop and Restaurant (1927). This sleek "streamline moderne" building was the original site of The Diamonds; it is currently the Tri County Truck Stop and Restaurant. Spencer Goff's original business began as a restaurant, but he soon added a motel and cottages which he arranged in the shape of a baseball diamond, hence the name. The building survived a fire in the 1930s, and was bought by Jim Smith in December 1971 after being closed for the five years since Goff moved the business east to Villa Ridge.

travel was particularly hazardous in mountainous regions such as the Ozarks. Missouri was among those states that had far more rutted, muddy paths than modern paved highways. A popular joke of the day was that you could drive into the state of Missouri, but you couldn't get out again. Located along this stretch is a small concrete bridge dating to 1922, the year that Missouri designated routes for its state trunk highway system. Among these first highways was State Route 14, which followed the already well-worn path of the Wire Road, so this bridge predates Route 66 by four years. This modest structure is historically significant as the oldest surviving bridge on Route 66 in Missouri. The noisy interstate lies just a few yards to the north, and high-speed travelers without a sharp eye easily miss the bridge.

On the north side of I-40 is Ozark Court (1930), a tourist court, filling station and souvenir shop started by a retired St. Louis policeman named Mr. Duke. Sitting on the crest of a hill, it looked innocent enough to pass-

ing motorists until they were pulled over one of Duke's two "deputies." Acting as the official Justice of the Peace, Duke made a good living levying fines. Exasperated travelers were forced to either "Pay up or face the consequences."[39] Other shady law enforcement-types along Highway 66 and other places in America have used similar tactics to fleece motorists out of their money, but modern times and complaints from the public gradually won out and the highways were safe once again. Ozark Courts grew to a sizable business, adding a filling station and cafe, but suffered a fire in later years and closed. Currently, it is being repaired and should soon be open again.

The highway arrives at Sullivan, which was bypassed by a four-lane stretch of Route 66 in the 1940s. The Shamrock Motel, just outside of town, is a fine example of the vintage motels still open along the Missouri portion of Highway 66. Next, Bourbon appears; street signs read "Old Highway 66" along the route through town. The city's name is a reminder of France's influence in the region

when this was part of Louisiana, and counties, towns, and rivers here have distinctly French names. After Bourbon is Onondaga Cave, owned by Lester Dill before he opened Meramec Caverns. During the 1940s and '50s, Missouri four-laned U.S. 66 across the state. A modern divided highway was built from St. Louis to an area several miles past Bourbon, where the project ended. The section from Bourbon west to Fanning (a very small village no longer in existence) got a scaled-down version, with a new double-lane road heading west from Bourbon and Old 66 taking traffic east toward St. Louis. The total length of this odd stretch of Highway 66 is approximately ten miles. The town of Cuba has the new Route 66 Café, in the same location as several previous cafés, including Chandler's Café on 66 and Old 66 Café. Despite the frequent name changes, the same small neon sign reading "EAT" remained above the doorway until it was recently removed by the new owners. Near the center of town is an abandoned brick cottage-styled Phillips 66 station that's been out of business for decades. One historic site in Cuba is the Hotel Cuba, which was built in 1915 on the Old Springfield Road. When Route 66 came through town, a second entrance was added to the new highway.[40] The Wagon Wheel Motel, at 901 East Washington Street, is often-photographed and lies just a short distance from of the center of town. The motel was built in the mid–1930s and each of the Wagon Wheel's tidy units are made of hand-cut Ozark stone. The Wagon Wheel Motel was first owned by J. C. Mathis and was purchased by its current owner Pauline Armstrong in 1963. Today, Pauline keeps the motel's intricate neon sign lit for tourists traveling on Highway 66.[41]

Top and bottom: Bridge near Sullivan, Missouri (1922). This is the oldest remaining bridge on the Missouri section of U.S. 66. It is east of Sullivan, Missouri. The bridge is in near-perfect condition despite its age and crosses the Spring Creek a few yards south of Interstate 44. The bridge was built in 1922 for Missouri State 14, the predecessor of Route 66. The bridge plaque is typical of those used by the Missouri Highway Department from the 1920s to the '40s.

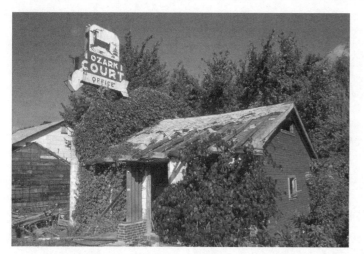

Beyond Cuba is Missouri's wine-growing region. The wine industry was started by a small group Italian immigrants in the late 1800s, who settled in an area known as Knobview in 1898. There they planted grape vines in the rocky loam and silt soil of the Ozarks. The route leaving Cuba, called County ZZ, follows a line of old telephone poles and is joined by County KK. A small green-and-white sign announces the town of Rosati. The old Rosati Winery's white-trimmed red building can be spotted just south of the highway. The winery has a tangled history, beginning in July 1870 when C. Cartel purchased the land from the Southern Pacific Railroad for $800 to promote immigration to the area. The land was bought by the Cardettis in 1929, who in turn sold it to the

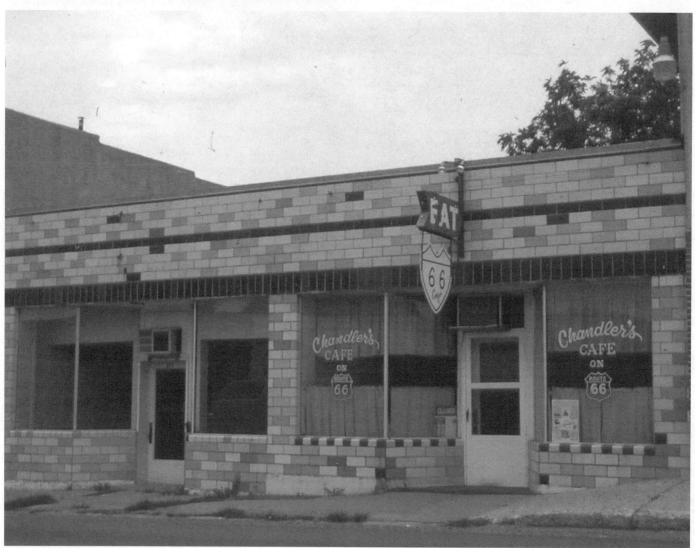

Top: (SEE COLOR SECTION C-6.) Ozark Court (1930). At the crest of a hill near Sullivan is the Ozark Court, started by retired policeman from St. Louis named Mr. Duke and begun as a filling station with garage, café and cabins. Duke soon turned this stretch of Route 66 into a notorious speed trap where, as Justice of the Peace, he fined travelers caught by his two deputies. The motel was damaged by a fire after this photograph was taken in the late 1980s. *Bottom:* Chandler's Café on 66, Cuba. An old brick storefront for Chandler's Café on 66 in downtown Cuba, Missouri. The restaurant was the Old 66 Café in the 1980s and early '90s before becoming Chandler's Café, and has seen a variety of owners over the years. It is currently the Route 66 Café.

Wagon Wheel Motel, Cuba, Missouri (1936). The Wagon Wheel Motel was constructed of native stone by Robert Martin during the height of the Great Depression. The motel has changed hands several times, and it has been owned by Pauline Armstrong since 1963. The motel has 18 inviting rooms. The motel has a picturesque setting, on U.S. 66 on the west side of Cuba. Pauline keeps the motel's neon in good working order and the Wagon Wheel's sign still lights the way for motorists traveling through the Missouri Ozarks.

Knobview Fruit Growers Association in 1934. The town of Knobview changed its name to "Rosati" at this time, after a local bishop. That year, the Knob View Co-op took over and built the present main building. They excavated the wine cellars using mules and man-power, building the underground cellar walls of poured concrete 11 inches thick. The venture was bankrupt by 1937, and Cardetti bought the winery in 1940 and decided to make wine the "old world way." That venture was also short-lived, as World War II sugar rationing doomed Cardetti's dream. Cardetti sold out to the Welch Grape Company, which operated the vineyard and paid area farmers $127 per ton to harvest the grape crop. In 1958 the Welch Company moved to Arkansas, selling the building, which was destroyed in a fire shortly after it was purchased by the new owner. The business had more ups and downs, becoming a winery again in 1971 when the Ashby family took over, and an Italian restaurant was added. The business was quite productive, making over 20,000 gallons of wine and 10,000 gallons of grape juice annually in wooden barrels, as well as the original concrete and new stainless steel vats. However, Welch ended its contract with area farmers and the business was foreclosed on upon 1988. In 1996, Marvin and Donna Ripplemeyer bought the property and now sell grapes, wine, and other products from nearby vineyards and farms. The Rosati Winery is the oldest on U.S. 66 in Missouri, and visitors can take a brief tour of the building and the original wine cellar.[42]

The city of St. James, the last major town on the plains, is frequently called "The Gateway to the Ozark Mountains." St. James hosts an annual grape festival and small roadside stands sell grapes to tourists during harvest time. One of the older vineyards in the area is owned by the Piazza family, which has been selling concord grapes directly to the public since the late 1920s, when U.S. 66 was just a gravel road. Only recently were the original telegraph poles placed here during the Civil War by the U.S. Army taken down behind the Piazzas' property.

(SEE COLOR SECTION C-7). **Piazza Grapes roadside stand, Rosati, Missouri.** In the late 1920s, Earnest Piazza purchased a 10-acre tract at this location along the new U.S. Route 66 for his vineyard. Piazza began selling his Concord grapes to passing tourists from a crude wooden roadside stand. This is the third structure on the site and is owned by son George and his wife Vera, who took over the business in 1959. The Piazzas' stand is idle for much of the year but comes alive during the fall harvest season, when hundreds of tourists stop to purchase the family's delicious grapes.

In the 1960s and '70s, some grape stands were situated so close to the interstate that motorists could stop on the freeway shoulder to buy grapes.[43]

In the center of St. James, at the intersection with Missouri State 68, is Johnnie's Bar, originally called the Rose Café (later the Commercial Café) when it opened in 1929. In 1950, John Bullock bought the café and turned it into a tavern.[44] Today, Johnnie's Bar is still open and is run by John's son, Russ Bullock.[45] Another historic site is the St. James Inn (1925), which fronted on the Wire Road before Route 66 was built. After the new highway came through St. James, a Pierce Pennant gasoline station, a café, a swimming pool and cabins were added facing U.S. 66.[46]

The city of Rolla, population 16,000, is the largest city between St. Louis and Springfield. The road crosses over the interstate as Bishop Avenue on U.S. 63/B. R. 44 and heads into town, first passing the motel–fast food–gas station strip familiar to today's traveler. On the north side of the road, west of I-44, is the site of the Pennant Hotel, a large four-story Colonial-styled hotel built by the Pierce Pennant Oil Company. The company had a vision of establishing a new standard of luxury and convenience for

Johnnie's Bar, St. James (1929). Just before the stock market crash, a café and Greyhound bus stop opened at the junction of U.S. 66 and Missouri State 68 in St. James, Missouri. In 1950, the Bullock family bought the business and turned it into a bar, named Johnnie's Bar after the original owner. Today, Johnnie's is run by Russ Bullock. St. James is at the foothills of the Ozark Mountains and just south of Interstate 44.

the roadside traveler. Also known as the Sinclair Pennant Hotel, it had a commanding view from a hilltop and narrowly escaped destruction when four-lane 66 (now I-44) was built in the 1950s. In 1963, it was remodeled and renamed the Carney Manor. However, it's gone now — replaced by a Drury Inn — as is its twin, the Pennant Tavern, once located down the hill. Also dating to 1928, the Pennant Tavern was similar in style and included a gas station and café. Later a hotel was added, and it was renamed the Pennant Café and Hotel Martin when Mr. and Mrs. J. M. Martin took it over. A 1953 fire doomed the business and it was torn down the same year.[47]

The road through Rolla makes a right turn onto Kingshighway (Business Route 44), passing a slew of cookie-cutter chain businesses until it reaches I-44. Route 66 turns left onto Martin Springs Drive just before the I-44 interchange and runs along the south side of I-44, where only a chain link fence separates the two highways. Another row of travel-related accommodations lie along this stretch, some dating back to the 1960s, like the Wayfarer Inn. The roadside businesses end as 66 leaves Rolla, continuing southwest along a short stretch of vintage roadway with its original cement curbing, crossing an old single-lane cement bridge on a tight curve.

The area becomes more wooded as Route 66 passes through portions of Mark Twain National Forest. An area on the north side of the highway was known as Sycamore Spring during the 1800s. The Ozarks contain thousands of springs and other natural phenomena, some of which were exploited by savvy entrepreneurs to attract the tourist trade. In the late 1920s, Bill and Emma Martin built a store and service station on their farm along Route 66 and renamed the area Martin Springs. Just past a single-lane cement bridge is an abandoned stone building, on the south side of the road on a hillside, built in 1937 by W. D. and Lynna Aaron. For many years, this was Aaron's Radiator Service, and the single-car garage can be seen on the rear side of the building. Three years earlier, the Aarons had built a filling station and café just down the hill near the garage, named The Old Homestead, but these structures are now gone. Years later, when the interstate bypassed the area, they relocated the radiator shop to Rolla. The building later housed a car dealership that also sold for Evinrude motors later housed a car dealership that also sold Evinrude motors.[48]

Next is the town of Doolittle (named for the famous World War II bomber commander), barely noticeable today. At the intersection with Highway T is Malone's service station, which began as a Hudson service station in 1941. In 1952, it was bought by Dan Malone, and it once had 12 gas pumps.[49] Today, only two pumps remain and the station is vacant. The road dead-ends at Arlington, which became isolated after U.S. 66 was realigned to

bypass the tiny town. The original roadway passes beneath the twin I-44 bridges which span the deep valley formed by the Little Piney River, then ends at the town of Arlington. The west-bound I-44 bridge is the third and final alignment for Route 66, while the newer bridge was added for the east-bound lanes for the interstate.

From the 1920s through the 1950s, this part of the Ozarks had numerous cabins, cafes, gas stations, and "tourist traps." Approximately seven miles west of Rolla was Bennett's Catfish and Cabins, started by Paul Bennett in 1943, which served a complete catfish dinner for only $1.00. The original café (now a private home) still exists, as do the stone gateposts to the resort. Towells' Store and Cabins was built nearby by Ike and Edna Towell in 1928 and included a Sinclair station, but it closed in the late 1950s. Joe and Ruth Terill Tabor operated a small store along this stretch until four-lane Route 66 was built just to the north after World War II. It too is now a private home. The Tabors moved in 1952 and built the T & T Café and Garage (named after themselves, of course) on the new highway, but the business failed after the interstate cut off access to the café in the 1960s.[50]

Vernelle's Motel, however has survived the rerouting of alignments and can be seen to the north across the interstate from Martin Springs Drive (the second Route 66). This business dates to 1938, when E. P. Gasser built a gas station, store, novelty shop and six cabins called Gasser Tourist Court. In 1952, Gasser sold the property to his nephew, Fred. He and his wife Vernelle Gasser built a restaurant and Cities Service station on the north side of the present-day motel, with a large sign on the roof advertising "Bar-B-Que." The restaurant and filling station were torn down in 1957 when the interstate was built over four-lane U.S. 66 and the right-of-way widened. The sign and adjacent motel building are original and can be visited by taking a bridge across I-44 just before the motel comes into view, where a newer frontage road marked as Sugar Tree Outer Road passes Vernelle's Motel. The construction of the interstate required a wider right-of-way and Vernelle's lost a good piece of its front yard to the freeway. The business was bought by Forest Riley, then purchased by Nye Goodridge in 1960. A quick trip past Vernelle's is a worthwhile detour. Travelers might get an opportunity to talk to motel owner Nye Goodridge, who is well-acquainted with the history of the area.[51]

Just a few yards west of Vernelle's are the ghostly remains of John's Modern Cabins. Dating to 1942, this originally was "Bill and Bess's Tourist Camp," one of the last auto camps built before the post-war boom of motel construction. The site consists of a wooden structure with no paint and several attached motel units, another white building, four rustic log cabins, and three white-painted cabins. Partially hidden in the forest behind the buildings

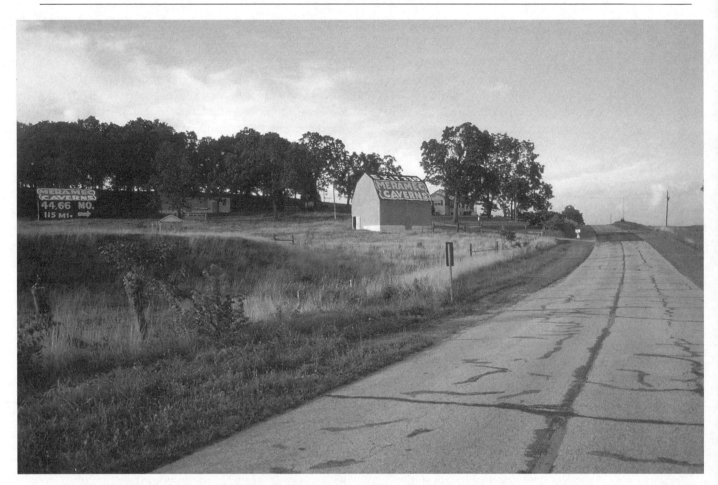

Meramec Caverns barns. A pair of barns advertising Meramec Caverns have been situated on a curve along U.S. 66 since the 1940s. Located in Stanton (six miles east of Sullivan, Missouri), Meramec Caverns relied on highway billboards since opening in the 1930s, some with zany slogans to entice tourists. Owner Lester Dill changed the billboards in the 1950s to an eye-catching black, white, red and yellow color scheme. Time and the elements claimed some Meramec Caverns barns as the years passed, but a few, such as these west of Rolla, are still standing on Route 66 and other U.S. highways.

is the original neon sign reading "John's Modern Cabins." When World War II ended, Bill and Bess's was sold to John Dausch, who changed the name to John's Modern Cabins. The motel included a small store where he sold beer, snacks and other food items. The business persevered through the 1960s, until the coming of the freeway. During 1965 and '66, the state built Interstate 44 through the area and Goodridge, Dausch, and other property owners lost some of their land to make way for the new freeway. Dausch had to move his entire business farther to the north, where it remained open for a few more years before finally closing. The road comes to a dead end after rounding a curve, with the sights and sounds of the interstate a short distance away.[52]

Back-tracking to the original Route 66 (Martin Springs Drive), drivers will find the remnants of the towns of Jerome and Hooker. The terrain in this vicinity is mountainous and the old two-lane was steep, curvy and dangerous, so the Missouri Highway Department built a four-lane road through this area in the early 1940s. A major hillside north of Hooker was blasted to make an easier grade for vehicles, carving a path through the hill known as "Hooker Cut." The only building left in Hooker is a former store and souvenir shop with a peaked roof, on the south side of the highway. The road heads downhill past Hooker on a short stretch of the original four-lane 66 built in the 1940s. In contrast to today's interstate highways, with their wide shoulders and medians, these early freeways had curbs and narrower center medians, making this fine example of an early four-lane highway a pleasure to drive on. Decades ago, a Missouri state patrol station was located west of here; it included a radio tower that stood in the narrow median. This four-lane section of 66 was built for two reasons: to aid military vehicles in the vicinity of nearby Fort Leonard Wood, and to bypass a hazardous section of U.S. 66 that has been feared by travelers for years, known as Devil's Elbow.

The four-lane alignment arrives at dual cement bridges (circa 1942) over the Big Piney Creek and bypasses a very old piece of original U.S. 66. The area was

Vernelle's Motel (1938). Originally the Gasser Tourist Court; founder E. P. Gasser sold the business to his nephew and wife, Fred and Vernelle Gasser, in 1952. The motel was renamed "Vernelle's," and a restaurant specializing in bar-b-que was added. The restaurant was torn down in 1957 when I-44 was widened, and the Gassers sold out to Nye Goodridge in 1960, who has been operating Vernelle's under the same name since then.

named Devil's Elbow after a rock formation just south of the highway, which causes the Big Piney Creek to follow a twisted course through the valley. If heading west, this alignment is a quick left turn off four-lane 66 just before the four-lane bridge over Big Piney Creek. This old road is usually deserted and passes a local tavern, currently the Elbow Inn. Built in the late 1930s by Nelle Munger and Emmett Moss, they named it the Munger-Moss Sandwich Shop. The small café offered passing motorists "Old Kentucky Barbeque" and Orange Crush soft drinks at first. Munger and Moss added a second building for a residence and gift shop but decided to leave the business and start a resort several miles to the west, selling out to Peter and Jesse Hudson. The Hudsons continued to operate the business under the same name, then sold it in 1946 to Paul and Nadine Thompson, who renamed it the Elbow Inn Bar B Que.[53] The Elbow Inn currently caters mainly to a local clientele and lies in a quiet setting south of modern Route 66. Business tapered off considerably when it was bypassed in the 1940s by four-lane Route 66, then took a second hit when I-44 was built in the 1960s. The Big Piney Creek carves a sizable valley through the Ozarks, and this was the final portion of I-44 to be built in Missouri.

Immediately after the Elbow Inn, the road enters a sharp curve leading to an old steel truss bridge, built in 1923, called the Devil's Elbow Bridge. Across the bridge on the left is the site of the Devil's Elbow Café and Conoco, built by Dwight Rench in 1932. The building was made of rock (typical of many buildings in the Ozarks) but burned in the late 1970s.[54] The road continues for several miles and rejoins four-lane 66. A few miles farther west, the route leads to the interstate and crosses to the north side, towards the town of Waynesville.

The route into Waynesville is typical of how towns were bypassed along Highway 66 in the 1940s. The interstate uses the same right-of-way as four-lane 66, so only a few sections of the original road survived, the short piece at Devil's Elbow being one of them. The four-lane bypasses built during the 1940s and '50s became the alignment for the interstate, and the "City 66" routes into towns used for freeway exits.

The highway glides into Waynesville past Jackie's Bar and the Tinkle Bar, both looking a bit frayed (the Tinkle Bar is closed). During World War II, Waynesville was a mecca for troops at nearby Ft. Leonard Wood and the town experienced a brief period of prosperity. Just past

John's Modern Cabins (1942). A short distance west of Vernelle's Motel is the site of Bill and Bess's Tourist Camp, which opened during the Second World War for travelers and soldiers stationed at nearby Fort Leonard Wood. After the war, the resort was purchased by John Dausch and renamed John's Modern Cabins, and a small store and a motel were added. The business was moved a short distance to make way for Interstate 44, in the mid–1960s, but closed shortly thereafter as the freeway drained off customers.

came a Super Way grocery store in its later years. An old liquor store is next to the market. Mallow's Market is closed and up for sale. A second vintage gas station, Ed Wilson's, is a short distance away. The road through this area is now designated as Missouri State 17, and crosses I-44 at Laquey.

After Waynesville, Route 66 slowly makes is descent from the highlands of the Ozark Mountains. The route is marked as County AB and heads west to Hazelgreen, which consists of only a few old buildings. Route 66 runs along the south side of the interstate through Sleeper, another forgotten hamlet, then crosses over I-44 and becomes County Road F. This area was home to a collection of forgotten businesses, like the Blue Moon Camp; Riley's Snack Bar and Souvenirs; a roadhouse known as The Harbor (a café, gas station and tourist cabins that later became Brownie's Truck Stop, Andy's Midway, and finally Geno's), the Rock Bridge Store and Station; and the Sunrise View Tourist Court. Little remains of these places today, although remnants of the Riley's filling station and a lone cabin can still be found.[55] The interstate interrupts the Mother Road once again, so I-44 must be taken to the next town, Lebanon, at Exit 130.

Lebanon is one of the larger towns on Missouri Route 66 and once had many roadside facilities, but most are long gone. The first site of interest is the Munger Moss Motel, built after World War II by Pete and Jesse Hudson after they sold the Munger-Moss Sandwich Shop at Devil's Elbow. The location was originally a roadside diner called the Chicken Shanty, and also had a filling station and garage. The Hudsons renamed it the Munger-Moss Barbeque and built seven motel buildings with garages, using black market lumber (many commodities were scarce during the first few years following the war). They were arranged in a semi-circle facing Route 66. They named it the Munger Moss Motor Court and added a small gas station out front. After Interstate 44 came through and bypassed Lebanon, the gas station and restaurant were torn down.

the Tinkle Bar is a nice cement bridge (circa 1923) crossing the Roubidoux Creek. On the other side of the bridge, the road curves past an old filling station, currently a flower shop. Across the road is Mallow's Market. Mallow's Market has been here for decades, although it be-

Left: (SEE COLOR SECTION C-7.) **Devil's Elbow Bridge, Hooker (1923). During the early 1920s, this steel truss bridge was constructed across the Big Piney Creek (the road was still a state highway) at a location known as Devil's Elbow. The bridge can be found on a loop road south of four-lane U.S. 66. This view is of the east approach to the bridge, situated on a sharp curve which is preceded by a tavern clled the Devil's Elbow Inn (originally the Munger-Moss Sandwich Shop). In the early 1940s, a four-lane highway bypassed the bridge and this hazardous stretch of road, removing a major headache for travelers on Route 66.** *Right:* (SEE COLOR SECTION C-8.) **Big Piney Creek and Devil's Elbow. A view of Devil's Elbow from the Devil's Elbow Bridge, named for the winding Big Piney Creek and high cliffs in this vicinity. This hilly region on U.S. 66 was the last portion of the old road to be four-laned in the state of Missouri, in 1981. Today, this stretch of highway is nearly deserted and carries mainly local traffic and occasional Route 66 travelers.**

In 1971, Bob and Ramona Lehman bought the motel, and they have done extensive work to keep the premises in operating condition. A swimming pool lies in the center of the motel complex. The parking spaces and garages between the units were eliminated when additional units were built, making a total of 44 rooms. The original neon sign dates to the post-war era and is remarkably similar to those first used by the Holiday Inn motel chain. The motel's rooms are still period-condition, each decorated with Route 66 themes and vintage photographs.[56] However, not all owners of sleep accommodations are as conscientious as the Lehmans; Rittenhouse wrote that this area had many run-down cabin camps and resorts even back in the mid–1940s.[57] Across the highway from the Munger Moss is the Starlite Lanes bowling alley and the Forest Manor Motel, both looking quite original. A short distance away are the Holiday Motel, whose nice neon sign was recently replaced, and Wrink's Food Market, built in 1950 by Glenn W. Wrinkle, Sr.[58] The highway intersects with a new road leading east toward Interstate Exit 130, while Old 66 makes a right turn into Lebanon.

By the mid–1920s, the state of Missouri finalized its plans for the routing of State Route 14 and conversion of the dirt and gravel trail into a modern portland cement all-weather road, but Route 66 would not be completely paved until 1930. Lebanon lobbied hard to get highway planners to follow the path of the Ozark Trail and route the new highway through the center of town. Route 66 continues west into Lebanon on Elm Street, passing the Chalet Village, which replaced Camp Joy, a tourist camp dating to the early days of American motoring. It began in 1927 as a tent camp charging 50 cents a night, then added a filling station, grocery store and cabins. Emis and Lois Spears ran Camp Joy for some 44 years, until leaving in 1971.[59] An archway reading "Camp Joy" greeted visitors entering the camp; today, only the two white cement posts remain.

At Jefferson and Old 66 is the site of an even bigger tourist camp, the famous Nelson's Dream Village, brainchild of Colonel Arthur J. Nelson, an early advocate of road improvement. The Nelsons owned a hundred-acre apple orchard at this location, and the Colonel was among those responsible for convincing the state highway department to route the highway through town. After several

Tinkle Bar, Waynesville, Missouri. In the center of Waynesville is the Tinkle Bar, opened right after Fort Leonard Wood was built north of Waynesville in 1941–42. Waynesville experienced a short-lived boom during World War II as a popular place for "R and R" for servicemen stationed nearby. The Tinkle Bar has been closed since the early 1980s, but Jackie's Bar (owned by the same man who owns the Tinkle) is still open.

years of controversy, the new State Route 14 (soon to be U.S. 66) was built on Elm Street through their property between Jefferson and Madison Avenues. The Nelsons were fairly well-off financially and donated some of their property for the right-of-way for Route 14. Many property owners whose land abutted the new highway sensed an opportunity to capitalize on the anticipated tourist trade and the Nelsons were no different, so they began converting their orchard business into a tourist attraction. Nelson immediately built a gasoline station at the southwest corner of Elm and Jefferson using cobblestones. Matching pillars marked the entrance to a group of eight cabins that he called the "Top of the Ozarks Inn." Each cabin was named for one of the eight states through which Route 66 passes. They were next to a primitive campground. The gas station opened on July 3, 1926 and the hotel (with a tavern) five years later. Nelson planted trees and flowers on the property and along the roadside; many travelers described the area as one of the most picturesque places in the Ozarks. Across the highway to the north,

Nelson constructed his ultimate fantasy, the Nelson Dream Village, in 1934. The "village" was a V-shaped arrangement of cabins with a 12-unit building farther from the highway and a "musical" fountain in the center courtyard, with the Nelsons' home just west of the Dream Village where the Lindsey Chevrolet dealership now stands. Nelson's filling station sold Barsdall oil products and a large 10 × 20-foot sign painted green and white (the same color scheme as the gas station) reading "Barsdall" was placed above the pumps. The sign confused many motorists, who thought that the town was named Barsdall, so Nelson replaced it with giant lettering reading "Lebanon." Several years later, Nelson replaced the original sign with a neon sign, which had an arrow pointing toward town. The business prospered for many years until a new four-lane alignment for Route 66 was built in the late 1950s, just as the interstate highway system was approved by Congress. The Dream Village closed in 1957, and lay abandoned until it was completely torn down in 1973.[60] Fortunately, one of Nelson's original cabins was

(SEE COLOR SECTION C-9.) **White Sands Motel vintage billboard. Hidden behind some underbrush is an old highway billboard, which survived destruction by highway esthetics activists. The sign advertises the motel as being on City 66, as opposed to the four-lane U.S. 66 that bypassed cities along the route in Missouri. It is on westbound Route 66, east of Lebanon.**

saved by a local woman, who moved it onto her property farther south on Elm Street, on the west side of the highway between Utah Street and Howard Drive.[61]

Lebanon became a busy place as soon as Route 66 made its debut in the late 1920s. The junction of Elm and Jefferson saw many accidents when motorists failed to stop at the intersection. J. W. Owens' Conoco was at the northeast corner in the 1920s, but was replaced by a large Greyhound bus station known as the Union Bus Depot and a Standard station (part of the building is still on the site). Next door was a handsome Spanish-styled Sinclair station called Lowrance Sinclair, now gone. Owens relocated his gas station to the site of what is now Eilenstein Auto Sales. The Ozark Café was just across 66 on the southeast corner; today, it's a vacant storefront.

In the 1950s, cities across America stopped using the electric streetcar for urban transit and began city bus services, so thousands of streetcars were scrapped. Some were saved and converted into diners and restaurants. These are considered historic buildings today, when new developments are steadily replacing old roadside landmarks. West of the Nelson's Dream Village, at Elm and Jackson, was a salvaged streetcar called Andy's Street Car Grille, opened in 1955 by Andy Liebl. A large sign on the rooftop (with a clock) proclaimed "The Finest Food in the Ozarks Served Here" (their specialty: Andy's Famous Fried Domestic Rabbit). Andy's did not last long. Highway 66 was relocated only two years later, and Andy's disappeared soon after closing in 1961. At 679 East Elm was the Blue Bird Café, now the Lebanon Art Guild. A metal sign that read "Lebanon — Our Town — Your Town" once straddled Millcreek Road, which is off of Route 66 where Elm Street curves southwest toward downtown Lebanon. Also on the north side of town is a porcelain-enamel Mobil station (once Speaker's Mobil, and prior to that, Bacon Station) and three units of the Del-Ray Motel, owned by Ray and Myrtle Reid.[62]

South of Lebanon, Route 66/West Elm Street ends at I-44, although it continues for a short distance along the north side of the freeway as a frontage road, County Road W. Across Dover Road is the location of the Bungalow Inn, a Mobil gas station and cabins. At 18773 Route 66 was McClary's Restaurant and Motel. It closed in 1957 after the interstate came through, as did many businesses along Highway 66. The motel lies behind a private residence that was once the restaurant.

The route (still County W) passes through what remains of Caffeyville, approximately eight miles south of Lebanon. Most of Caffeyville was wiped out by the construction of I-44 in 1957. The site of the former town is near freeway Exit 123. One lost treasure is Caffey Station, an unusual-looking, quaint structure begun in 1924. The business was started by Floyd Caffey (who named the new village after himself) and was a combination filling station, café, and cabins. He also owned a feed mill nearby. Caffey Station served travelers for many years, but all traces are gone now. The structure featured a café and tiny filling station building, connected by a roof under which one vehicle could drive. Next to the café were two gravity gasoline pumps, protected by a small roof whose styling matched the other buildings. The Hi-Lite Tourist Court, Cabins, Café, and Texaco, currently owned by G. L. Greear, was the other main business in Caffeyville (its slogan: "Stop Here and Feel at Home"). The gas station and a few original cabins are still on the property. A nearby pair of barns, on the west side of 66, have been painted with Meramec Caverns ads since the 1940s. The road ends at I-44 but passes through an underpass that was built for the Frisco Railroad in 1926. The bridge, often

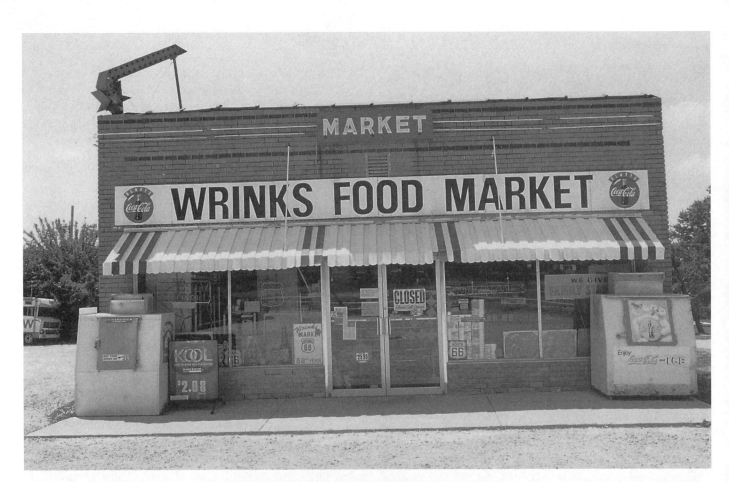

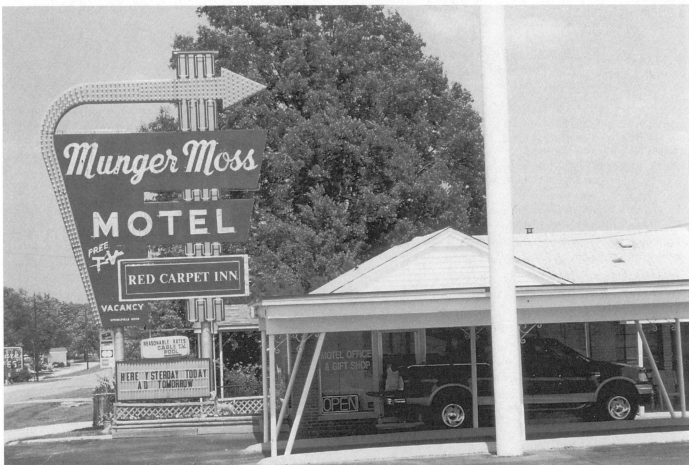

referred to as "the subway," had an unusually low clearance, forcing tractor trailers to make a long detour. This is the spot where the Underpass Café and station was once located; it was built in 1941 by Mrs. O. E. Carter with an inheritance. The station came first, and the café was added in 1950. The café was popular with truckers and area residents and flourished for several decades.[63] The road crosses I-44 to the south side of the freeway, and becomes County Road CC as it enters Phillipsburg.

The road from here to Springfield stays on the south side of I-44, uninterrupted by crossovers with the interstate. U.S. 66 passes several small villages: Conway, Sampson, Marshfield, and Strafford. Unfortunately, none of the original businesses along this stretch are operating and highway archeologists have to look hard for even the faintest traces of the original gas stations, roadhouses, and tourist courts that once existed here. Conway, four miles south of Phillipsburg, had several businesses on the original alignment of Route 66. At 14703 Old 66 is Medlin Transport, at the former location of the Twin Oaks service station and tourist camp, which were both run by the Press McMenus family during the 1920s and '30s. Several cabins, the auto repair garage and a main building with a peaked roof are still standing. The Harris Café and Texaco was northeast of Highway J (West Jefferson Avenue) and U.S. 66. It was replaced by the Conway Post Office. The Harris Court was across the highway on the northwest corner, where the Central Bank is now located. Both businesses were begun by Barney and Marie Harris in 1929. The café called itself "The Home of the Little Round Pie." The Harris Café served a lot of customers over the years—including outlaws Bonnie and Clyde during one of their many flights from justice in the midwest. Just outside of Conway on the north side of the road is the site of the famous Top o' Th' Ozarks Café and Tydol station, which burned in 1950 and relocated to the east side of town.[64]

The next settlement, Sampson, has no remaining Route 66 landmarks. However, just a few miles north of town is where some of the telegraph poles put up by the U.S. Army during the Civil War were once located. Jack Rittenhouse's Highway 66 guidebook records that the bottom few feet of the telegraph poles were still visible here as recently as the 1940s.[65] The road here is named County

OO, and it goes to Marshfield, located just off the south side of the highway. Marshfield was bypassed during the early 1930s. The road passes through Strafford as it continues southwest towards Springfield, first as County OO and then as Missouri State 744.

Route 66 enters Springfield as Kearney Street, and motels immediately appear. Many old ones have fallen by the wayside, like the Bell Motel, but others, such as the Rest Haven Court, are still open. The Rest Haven Court was built in 1947 by Hillary and Mary Brightwell. It began with eight stone cottages and a Phillips 66 station. The Rest Haven was conveniently located on the east side of town and was one of the first accommodations to greet the tired traveler entering Springfield. The business did quite well, so ten cottages were added in 1952, then ten more in 1955, and finally a gift shop. The Rest Haven was "air cooled," with steam heat, tile showers, and Beautyrest mattresses. In 1953, a handsome neon sign (similar to that of the Munger Moss Motel) with over 900 light bulbs was added. The sign still exists, although the gas station was torn down two years later when 66 was rerouted to the north. The cottages were remodeled into one continuous motel structure in the style of the typical post-war motel. The motel now boasted "100% refrigerated air conditioning," television sets in every room, telephones, and a playground, all recommended by Duncan Hines. Adjacent to the Rest Haven were the Springfield Motor Court and the Cortez Motor Court; all closed after the rerouting of U.S. 66.[66]

The route through Springfield is marked by the state Route 66 organization's "Historic Route 66" signs pointing the way through town. At Glenstone Avenue, the route turns left (south) and is currently marked as BL 44 (Business Loop for I-44). This stretch is crammed with the usual nationally-recognized chain motels, filling stations, restaurants and other services. Only a few of the older motels, like the Satellite Motel, have held on. The road passes under the Chestnut Expressway, a four-lane highway that was constructed in later years to divert traffic off of residential streets and around the center of town. The Chestnut Expressway (formerly Bypass 66, now called BL 44 and BR 65) eventually meets up with City 66 on the western side of town. This is the quicker route, but the more scenic is still City 66, which continues south on

Opposite, top: **Wrink's Food Market (1950).** On June 10, 1950, Glenn W. Wrinkle, Sr. opened a grocery market in this building on the north side of Route 66 in Lebanon, Missouri. Wrink's Market has survived for over 50 years, thanks to its loyal customers in the Laclede County area, and is located at 135 Wrinkle Avenue. Its present owner, Glenn Jr., is keeping the family tradition alive. *Bottom:* **Munger Moss Motel, Lebanon (1946).** Just a short distance from Wrink's Market is the Munger Moss Motel, built just after World War II during the country's post-war motel-building boom by Peter and Jesse Hudson. The site originally operated as a filling station and restaurant known as the Chicken Shanty, which became the Munger-Moss Barbeque when they bought the property in 1946. The Hudsons built cabins with several units each and garages in a semicircle and named it the Munger-Moss Court. The motel is named after the original owners of the Devil's Elbow Inn, Nelle Munger and Emmett Moss. The Munger Moss Motel has been owned by Ramona and Bob Lehman since 1971.

Glenstone Avenue for a short distance until it turns right (west) at St. Louis Street. This alignment passes Central Square in old downtown Springfield, becoming College Street and continuing west to the Chestnut Expressway. A Steak and Shake restaurant dating back to the days of *American Graffiti* is located at the intersection of St. Louis and North National Avenue.[67] The road leaves town as Missouri State 266, passing under I-44 at Exit 72.

The final leg of the Missouri portion of Route 66 contains a treasure trove of surviving roadside structures and artifacts. The road continues west as Missouri State 266 and takes a few jogs to the south. A string of small villages, each consisting of only a few buildings, remain today. Halltown had 15–20 businesses before the interstate freeway came through. Now, it's a few old wooden buildings, some still selling antiques. Three miles down the road is Paris Springs Junction, where a lone service station remains (it closed only recently). The old route turns south and crosses Missouri State 96 (a neon "Gasoline" sign, with an arrow pointing north towards the gas station, was recently taken down) and arrives at a town once called Spencer, later called Casey's Corner. This old alignment turns west again, crosses several rusting bridges, and loops back to Missouri 96. The route continues due west past the remnants of the towns of Albatross, Phelps, Rescue, and Avilla. The interstate runs parallel to U.S. 66 to the south and replaces a section of U.S. 66 and U.S. 166 for several miles. The old Kettle Lake Motel lies next to a reservoir and a long cement bridge to the north of the interstate.

The towns between Carthage and the Kansas border are so close in proximity that they are almost one continuous city. Most of the small villages fell on hard times after nearby lead and zinc mines played out following the First World War. As the highway reaches the northern outskirts of Carthage, City 66 is a left turn to the south,

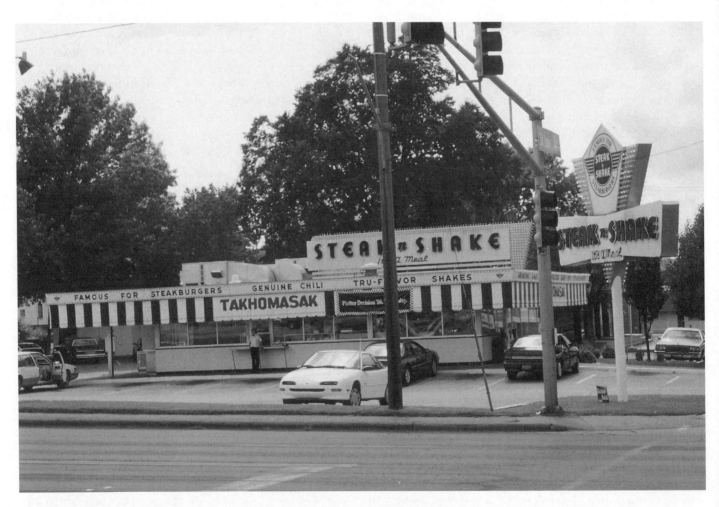

Steak n Shake restaurant, Springfield, Missouri (1962). Before the proliferation of restaurant chains on the American highway, Steak n Shake opened its first location in Normal, Illinois, in 1934. Patrons of the original Steak n Shakes were able to see their meals prepared through a large opening to the kitchen; as business soared, the restaurant chose its original slogan: "In sight, it must be right." This Steak n Shake is on the corner of City 66 (St. Louis Avenue) and North National Avenue in Springfield, Missouri, and was opened by Gus Belt in 1962. It is currently owned by Gary and Herb Leonard.

Rusting signs, west of Springfield. Three fading signs that have managed to survive time and "highway beautification" legislation lie between Springfield and Paris Springs Junction. The Champion spark plug sign (west of Springfield) and the sign for Cook's Paints (at Paris Springs Junction) were common sights along the roadsides for decades. The old gas station at Paris Springs Junction closed recently and its vintage neon arrow sign reading "Gasoline" is now gone (SEE COLOR SECTION C-10).

the year after Arthur Boots moved into the area from nearby Independence, Missouri. The motel was first called Boots Court, since tourist courts were far more common in pre–World War II days. Boots designed the motel and a drive-in restaurant across the street, putting all of his ingenuity to work in making his new enterprise a memorable place for tourists visiting southwestern Missouri. Boots' plans incorporated four-unit structures with two rooms each and a driveway separating each unit so that guests could park next to their doorway. In the early years, Boots operated a Mobil station in front of the first four-unit building. He decided that the motel business was more profitable, so he tore down the gas station and added four additional units. The rooms originally rented for $2.50 a night and advertised "A Radio in Every Room," a luxury in those days. The entire motel remains in 1930s condition, with original hardwood floors and rounded corners of the closets and bathroom reminiscent of streamlined moderne styling of the era. Boots removed the windshields from Model A Fords to make a watertight window for the shower and he used pipe fittings for the window awnings. After World War II, motel construction exploded across the United States as highway travel returned to pre-war normalcy, so Boots changed the name to Boots Motel. Boots kept up with changes in the hostelry business, adding air conditioning, television, and constructing a pitched roof on the units for a more modern appearance. The Boots Motel did a steady business in the decades following the war and Boots expanded the motel's occupancy by adding five more rooms behind the

while Alternate 66 continues straight ahead. Alt 66 comes to a T-intersection with U.S. 71 north of town and turns left back into the center of Carthage.

The junction of U.S. 66 and U.S. 71 once was a major cross road and although most businesses disappeared long ago, the art deco Boots Motel remains open. The Boots Motel is a rare find on the old highway. It opened in 1939,

main building. There is no Room 13, although film actor Clark Gable once checked into Room 6. Today, people come from all over America and from abroad just to have the opportunity to stay at the Boots Motel.[68]

Heading south on U.S. 66/U.S. 71, drivers will find another landmark, the newly-refurbished 66 Drive-In Theatre. The drive-in is outside of town, and can be reached by taking Oak Street west from the intersection with Baker. The road reaches a Y-junction where the route continues west across a cement bridge and passes the drive-in. The first drive-in movie theater opened in 1933 in Camden, New Jersey, and this distinctly American phenomenon grew along with the nation's love affair with the automobile. Their popularity continued during the years of post-war prosperity from the late '40s through the 1950s. By the mid–1960s, there were over 5,000 drive-ins in the United States. Their giant movie screens could be seen on the fringes of every major U.S. city and numerous small towns across the country. The public gradually lost interest in drive-in theaters and their numbers dwindled; less than 800 remain today. Rising land values have made them a target for land developers. The 66 Drive-In closed in the mid–1980s, forced out of business like so many others. The drive-in was saved by Mark Goodman, who bought it in 1986 for his scrap metal business. The property became a graveyard for junked cars over the next ten years. Goodman was a member of a drive-in theater organization, and he noticed a resurgence in the popularity of drive-ins around the country, particularly on the East Coast. In 1996, Goodman fixed up the old theater and improved movie sound quality by eliminating the old speakers and broadcasting via each car's FM radio. After much hard work, the 66 Drive-In Theatre reopened on April 3, 1997. The 66 Drive-In is the lone survivor of six drive-ins once named for the famous highway, and is again the focal point of nighttime entertainment each summer in the Carthage area.[69]

The road curves south and ends at four-lane U.S. 71 (the original route heads due south of Carthage but ends at the same freeway). Route 66 exits at County Road HH for Cartersville, and follows Main Street through town. After Cartersville, U.S. 66 becomes Broadway as it enters Web City. In Web City, there is a vintage sign with an arrow pointing towards the business district of "The Zinc City." The road turns south (left) at U.S. 71 and passes Babe's Drive-In, home of the "chubby cheese" hamburger.

Drivers enter the Joplin city limits as soon as they leave Web City's. The north-south route into Joplin is called Madison Avenue, and makes a turn west onto Seventh Street. From here to the Kansas state line, the route is renamed Missouri State 66. Joplin's West Seventh Street was well-known to folks in southwestern Missouri as a place where there was plenty of action, and was referred to as "The Strip." In the heyday of Route 66, this stretch was lined with the flashing neon of more than a dozen bars, lounges, and night clubs, with names like Dutch's Top Hat, Dixie Lee's Dine and

Spindle bridge, Carthage, Missouri (1934). Highway engineers used a variety of designs for bridges during the early decades of the twentieth century from plain and utilitarian to more ornamented motifs. Among them was the "spindle bridge," like this example in Carthage, Missouri. This one is the only remaining spindle bridge on Route 66 and was recently damaged in an accident when a bus crashed over the guardrail.

Top: 66 Drive-In Theatre, Carthage (1949). The 66 Drive-In is among the last drive-in theaters still operating on Route 66. The 66 Drive-In Theater opened on September 22, 1949, and remained open until the early 1980s. It was purchased by Mark Goodman in 1986 and became an auto salvage yard for ten years. Goodman restored the historic drive-in and presided over its grand re-opening on April 3, 1997. *Bottom:* Dixie Lee's Dine and Dance Bar, Joplin, Missouri (1930). Downtown Joplin has been a hotspot for liquor establishments for decades, and places like Dixie Lee's Dine and Dance Bar were magnets for locals and passing travelers. Located on the west end of Joplin, Dixie Lee's is now closed.

Dance, and Dana's Bo Peep. Dixie Lee's was built in 1930 and was a hopping place for decades but closed in the 1990s.[70] Dana's Bo Peep is still open at 615 Tyler Street, just a block off of Missouri 66. Dana Devine ran the Bo Peep, which opened in 1948, for almost 50 years. The bar survived Dana's death in 1997; most of the other establishments had already closed following the construction of Interstate 44. A collection of old used car lots lines the route as it leaves town, passing a power station and an auto salvage yard called "Parts and Pieces."

Missouri 66 is four lanes as it makes a bee-line for the Kansas border. The section of Highway 66 through Kansas has the shortest mileage found in any state along its route, just 13.2 miles. The Kansas segment of U.S. 66 was, like the segment in Illinois, paved by 1929. Just a few miles before the state line, drivers will find a rare piece of Route 66 history. On the westbound side of four-lane Missouri 66 is a green-and-white highway sign reading "Old Route 66, Next Right" (a similar sign is posted for those traveling east). After leaving Missouri 66, the road makes a slight curve and enters a straight stretch. The sounds of highway traffic are quickly left behind on this ghost road, used mainly by local residents. This section of U.S. 66 still had its original concrete pavement until the late 1990s, when it was covered with asphalt. The route passes some homes and a few surviving filling stations, then bends to the south. The road crosses an old viaduct over a set of railroad tracks and enters the city of Galena, Kansas, named for a lead ore once mined nearby. The route is marked as Kansas State 66 and turns left (south) past abandoned storefront buildings along the town's main street. The Howard Litch Historical and Mining Museum (named for a long-time local garage owner) is a new attraction, and preserves the history of mining in southeast Kansas. The route follows Kansas State 66 and turns right and west again. Approximately three miles ahead, U.S. 66 crosses the Spring River on two bridges, the east-bound one being the older of the two; the westbound bridge is of the modern, slab-sided design common on today's freeways.

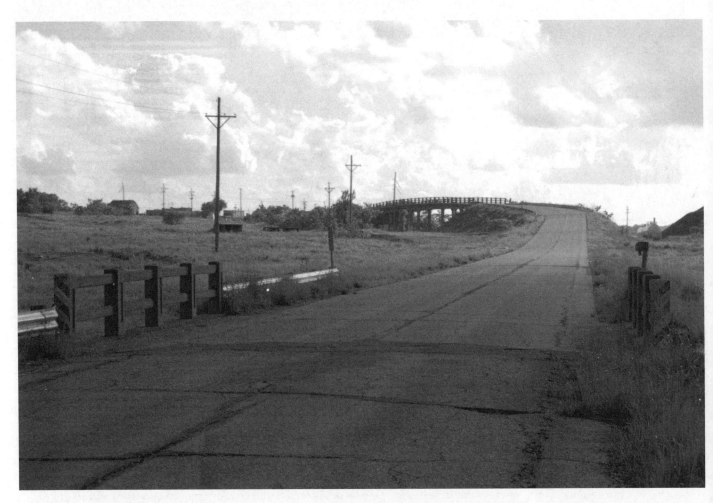

Viaduct on approach to east side of Galena, Kansas. U.S. 66 crosses a concrete viaduct over a set of railroad tracks located on a vintage loop of road leading to Galena. In the foreground is a small cement bridge at a culvert, one of several along this route. This photograph was taken on the Missouri–Kansas border, looking west; beyond the viaduct is the town of Galena, Kansas.

Beyond the Spring River is the town of Riverton, Kansas. On the north side of the highway is Eisler Brothers Old Riverton Store, in continual operation since 1925. Originally a Standard station and food market owned by Leo and Lora Williams, the business was purchased by Joe and Isabel Eisler in 1973 and given its present name. The store retains its old-time atmosphere, with original counters and glass showcases, a vintage meat counter and a genuine flat-top beverage cooler. The store is currently owned by Scott Nelson, president of the Kansas Route 66 Association, and his wife.[71] Beyond Eisler's store is the junction with U.S. 69, which joins U.S. 66/Kansas State 66 from the north. The combined routes continue southwest; approximately a mile west of Riverton, U.S. 69 turns left and heads south toward the last town on Route 66 in Kansas, Baxter Springs. Old 66 and Kansas State 66 continue straight ahead, following the original route. The road curves sharply to the left and approaches another historic monument on Highway 66: the Brush Creek Bridge.

The Brush Creek Bridge is a suspension bridge built using the arch design, a one-of-a-kind sight on Route 66 and the last of several that once existed in the area. The bridge is constructed of steel-reinforced concrete with an arch over a single span crossing the Spring River, a style prevalent in many parts of the United States from the 1920s through the 1940s. The bridge is an important landmark to locals and Route 66 buffs, and is visited frequently. The Brush Creek Bridge (sometimes referred to as the Rainbow Arch Bridge) was covered with graffiti until recently, when it was refurbished by the Kansas

Route 66 Association and the Cherokee County Commission. The bridge is marked with signs at either end, and date plaques (behind the steel guardrails that were installed later during the bridge's active life) record this as a federal–aid project completed in 1923. This fine relic was deemed outdated by the Kansas Department of Transportation in the late 1980s, and only escaped demolition through the efforts of local residents and preservationists. A similar triple-span arch bridge over the Spring River on the eastern outskirts of Riverton was not so lucky, and was dismantled in 1986.[72]

Highway 66 cross a small cement bridge as it enters Baxter Springs' north side. The town refers to itself as the first cow-town in Kansas, recalling the days of cattle drives through here in the late 1800s. The route heads south past a vacant cottage-style building, formerly a Phillips 66 station, and continues through downtown, passing Bill Murphey's Restaurant, opened in 1941 by William and Wanda Murphey. Wanda Murphey sold the restaurant in 1976, eight years after husband Bill passed away.[73] The building was originally a bank, and has housed several restaurants since Wanda sold it. The original sign remained for years, despite the changes in ownership, but the lettering and neon spelling "Bill Murphey's Restaurant" were recently removed. Before leaving Baxter Springs, Route 66 splits off from U.S. Alt 69 for a short distance, turning left on Roberts Road, right on 30th Street and left back onto Alt 69. After leaving town, 66 enters Oklahoma and curves left into Quapaw.

Even before there was a federal-aid highway, travelers stopping in Quapaw heard stories about an odd local

Left: (SEE COLOR SECTION C-11.) Eisler Brothers' Riverton Store (1925). **This old country store has been on the north side of U.S. 66 in Riverton, Kansas since the earliest days of the highway. The store originally sold Standard Oil gasoline, and has been visited by thousands since the inception of Route 66. The Old Riverton Store is currently owned by Scott Nelson, president of the Kansas Route 66 Association, who is active in organizing annual events to commemorate the famous road.** *Right:* (SEE COLOR SECTION C-11). Brush Creek Bridge, Riverton, Kansas (1923). **This is the last "arch-style suspension" bridge on Route 66 and is on a short loop road west of Riverton, Kansas. The bridge dates to 1923, before U.S. 66 became a reality, and was recently saved from destruction by local preservationists. Several others existed in the area, including a triple-arch bridge that was east of Riverton spanning the Spring River. The graffiti was removed when the bridge was refurbished in the late 1990s.**

Bill Murphey's Restaurant, Baxter Springs, Kansas (1941). The best-known restaurant in the southeast corner of Kansas was Bill Murphey's, owned and operated by William and Wanda Murphey since the early 1940s. The building was originally a bank which was robbed by the Jesse James Gang in 1876. Bill passed away in 1968 and his wife, Wanda, sold the business in 1976.

phenomenon known as "Spooklight." In 1886, farmers and others began reporting seeing balls of light flying around after dusk near the old Quapaw Indian Reservation northeast of town. Eyewitnesses report that the object usually appears as a single ball of light, although it sometimes divides into two separate balls, and efforts to photograph or capture it have failed. The strange phenomenon was first seen by members of the Quapaw tribe and later studied by the U.S. army during World War II. Spooklight received national attention when it was featured in an episode of the television program "Unsolved Mysteries." Theories abound, including headlights from cars on Route 66, radiation from nearby mineral deposits, swamp gases, or UFOs. Spooklight is often visible when the sky is overcast and is found in an area northeast of Quapaw on Devils' Promenade Road near the Missouri border, or via Missouri State 53 if coming from the north.[74] To date, no one has adequately explained Spooklight.

After leaving Quapaw, the highway curves west past the place where a billboard for the Buffalo Ranch stood for

many years. The sign advertised a long-time family-oriented tourist attraction and read "Buffalo Ranch — 21 mile — Stay on 66." Almost all of Route 66 through Oklahoma is in fine condition, and it follows I-44 (the Will Rogers and Turner turnpikes) and I-40. Over 400 miles of the old road lie within Oklahoma, more mileage than any of the eight states through which Route 66 passes. The route meanders through northeastern Oklahoma's oil country, where several major petroleum companies are headquartered, to Oklahoma City, located in the state's geographic center. This route was part of the Ozark Trail and was Oklahoma State 7 until it became U.S. 66 in 1926.[75] U.S. 66 follows a zig-zag course from Quapaw (named for one of 24 Indian tribes resettled in northeastern Oklahoma by the federal government), to Oklahoma City.

Route 66 makes a wide 90-degree turn into Commerce, the childhood home of baseball great Mickey Mantle. Route 66 is First Street N.E., then Main Street as the route makes two right turns through town. The road departs Commerce on a course due south. It passes through

a new village called North Miami before entering the Miami city limits on a four-lane highway. The route continues south through town on Main Street. On the northwestern corner at the intersection with Oklahoma State 10 is the B & M Motor Company, still operating out of the same brick single-bay garage as it has for over half a century. Across the street is the equally old-looking Woody's Café.

In the central Miami business district is the Coleman Theater Beautiful, a local landmark since 1929. At the turn of the century, northeast Oklahoma's mines made some men quite wealthy, including George L. Coleman, who financed and planned the finest movie theater within 200 miles of Miami. Coleman spent a hefty $600,000 on the project and spared no expense in executing its design. The exterior is classic Spanish Colonial Revival, with terra cotta trimmings and complete with gargoyles. For the interior, however, Coleman opted for a Louis XV–inspired treatment, lavishly decorated with gold leaf, silk, mahogany and other expensive materials. The Coleman Theater (now on the National Registry of Historic Places) was

built during the final days of vaudeville and was a Class-A movie house for over 50 years. The Coleman is a grand piece of architecture for a city the size of Miami, but it fell on hard times in recent years. The theater stopped running movies in the 1980s and quickly fell into disrepair. In 1989, the Coleman family donated the theater to the city of Miami, with the provision that it be used to show first-run movies, or as a civic auditorium or performing arts center. Unfortunately, the years and neglect finally took their toll on the old building, and it became unusable. Fortunately, the Coleman was well-constructed and remained structurally sound, although the upper balcony was damaged by an earlier roof leak and the 2000-pound chandelier needs extensive work. Local students and others have raised over $1.5 million to restore the Coleman, with several million more dollars needed to complete the project.[76] Thanks to the efforts of philanthropic citizens, the old theater will one day look as splendid as it did when it first opened.

Route 66 leaves Miami via A Street, heading south out of town. A rare, historic alignment lies just south of

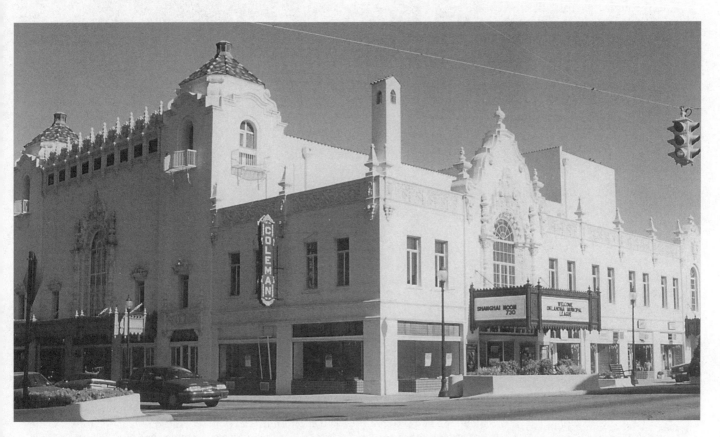

Coleman Theater Beautiful, Miami, Oklahoma (1929). Designed by the Boller Brothers firm of Kansas City, the Coleman Theater Beautiful was the inspiration of George Coleman, Sr., who spent $600,000 on this elegant Spanish Colonial Revival structure in the center of Miami. Coleman was an avid follower of vaudeville and motion pictures and borrowed ideas from other theaters that he visited across the country. Major national acts played at the Coleman, including Will Rogers, Tom Mix, and Bing Crosby. Later, the Coleman family operated the theater exclusively for movies, until 1989 when they sold it to the city on condition that it be used as a theater or for some type of civic purpose. The theater is currently used by the local school district while funds are raised to complete restoration, and the structure has been placed on the National Registry of Historic Places.

58 R O U T E 6 6

Miami, hidden from the newer alignment by farmers' fields. The road is called the "Sidewalk Highway" and can be found by following Main Street south until the road leaves the city limits, passing the Miami City Fair Grounds and the Ottawa County Cemetery. The road comes to a T-intersection in front of a farm, where a right turn west immediately takes the traveler onto a single lane of cement pavement in the center of the dirt roadway. This Route 66 time capsule is a two-mile section of roadway, only nine feet wide, that was by-passed by a later alignment in the very early years. Probably due to economic reasons, the highway department only made a single-lane through this area; the road zig-zags a few miles through farmland before rejoining modern U.S. 66. A second piece of the Sidewalk Highway—a short L-shaped section that loops back to the main alignment—can be reached by taking a right turn before the curve at the Buffalo Ranch on the west side of U.S. 66/Oklahoma 66.

The later route out of Miami crosses the Neosho River on a modern cement bridge; built in 1996, it replaced an old steel truss bridge just a few yards to the north. South of town is a large roadside park that dates back to the 1930s. Highway 66 makes a few right-angle turns as it approaches Narcissa, a town that seems to have vanished. The route continues south as U.S. 69 and passes underneath I-44. U.S. 60 now joins the route from the east and the combined highways approach the city of Afton. The road is four lanes and crosses over a weathered cement railing-styled bridge. The Buffalo Ranch's two main buildings are on the south shoulder in a right-hand curve, with the Dairy Ranch ice cream store next door. The Buffalo Ranch

The Sidewalk Highway. In the late 1920s, the first section of Route 66 was paved just south of Miami. State highway departments across the country had limited funds for road construction and Oklahoma was no exception. The result was this one-lane section that runs for several miles south of Miami, Oklahoma, affectionately called the "Sidewalk Highway." This section of U.S. 66 is one of only a few such early highways that still exist in the United States.

has been closed for some years now. There are rumors that it is slated for demolition, but it is still standing. For over 50 years this Route 66 attraction was especially

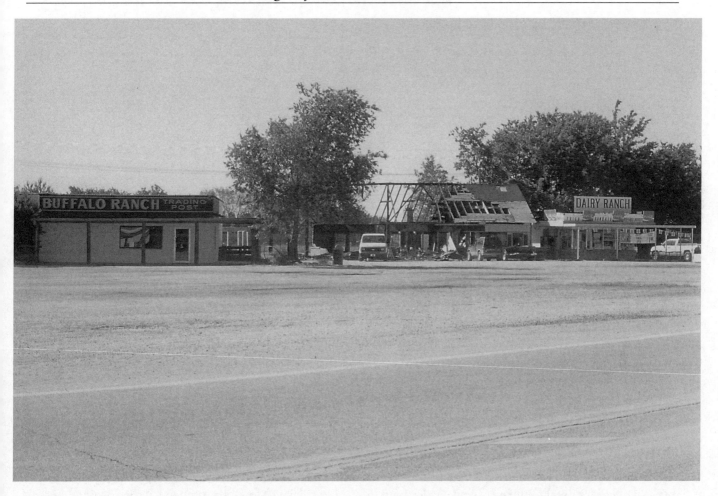

Buffalo Ranch, Afton, Oklahoma (1953). On the east side of Afton is the famous Buffalo Ranch, a tourist stop on U.S. 66 for many years. The Buffalo Ranch featured a variety of "exotic" animals and was especially enjoyed by children, who often implored parents to stop for a visit. The Buffalo Ranch is now closed, another loss for the Mother Road.

popular among children, and included an animal zoo and had various souvenirs for sale to tourists. The Green Acres Motel across the highway is now closed, its sign covered over to advertise another business.

The route takes some more surprising twists, rounding another curve, crossing the narrow cement bridge over the Horse Creek, and finally passing over a steep post-styled concrete bridge into town. The Rest Haven and Avon motels are shuttered, as is the Palmer Hotel, located in a business block in the center of town. The Palmer Hotel was the most prominent business in town, after the local bank. The present brick structure was built in 1911 to replace a wooden building that burned down. After U.S. 66 was paved through town, the hotel got so busy that a café was added around 1940. Afton was a railroad town years ago and the Palmer Hotel and its café were frequented by railroad workers. The town had a roundhouse and turntable, but both were demolished long ago.[77] Located in the same block is the old Pierce and Harvey Buggy Company (1911) and Bassett's Grocery, still operating.

Leaving Afton, the highway continues west a short distance, then turns south. Approximately four miles farther on, Highway 66 makes an abrupt 90-degree turn at a location known as "Dead Man's Corner," named for the numerous accidents at this hazardous intersection. Located just around the sharp bend are two cement pillars— the only remains of the Lake Junction gas station — and a small roadside park.[78] Two dirt county roads also converge at this point, making this area a dangerous place for motorists years ago. This area was also the last section of Route 66 to be paved in the state.[79]

The highway continues west as Routes 60 and 69, crossing a metal arch bridge over the Little Cabin Creek, curving underneath I-44 and entering Vinita as a four-lane highway. The road crosses Bull Creek and passes the Inn Motel (which looks a bit like Alfred Hitchcock's Bates Motel) and the Lewis Motel. Clanton's Café, with a large sign reading "EAT," has been on the west side of 66 since the late 1920s. The route follows Main Street and turns left (south) at a stoplight at Wilson. On the northeastern corner of this intersection is the art deco Vinita City Hall,

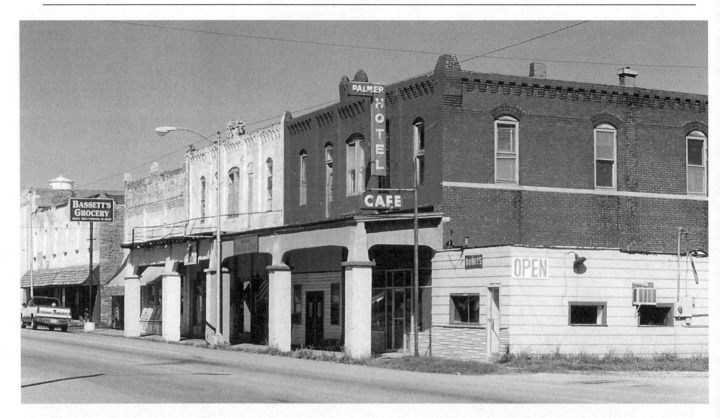

Palmer Hotel, Afton (1911). At the end of a business block on Afton's Main Street is the Palmer Hotel, opened in 1911 after the previous wooden structure was destroyed in a fire. The hotel's last operators were Alvin and Lulu Maloney, who ran the business from 1952 until Lulu's death in 1991. The hotel was sold the following year but its owners no longer reside in the hotel and have left the state, so the future of the Palmer Hotel is uncertain.

with an official city seal featuring two oil derricks and the initials " V. C. C. C." In the center of town on Wilson is the art deco Center Theater. The road curves past the Holiday, DeWard and Pauline motels, which have replaced their original neon signs with modern ones. The road crosses the Big Cabin Creek over two bridges, passes the brick colonial-styled Park Hills Motel and a sign for the Hi-Way Café. The road widens to four lanes as it leaves town. The combined routes of U.S. 66, U.S. 60, and U.S. 69 continue for several more miles until U.S. 69 splits off and heads south toward Pryor, while 66 follows U.S. 60 west. A bit farther down the road, U.S. 60 veers off to the right and Route 66, now called Oklahoma State 66, continues straight ahead toward the town of White Oak.

Little remains of White Oak besides a green-and-white sign for the town and the abandoned White Oak Mill north of the highway. The road turns into a four-lane again and passes through wide-open spaces. A red metal sign with white letters saying "Country Court," its neon missing, sticks out of a grove of trees off the north shoulder. The owners of the property might be the only ones who know the history of the Country Court. The highway enters Chelsea over a small metal arch bridge. The eastbound lane heading north has a bland, modern bridge. The road is a divided four-lane and curves past the

old Chelsea Motel, its wooden exterior badly in need of paint. The early alignment goes through a residential section of town over an old concrete bridge and loops back to the modern route. Oklahoma's first oil well was drilled in Chelsea in 1889. Downtown Chelsea is a right turn off of Route 66 at the town's only traffic signal. The city police station is in the Municipal Plant on the southeastern corner, and a pedestrian tunnel takes foot traffic underneath the highway. An unusual feature for a burg of this size, it is likely that the tunnel predates the stop light and was built due to the constant traffic on busy Route 66, which made it difficult for local townspeople to cross the highway safely. The route continues out of town on a four-lane with wide grass medians. The Oklahoma DOT is gradually making all of Oklahoma State 66 a four-lane and road work is constantly altering the old road. Several small concrete guardrails (where small creeks travel under the roadway) on the westbound lanes indicate that this is the earlier alignment.

After Chelsea are the towns of Bushyhead, Foyil and Sequoyah. In Foyil, the original road can be found passing through the center of town. A granite monument honors local boy Andy Payne, winner of the 3,423-mile "First International Inter-Continental Foot Race" (also called the Bunion Derby) in 1928, which passed through Foyil

and many other towns along the new U.S. Route 66. On the main highway is the Top Hat Dairy Bar, built in 1971 by Wanda Rice Derosia.[80] The interior styling of the Top Hat is purely 1950s-inspired, with historic photos of the Foyil area on every wall. Back in the 1930s and '40s, there were several businesses fronting on U.S. 66, including Texaco and Mobil gas stations sitting across the highway from each other.

Foyil is also the site of the Totem Pole Park, a creation of resident Ed Galloway. In the 1920s, Galloway and his wife bought some land four miles east of town and began building a stone house, a project which took years to complete. After the Galloways finally moved into their new home in 1940, Ed built picnic tables and other amenities for tourists. By 1948, he had finished a massive 80-foot concrete Indian totem pole. He added more totem poles, animals and other amusing shapes, all made of concrete, to the delight of curious tourists. In 1963, Ed Galloway passed away; the Totem Pole Park almost died with him. The site was abandoned, left to the weeds and vandals. As Irish luck would have it, the Totem Pole Park was rescued by the Kansas Grassroots Art Association and the Rogers County Historical Society and is currently being restored.[81] The Totem Pole Park is located on a hilly road four miles east of Foyil and is marked by a sign erected by the county historical society.

The route continues on to Sequoyah, which consists of just a few buildings, then enters Claremore, home of Will Rogers and the Will Rogers Memorial and the site where the late humorist and his wife are buried. Will

Rogers was an entertainer known throughout the world, starring in Wild West shows in places as far away as South Africa and New Zealand. He performed in the Zigfield Follies alongside vaudeville greats like W. C. Fields before making the transition into radio and the silent screen, where he delighted millions of average people with his wry humor as he lampooned politicians and others deemed worthy of his barbs. Rogers was born in 1879 in Oologah (12 miles or so northwest of town) and moved to Claremore, where he lived for much of his life with his family on a 20-acre parcel that is currently owned by the county historical society. The property is the location of

Left: (SEE COLOR SECTION C-12.) Top Hat Dairy Bar, Foyil, Oklahoma. Opened in 1971, the Top Hat Dairy Bar is a recent Route 66 attraction. The Top Hat is still operated by its original owner, Wanda Derosia, and is a "dairy bar" in every sense of the term, with a repertoire of ice cream delicacies too numerous to mention. Foyil was bypassed by a later alignment of Route 66. The original route through town is marked by locally-made signs. *Right:* (SEE COLOR SECTION C-13.) Ed Galloway's Totem Pole Park, Foyil. Four miles east of the Top Hat is the Totem Pole Park, a collection of brightly-painted cement totem poles that were the creation of Ed Galloway between the 1940s and his death in 1963. The Totem Pole Park is on the grounds of the Galloway home; the site is marked by a sign erected by the Rogers County Historical Society, which has taken an active role in preserving this important roadside attraction and other historic places. This is the largest of Galloway's totem poles, standing over 80 feet in height.

the Will Rogers Memorial and Claremore Museum, the latter housing an extensive collection of Rogers' writings, radio recordings, prints from 45 of his movies, and over 10,000 photographs. Rogers, his wife, and three of his children are buried at the site, which is open to the public.

Highway 66 enters Claremore as J. M. Davis Boulevard, passing the town's original motel row before becoming Lynn Riggs Boulevard. Claremore was the location of the famous (or infamous) radium water baths, an attraction visited by over four million tourists between 1903 and the early 1950s.[82] During the late 1800s and early 1900s, natural hot mineral springs were a popular attraction among the upper class, promising relaxation and relief from a host of physical maladies. Early tourists frequented luxury hotels at places like Glenwood Springs, Colorado, Hot Springs, Arkansas, Warm Springs, Georgia, White Sulfur Springs, West Virginia, and Baden Springs, Indiana. In 1903, an artesian well, its water smelling foully of rotten eggs, was discovered east of Claremore by a local farmer drilling for oil. An area physician collected a sample of the water, and chemical analysis revealed that it contained 14 different minerals, including high amounts of salts, iron, and sulfur. Initially, the underground water was found to cure dogs of the mange; it was later believed to be an effective treatment for arthritis, rheumatism and other ailments. More wells were drilled, and people with all sorts of illnesses journeyed to Claremore from around the country in search of a cure. Before long, Claremore was crammed with bath and massage houses catering to tourists. Some travelers stayed for several weeks, relaxing in the warm water baths and receiving massages, and reports of people arriving on stretchers and leaving Claremore able to walk unassisted were commonplace.

A wealthy man named Joseph Abraham was one of the many who claimed to have been cured of rheumatism by the "radium water" (a term coined by local residents) and he decided that the public needed a first-class hotel in town offering radium water baths. Abraham enlisted his son Louis, who formed the Claremore Hotel Company with Walter Krumrei and Morton Harrison. The expensive $321,000 project began in 1929, just as the country was reeling from the stock market crash, but was nevertheless completed the following year. The hotel's plans included a grand ballroom on the second story. The hotel was eventually named after the state's favorite son, Will Rogers. The six-story structure, made of steel and concrete, was essentially fireproof. The hotel's architects used a Spanish design similar to Rogers' Santa Monica home. It was officially dedicated on February 7, 1930. The Will Rogers soon became the town's main social center, attracting people from northeastern Oklahoma and else-

where for decades. It was an expensive hotel to maintain, as the high mineral content of the water rapidly corroded the plumbing leading to the sixth-story baths, making frequent repairs necessary. Eventually, the discovery of penicillin and other drugs made the mineral baths obsolete. Like other tourist trends of the past, hot mineral springs lost their appeal over the years, and the radium water baths of Claremore faded from the roadside scene. The once busy hotel gradually saw its business dwindle away, particularly after the Will Rogers Turnpike (now I-44) came through in the late '50s, and the grande dame of Claremore closed its doors and fell into disrepair. In its later years, the vacant hotel hosted a flock of marauding pigeons in the upper floors, its basement flooded due to extensive water leaks, and became a target of vandals. As is the case with many historic structures (like the Chain of Rocks Bridge), the hotel was so well constructed that demolition proved too costly for the bank that foreclosed on it. Later, an auction was held but drew no bidders. Finally, the Rogers County Historical Society purchased the property for $1.00 and raised the $2.7 million needed to restore the hotel. They then retained the services of Metro Plaines, Inc., a company based in St. Paul, Minnesota specializing in the renovation of historic buildings. The agreement between the county historical society, Metro Plaines and the city of Claremore allowed parts of the hotel to remain open to the public — tourists can visit the hotel's restaurant and the original ornate lobby on the first floor — while the remainder of the building is reserved as private apartments for seniors. The well, located several blocks away, was capped, so the mineral waters are no longer a feature of the historic hotel, although a wall sign at the top of the building still advertises radium water and massages. All of the other wells in Claremore have also been capped and their pumps removed, even in the area east of town once known as "Radium Town."[83] Another site offering radium water baths in Claremore was the Mason Hotel; it now houses the J. M. Davis Arms and Historical Museum, which has an amazing collection of firearms owned by famous characters such as Pretty Boy Floyd, Emmett Dalton, Pancho Villa, Henry Starr, and others.

The road heading out of Claremore is a four-lane highway, passing a string of faded motels on the way out of town. The Round-Up Motel was just recently razed, and the Elms and Okie Inn motels may suffer the same fate soon. A railroad and a line of old telephone poles follow the west side of U.S. 66, and the road goes under a freeway bridge and makes a wide curve into the tiny town of Verdigris. The road passes a large railroad bridge on the right, then turns south to cross the Verdigris River over two nearly identical truss bridges. Both bridges were dedicated to H. Tom Kight, a local politician, in 1957 and are

Hotel Will Rogers, Claremore, Oklahoma (1930). In the early twentieth century, a farmer east of Claremore discovered a vast underground reservoir of mineral water while drilling for oil, a phenomenon known locally as "radium water." Dozens of bath houses sprang up around Claremore, the boyhood home of the great American humorist, Will Rogers. The Hotel Will Rogers opened on February 7, 1930, and had 78 rooms and seven apartments. It was the first major hotel built in Claremore and served the average traveler as well as wealthy oilmen for decades, until modern medicine replaced radium water as a remedy for rheumatism and other ailments in the 1950s. Originally, there was a large sign on the roof with the words "Will Rogers" facing Route 66 and "Hotel" overlooking Will Rogers Boulevard. The hotel was abandoned but was rescued by the Rogers County Historical Society and a Minnesota company specializing in the renovation of historic buildings.

marked by cement monuments.[84] Highway 66, still called Oklahoma State 66, enters Catoosa and rounds a curve past another tourist attraction, the Animal Reptile Kingdom (A.R.K.) and Catoosa Alligator Ranch, built in the days before modern theme parks. They were started by Hugh Davis, a former director of the Mohawk Park Zoo in Tulsa, and his wife Zelta in the late 1940s. The Davises initially took in orphaned zoo animals at their home, collecting a variety of reptiles and other animals over the years, and opening the Animal Reptile Kingdom and Catoosa Alligator Ranch in 1952. Although Hugh Davis passed away in 1990, Zelta Davis still lives on the property and maintains the attraction, which includes a portion of a wooden ship and the famous Blue Whale, which lies in a quiet lagoon.[85] Just across the highway is the Arrowood Trading Post, which actually fronts on the origi-

nal alignment, a short loop road south of the current Route 66. A monument between the Arrowood Trading Post and the Blue Whale commemorates this as the route of the Postal Road. A short distance away was the Chief White Robe Trading Post (razed). Route 66 follows Pine Street through Catoosa, then follows Cherokee until it reaches a junction on the outskirts of town. Another piece of Route 66 history is outside of town: a portion of original Ozark Trail and a circa–1913 one-lane truss bridge.[86] The route continues south, and passes under the Will Rogers Turnpike (I-44) and makes a right-angle turn west, heading toward Tulsa.

Tulsa is situated near the famous Glenn Pool oil field and was built on oil wealth. The city became a boomtown during the 1920s and much of Tulsa's architecture reflects the art deco style of the period. Tulsa, like Los Angeles

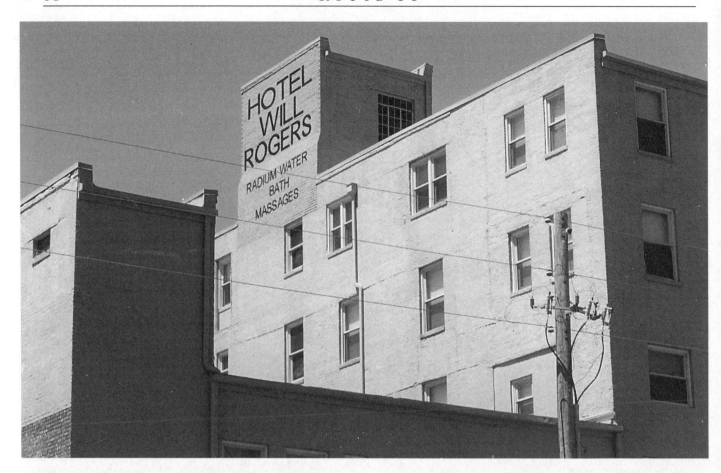

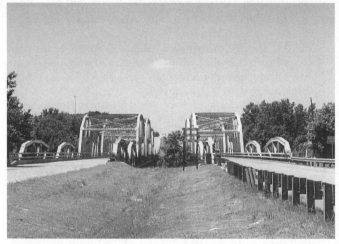

Top: Sign, Hotel Will Rogers. While most tourists patronized the cheaper bath houses in town, the Hotel Will Rogers attracted an upscale clientele who enjoyed heated mineral water baths and massages on the hotel's sixth floor. It was later learned that radium was a radioactive substance and since the mineral water contained no radium, the term "radium water" was discontinued. All of the mineral water wells in the area, including one located a block away that was used by the hotel, have been capped, but the original advertisement remains on the rear of the building. The hotel is now on the National Registry on Historic Places and has been renovated into apartments for seniors. ***Bottom, left:*** (SEE COLOR SECTION C-14.) Round-Up Motel. As Route 66 leaves Claremore and continues west, the road passes a group of dilapidated motels along the east side of the highway. Although the motels themselves survived the construction of nearby I-44, they fell on hard times as customers began to patronize modern motels along the interstates. Real estate prices have been escalating in Claremore in recent years, and the Round-Up Motel and several adjacent motels were demolished in 2001 to make way for new development. ***Bottom, right:*** (SEE COLOR SECTION C-14.) Twin bridges over the Verdigris River. Located just south of the tiny town of Verdigris are two nearly identical steel truss bridges spanning the Verdigris River. These are the longest steel truss bridges on U.S. 66 in northeastern Oklahoma. The bridges are marked at both ends by monuments naming these bridges for local politician H. Tom Kight, Jr.

(SEE COLOR SECTION C-15.) **Animal Reptile Kingdom and Catoosa Alligator Ranch, Catoosa (1952).** This attraction began as a home for rescued animals, from domestic to exotic. Over the years, Hugh and Zelta Davis expanded the "Animal Reptile Kingdom (A.R.K.) and Catoosa Alligator Ranch" and it was especially loved by younger travelers. The smiling "Blue Whale" still lies in its pond, and the park is still operated by Zelta Davis.

and Miami Beach, has many fine examples of deco designs. The Greenwood and Cherry Street Historic Districts have well-preserved examples of period architecture and are just a short distance from the downtown area. Route 66 itself passes the art deco Tulsa Monument Company. The exquisite Boston Avenue Methodist Church's 15-story tower, just south of downtown Tulsa, has been a landmark since 1929. The church is decorated with a stunning array of deco designs and today would cost $44 million to replace.[87] The city was the headquarters of several major oil companies—some long gone, such as Skelly and Tydol, and other still in business, like Phillips Petroleum Company, located a few miles north in Bartlesville. In 1929, Phillips Petroleum decided on a trade name for its gasoline; although there are several versions of the story, the fact that the Mother Road passes near Bartlesville no doubt played some role in the choice of "Phillips 66."

Highway 66 resumes at the exit off of I-44 and Oklahoma 167 and follows 193rd East Avenue. The route crosses under the freeway and heads south, then takes a right turn onto Eleventh Street. Eleventh Street continues past the Warehouse Market toward downtown Tulsa and reaches Elgin Avenue, where the route jogs south onto Tenth Street, then becomes Eleventh Street again at Cheyenne Avenue. A few blocks later, 66 follows Eleventh Street, curving south after Denver and crossing over the interstate. The route now becomes Twelfth Street and comes to a T-intersection at the Arkansas River, then turns left onto Southwest Boulevard. Southwest Boulevard is now parallel to the beautiful Eleventh Street

Bridge, which was part of the original Route 66 but is now demolished. Currently, the route out of town takes Southwest Boulevard across another bridge over the Arkansas River and follows I-44 and I-244. Just off the freeway is a group of 1950s-era motels that were once on Route 66 before the interstates came through. The Western Capri Motel has a giant neon sign; nearby are the Crystal Motel and the Gateway Motel. At the Hurst exit, the road resumes as Oklahoma 66-West as it heads toward Sapulpa.

Route 66 continues southwest as Sapulpa Road, then passes under the Turner Turnpike as Franklin Road, then Mission. The route through Sapulpa makes a 90-degree turn west at Dewey Street and leaves town. For many years, Norma's Café was the place to eat in downtown Sapulpa; it's now called Rivett's Route 66 Café. Sapulpa was established in 1918 by Jim Sap, who started a modest store here; it became a boom town when oil was discovered just to the north.[88] A sign in Sapulpa claims that the town was the location of Oklahoma's first oil well. Just outside of town on the north side of the highway is a short piece of old U.S. 66 which passes over a rusting truss bridge. This is the Rock Creek Bridge (1921), now closed to motor vehicles, one of the oldest surviving structures on U.S. 66.[89] The bridge is unique for its original brick-paved bridge deck; such features are a rarity in modern times

(SEE COLOR SECTION C-15.) **Boston Avenue Methodist Church, Tulsa (1929).** Built during Oklahoma's oil boom, the Boston Avenue Methodist Church has dominated Tulsa's skyline for over 50 years. The 15-story church is constructed of Indiana limestone and is 255 feet tall. At the building's pinnacle is a chapel which was opened in 1963 when an elevator was installed. The church was designed by Adah Robinson, an art professor at the University of Oklahoma, after plans from several architects were deemed unsuitable. Besides being an art deco masterpiece, Robinson's design incorporates various motifs, including local wildflowers and religious symbolism, from its terrazzo flooring up to the four glass shards on the church's tower.

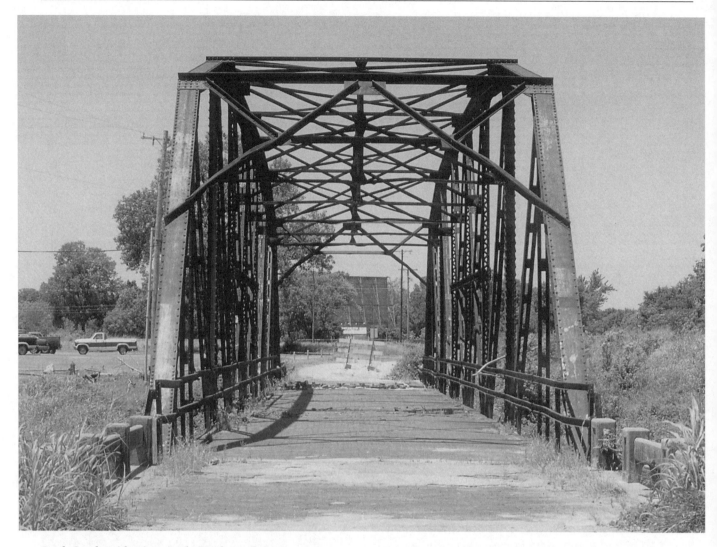

Rock Creek Bridge (1921). The Rock Creek Bridge, dating to 1921, is just south of Sapulpa on a short loop road that spurs to the west of U. S. 66. The bridge's original brick-paved deck is a rarity on the old highway. The Rock Creek Bridge is closed to motor vehicles, but pedestrians can still walk onto the bridge and examine this vintage structure.

when landmarks and monuments are often altered or torn down.

After Sapulpa, the road takes a curving route south-west through a succession of small towns— Kellyville, Bristow, and Dupew. This stretch of Highway 66 contains some bridges and short sections that were bypassed when the road was straightened and routed around the local communities. Two old alignments are on the west side of the highway, the first a brief stretch just past Kellyville, followed by an L-shaped route dating to 1925, which returns to the 1939 alignment. Just past where the 1925 alignment reaches 66, the road passes under I-44 and enters Bristow as Main Street, making a couple of jogs before leaving town. Bristow once prospered, first as a trading post for the Creek Indian tribe and later as a center for the oil and gas industry. The town once had two auto garages (the 66 Motor Company and Bristow Motor Company), one hotel (the Roland Hotel) and four auto

courts (Mac's, Brayton's, Thurman's Bristow Court and Trailer Park and the Rest-Well), stores and other accommodations.[90] Today, none of these businesses remain. The town of Depew is located just south of the highway and contains a main street of nicely-preserved storefronts. Beyond Depew, Oklahoma 66 slowly heads due west and continues almost uninterrupted to Oklahoma City.

Highway 66 next passes through Stroud, home of the Rock Café. Built by Roy Rieves after his retirement, the café was actually operated by Thelma Holloway when it first opened on August 3, 1939. Rieves decided on the name "Rock Café" since the building's exterior is made of pieces of sandstone rock purchased from the excavation for a section of Route 66 near Kellyville. Rieves bought the salvaged material for a "rock-bottom" price of just $6.00. The café has seen a succession of owners over the years. Mamie Mayfield purchased the business from Rieves in 1959 and ran the Rock Café until selling out to current

Rock Café, Stroud (1939). Just as the Great Depression was about to end, Roy Rieves built a new café in Stroud, Oklahoma. Being retired, Rieves didn't take an active role in running the business, so Thelma Holloway opened up the café on August 3, 1939, and ran it for several decades. The exterior of the building is made of pieces of sandstone rock that Rieves salvaged from the excavation for the construction of Route 66 near Kellyville. The Rock Café is currently owned by Dawn Welch, who purchased the business in 1993, and her husband Fred.

owner Dawn Welch, who took over in 1993.[91] Manvel Street, where a few old filling stations remain is the main route through town. On the way out of town is the Skyliner Motel, with an easy-to-spot vintage neon sign dating to the post-war period.

Next comes Davenport; the road makes its characteristic Z-shaped path through town, as it does in many of the towns in northwestern Oklahoma. One of only four remaining concrete obelisk markers for the old Ozark Trail, erected in 1917, is on a dirt section of Old 66 northeast of town.[92] The highway passes under a viaduct for the old St. Louis and San Francisco Railroad before it reaches Chandler. Chandler has a perfectly-preserved "cottage-style" Phillips 66 station dating to the 1930s near the center of town. The route turns west and passes the Lincoln Motel (circa 1939), which has served travelers for over 60 years and looks almost as new as the day it opened.[93]

After leaving Chandler, the road makes a sharp turn south and goes under another railroad viaduct, then abruptly turns west again, passing under Interstate 44.

Prior to reaching the freeway, travelers can see the only Meramec Caverns barn remaining in Oklahoma. The barn faces west; for westbound drivers it is easy to miss, but Californians driving east have fond memories of this historic barn, painted with Lester Dill's familiar color scheme. South of the main highway is Warwick, a town that died long ago, after the newer Route 66 bypassed it to the north. A few buildings still survive, including a recently restored circa–1921 gas station that has been placed on the National Register of Historic Places.[94] On the west side of I-44 is another old loop road north of the highway. It begins at an abandoned gas station with carport near a sign for "OK 66B" and leads to the town of Wellston. Wellston was bypassed in 1933 when the "Wellston Cut-Off" was built to make a safer road and save mileage. The citizens of Wellston were naturally unhappy with plans for the new bypass and protested to the Oklahoma State Highway Department, but their efforts failed. However, state highway planners agreed to name the bypass OK-66B and pave the loop road to Wellston.[95]

Lincoln Motel, Chandler (1939). The same year that the Rock Café opened in Stroud, the Lincoln Motel made its debut in nearby Chandler, Oklahoma. The motel has never closed and has been owned by Mike Patel since 1980. The Lincoln Motel started with 20 units, with four additional rooms added in 1969. Today, Mike Patel keeps the premises in period condition.

The main Route 66 continues west past Wellston over three small concrete bridges. At the Lincoln-Oklahoma county line, an old station/café sits on the south side of the road. The highway continues straight west toward Luther. Luther isn't on Highway 66 and is only a few buildings, mainly a feed mill and an empty filling station. Engle's Grocery Store operated here for many years, until closing a few years ago. People came to Engle's from all over the world to buy up vintage signs and other memorabilia.[96] The highway follows hilly terrain, then passes through a marshy area, crossing five concrete bridges over small streams like Soldier Creek during a four-mile stretch outside of Arcadia. Unfortunately, the Oklahoma DOT is in the process of replacing these old bridges. A circa–1920 gas station, now DJ's BBQ, is a few miles west of Luther. Arcadia, just north of the road, is the site of the old Harvey Ruble Motor Court. An old general store (now a modern-day business) is on the edge of the highway and the bank is just up the block. On the main road is Hillbillie's Café, originally a gas station and cabins. However, the main attraction in Arcadia is the great Round Barn, which sits adjacent to the highway behind an abandoned filling station, on a hillock on the west side of town.

The Round Barn is a unique structure on Old 66. It was built in 1898 by W. T. Odor, a farmer and teacher who

moved to the area from Potwin, Kansas. The barn is 43 feet tall and 60 feet in diameter, and is constructed of burr oak from J. H. Keely's farm (Odor's brother-in-law) nearby. The reason for the barn's circular design is a mystery. Tornados are common in the southern Great Plains, with Oklahoma experiencing an average of 47 tornados annually (third-highest in the nation, after Texas and Florida), and many have theorized that a round barn would have a better chance of surviving a tornado's winds.[97] It is claimed by some that Odor, being a religious man, opted for a round barn so that the devil couldn't corner him. Round barns have been used in Europe for centuries, but only a few hundred remain in the United States, mainly in the east. Whatever the reason, Odor chose the circular design and used an old method to bend the wood into a curved shape, soaking green burr oak planks in the Deep Fork River just west of town and using pre-made forms to shape them until dried. The barn's floor was likewise made of burr oak, and its smooth surface was ideal for barn dances. Odor's Round Barn was legendary in the surrounding counties and at sundown appeared like a huge mound to passing motorists, its massive silhouette looming over the Mother Road. It survived fire and wind for 90 years, but time took its toll on the structure and its roof and double doors collapsed in June

(SEE COLOR SECTION C-16.) **Round Barn, Arcadia (1898). Long before the birth of Route 66, the Round Barn was the main landmark in the vicinity of Arcadia, Oklahoma. The barn was constructed of burr oak from a nearby farm and withstood storms and fire until 1988, when the barn's roof caved in. However, area businesses and a group of seniors calling themselves the "Over the Hill Gang" joined forces to restore the old barn at a cost of $51,000, one-tenth what professional contractors would have charged to finish the project. On April 4, 1992, the restored barn was dedicated and it has lived to see its second century.**

1988. The demise of the great barn was a shock to its many admirers, and at first it seemed that restoration would be impossible. Undaunted locals, led by a retired building contractor named Luther Robinson and a group of seniors calling themselves the "Over-the-Hill Gang," came to the rescue, raising funds to repair the old barn. The Gang's goal was to make as faithful a restoration as possible, using many of Odor's original building methods. When local fundraising efforts fell far short of the $500,000 needed for the project, area businesses stepped in, donating time and materials to finish the job. The restored barn was dedicated on April 4, 1992, and the Round Barn looks as good as new, standing like a sentinel on Route 66.[98]

A few miles past Arcadia, the highway passes underneath Interstate 35 and enters Edmond on East Second Street. The area between the interstate and Edmond was open country at one time, but is now a continuous strip of shopping malls, fast-food restaurants, and suburban development, so if time is a factor, travelers should take the interstate (marked as I-35, I-44, and OK 66). These route designations continue to the center of Oklahoma City, where I-40/West takes the traveler out of town. If time is not an issue, the original Route 66 continues straight west into Edmond. Edmond was once considered a fair distance away from the Oklahoma City metropolitan area, but steady population growth over the years has moved people and development to the Edmond area. The

route enters the city on a westward heading as Second Street, then turns south onto Broadway (U.S. 77) toward Oklahoma City. The city had quite a few restaurants and cafés before Route 66 was diverted south along the right-of-way of I-35, including the Lone Elm, the Wide-A-Wake, Royce's, and the 66 Highway Café.[99]

After Edmond, Broadway becomes a shoulder road, then a four-lane freeway called the Broadway Extension. At this juncture, travelers have a choice of a city route, a bypass route around Oklahoma City, or the interstate through the city. The bypass (formerly called "Belt-line 66") leaves U.S. 77 and heads west one mile past the KOMA radio transmitter tower. The road passes another radio tower before entering Britton, then makes a 90-degree turn south (left) onto North Western Avenue, heading toward the suburb of Nichols Hills. The original road is lost here; it was replaced by I-44/I-240, so the freeway must be used temporarily to trace the original alignment. The route continues south on North Western Avenue and follows I-44 due west for approximately three miles until it becomes Oklahoma 66 (a four-lane highway). Oklahoma 66 continues west toward Warr Acres, while I-44 continues south toward I-40. Jack Rittenhouse's 1946 guide book advises travelers that this locale contained "many fine tourist courts."[100] Immediately after Warr Acres is Bethany, once on the western edge of the Oklahoma City metropolitan area. The highway continues as OK 66 (also the 39th Expressway) past a row of post-war motels—The Carlisle, the Nuhoma, the Starlite, and the Arcadia. The route is a busy four-lane business thoroughfare with plenty of traffic signals as it passes the 66 Bowl and the suburb of Bethany. After passing Stinchcomb Road, Lake Overholser (the city's first reservoir) can be seen to the south. The original alignment can be found between OK 66 and the lake. This old route can be accessed by exiting off of OK 66; this short yet historic road passes over the four-span steel truss bridge over the Canadian River, followed by a smaller concrete bridge of similar vintage and a series of roadside picnic areas. On the west side of the lake, the old highway makes a right turn (west) onto Lakeshore Drive, which passes through suburban developments for perhaps a mile before returning to four-lane 66. Oklahoma 66 continues west, heading toward the city of Yukon, as Oklahoma City's suburbs are replaced by Oklahoma farmland.

Oklahoma City was a quiet town, even for a state capital, until oil was discovered in 1928. The city was built on a giant oil field and over 1,000 oil derricks dotted the area during the early days of the oil strike, particularly in southwestern Oklahoma City. Years ago, several derricks sat right on the state capitol grounds, pumping out the black gold. The final 110 miles of U.S. 66 from Oklahoma City to the Texas state line was originally Oklahoma State

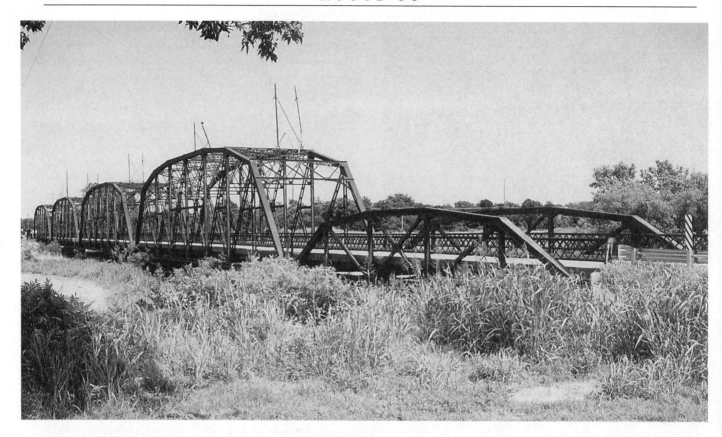

Bridge at Lake Overholser, Bethany, Oklahoma. West of Warr Acres on Bypass 66 (OK 66) is the city of Bethany, on the east side of Lake Overholser, Oklahoma City's first reservoir. Just south of four-lane OK 66 is an early alignment that follows the north side of Lake Overholser for approximately two miles before rejoining the modern four-lane. This old route crosses this four-span truss bridge and passes several picnic areas which were used by travelers prior to and after the Second World War.

3, and was completed between 1931 and 1934. The state designed the highway to last for only 20 years, but the Mother Road lived far beyond the highway department's expectations.[101] The route through downtown Oklahoma City begins at Edmond and heads south on present-day U.S. 77 for a mile or so, until it exits off the freeway before the John Kilpatrick Turnpike at 136th N. E. and Kelley Avenue. The route turns left (east) under U.S. 77 onto Kelley Avenue for a block and turns right to head south. The City 66 alignment dates to 1931; it begins by passing under the John Kilpatrick Turnpike as North Kelley Avenue. The route continues south approximately six miles to N. E. 50th Street, where it turns right and heads west, then south again at Lincoln Boulevard. Lincoln Boulevard is a four-lane road that leads directly to the State Capitol Building, past some aging post-war motels. The Park-O-Tell, an exquisite example of southwestern motel architecture of the 1920s and '30s, was once two blocks north of the capitol on Lincoln. Lincoln Boulevard ends in front of the capitol at N. E. 23rd Street; U.S. 66 turns right (west) onto N. E. 23rd Street and crosses under I-235/U.S. 77. At Clausen Boulevard, Business 66 passes the giant milk bottle advertising Townley's Milk, one of the few "programmatic" architectural gems left on U.S. 66.

The building has housed a variety of businesses over the years, but the milk bottle remains. The 1931 alignment took a right turn north onto Clausen, then left (west) onto 39th Street. In 1936, City 66 was rerouted at this point and continued west on 23rd to North May Avenue, right at May Avenue and west onto 39th Street.[102] At 1310 25th Street NW is Kamp's, an old-fashioned general store opened in 1910 by Henry and Bill Kamp. In its early years, Kamp's sold feed and other agricultural products to area farmers in addition to groceries, glassware, and other household items. In 1938, the Kamps added a bakery. The store's reputation grew over the years, and Oklahoma designated it as a state historical site in 1976. Kamp's has become so popular that the building itself has been enlarged, but it retains the same old-time general store atmosphere.[103] Continuing north on Clausen and turning west onto 39th Street, the route ends at I-44/I-240, where Route 66 resumes by following the interstate west, and continues on Oklahoma 66 west toward Warr Acres.

Highway 66 continues west as a four-lane and is still marked as OK 66, with U.S. 270 sharing the route for approximately 15 miles. The town of Yukon comes next, home of the Yukon Flour Mill, formerly the Dobry Flour Mills, which is located in the center of town.[104] On the

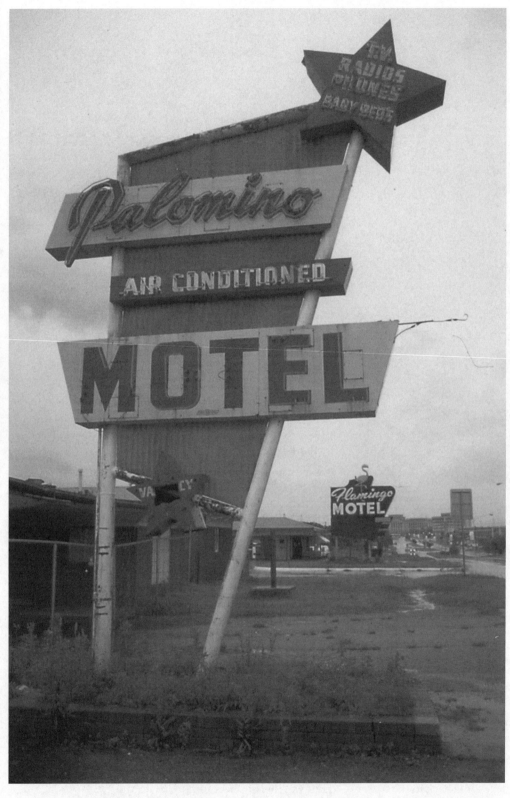

Palomino and Flamingo Motels, Oklahoma City. Travelers heading west had two alternatives when passing through Oklahoma City: a city route and a route that bypassed the metro area on the north and west sides. The city route enters downtown Oklahoma City on Lincoln Boulevard, a four-lane thoroughfare which runs north–south to the Oklahoma State Capitol Building and heading west. An old motel row was just north of the capitol, where the Park-O-Tell motor court once stood. Today, only a few aging post-war motels such as these can still be found on Lincoln Boulevard.

rooftop of the mill are a pair of giant advertising signs, one facing east and the other west, which were restored in 1989, although the mill itself closed in the late 1990s. The signs each have hundreds of light bulbs outlining the words "Yukon's Best Flour" which lit in sequence and shone line giant beacons when lit at night. The Chisholm Trail, a route used to herd longhorn cattle from San Antonio, Texas, to Abilene, Kansas, ran north–south along present-day Ninth Street from 1867 to 1879.

The highway continues west as a four-lane for approximately 12 miles and arrives at El Reno, named for Fort Reno, a military reservation west of town. The road comes to a T-intersection with U.S. 81 and turns right, heading north into town. The route crosses over a long concrete bridge that's as old as the current alignment, and past the Big 8 Motel, which was once featured in a Hollywood movie (today, the Big 8 is closed). Oklahoma 66 makes five 90-degree turns and crosses three separate rail lines through El Reno, continuing west as it leaves town.

A short distance west of El Reno, a pre–1932 alignment for Route 66 can be taken to the north. This original routing is marked as U.S. 270 and makes a right turn to the north off of OK-66. The first 17 miles of this 26-mile loop road leads to Geary, with the tracks for the old Rock Island Railroad running

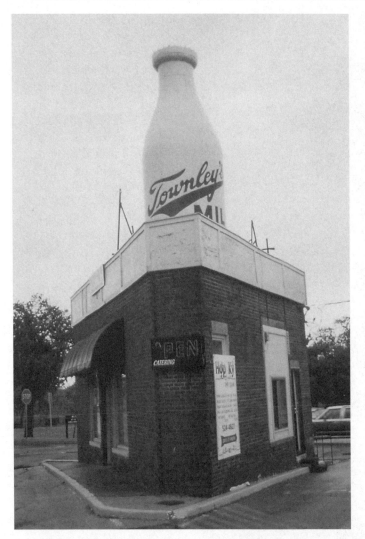

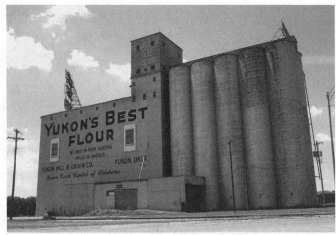

(SEE COLOR SECTION C-18.) Yukon Flour Mill, Yukon, Oklahoma. West of Oklahoma City is Yukon, a farming community. The Yukon Flour Mill (formerly the Dobry Flour Mills) is located in the center of town. The mill has two large electric signs at either end of the building, which were recently refurbished. At night, the Yukon Flour Mill was a beacon, guiding travelers on Route 66 for many decades. The Yukon's signs are now darkened, as the mill closed in the late 1990s.

(SEE COLOR SECTION C-17.) Townley milk bottle, Oklahoma City. Situated on the corner of City 66 (N. E. 23rd Street) and Clausen Boulevard, an over-sized milk bottle advertising the Townley Milk Company sits atop a small building. A rare example of "programmatic" architecture that was once common on the nation's highways, this local landmark has amused passing motorists for decades. Although the building's tenants have changed over the years, the milk bottle has remained undisturbed on its perch high above Old Route 66.

parallel to the highway just to the north. The road passes through the tiny town of Calumet, which is easy to miss, and reaches a T-intersection at U.S. 281, with Geary just to the north and Oklahoma 66 eight miles to the south. Old 66 heads south on U.S. 281 from this location for approximately four miles and arrives at a Y-junction. The left fork is a more modern route leading back to the newer U.S. 66, while the right fork follows an older alignment toward Bridgeport. This route crosses a spectacular 38-span concrete "pony" bridge over the South Canadian River, the longest such bridge on all of Highway 66, before the road reaches Bridgeport. This 3,944-foot-long landmark was a federal-aid highway project constructed

with state and federal funds and completed on July 1, 1933. The Canadian River is wide but shallow in this area, particularly in the dry summer months, but occasional flooding forced highway engineers to build a large multi-span bridge to cross the river bottomlands. The bridge replaced a 1,000-foot-long suspension bridge built farther upstream in 1921 by George D. Key, a local politician who charged exorbitant toll fees for crossing ($1.00 for autos, $1.50 for trucks, a considerable sum in those days). The original alignment for 66 was a dirt-and-gravel road leading from Geary south to the suspension bridge (west of current U.S. 281). Key enjoyed a few profitable years, but complaints from motorists and locals fed up with his toll fees led to the construction of the new toll-free bridge. The new bridge spelled the end for Key's toll bridge, which was abandoned and later sold for scrap.[105] The original piers for the old suspension bridge can be seen on both sides of the river, to the west of the pony bridge. Years later, the pony bridge itself was bypassed by a straighter route traveling east–west to save mileage, and a modern bridge over the South Canadian River was built east of Bridgeport.

The highway through the Bridgeport area was formerly a post office route and was known as the Postal Highway before becoming U.S. Route 66. Approaching Bridgeport from the east on newer Route 66, the road nearly runs into I-40, but turns slightly northeast past the Cherokee Trading Post and Truck Stop. This road has been made into a modern four-lane, and replaced a two-mile section of the old road. A piece of the pavement, however, is now at the Smithsonian Institution, along

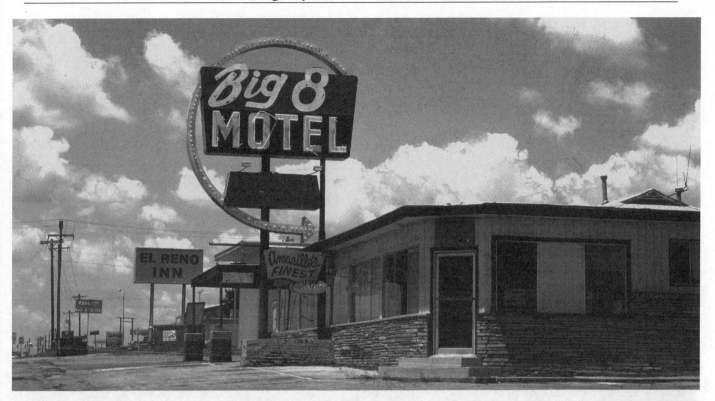

Top: Big 8 Motel, El Reno. Named for nearby Fort Reno, El Reno is where the Big 8 Motel operated since the late 1940s. The motel is currently closed but had one last moment in the sun before its demise: it was a backdrop for part of the movie *Rain Man* starring Dustin Hoffman. The movie is set in Amarillo, Texas and the sign, "Amarillo's Finest," is the only clue to the Big 8's last act. *Bottom:* Thirty-Eight Span Bridge over the Canadian River (1933). This 38-span "pony" bridge is the longest bridge on U.S. 66 in Oklahoma and is north of the town of Bridgeport. This handsome structure was built to replace a privately-owned toll bridge that charged motorists exorbitant fees for crossing. The 3,944-foot-long bridge was a federal-aid project begun in 1932 and opened for traffic on July 1, 1933.

with a sign for Hamon's Motor Court, which was once near this location. The road reaches a Y-junction, with Spur 281 heading right toward Geary and the left fork continuing west on post–1933 U.S. 66 over Bridgeport Hill. The steep grade over Bridgeport Hill was difficult for trucks and many early autos, which lacked sufficient horsepower to climb the hill. This is one of several areas on Route 66 where the older cars such as the Ford Model T actually had to drive backwards, since reverse gear had more torque, and the old gravity-fed fuel systems caused cars to stall for lack of fuel while driving uphill.[106] After Bridgeport Hill, the road comes to a T-intersection once known as Hinton Junction, named after Hinton, a town approximately eight miles to the south on U.S. 281. A vintage roadside park, dating from the 1930s, lies within the triangular area between the highways and was described in Rittenhouse's guide as having picnic tables, fireplaces and water, with a café, filling station and two auto courts nearby.[107] Even during the Depression '30s, the state of Oklahoma generously placed roadside parks with stone tables in shady groves at convenient intervals for the benefit of fatigued travelers. This is also where Leon Little's Phillips 66 service station, motel and café once stood. Over the years, Leon Little operated businesses at several locations along this stretch of U.S. 66, the last being just west of Hinton Junction.

The highway continues due west over roller-coaster hills, with the interstate running parallel just a short distance to the south. The roadway here is in pristine condition and its pavement has a pinkish hue. The soil in Oklahoma and other southwestern states is a deep red color in many places, and there are some long stretches of U.S. 66 in western Oklahoma which have this pink coloration; highway builders in the region no doubt used local rock as aggregate for road construction. The highway's original sloped curbing is intact, which is uncommon since Route 66 has been resurfaced in most places. The town of Hydro is just off the road to the north. Lucille Hamon's gas station and store has been located on the main highway since 1941. The filling station's second story protrudes above the gas pumps and keeps customers out of the elements, a design that dates to the early days of the American highway through the 1940s. Behind the station were Lucille's home and a small motel called Hamon's Court. Until her death in August 2000, Lucille was a

(SEE COLOR SECTION C-18.) Abandoned Café and Truck Stop, Hinton Junction. Mentioned in Jack Rittenhouse's *Guide Book to Highway 66*, this is all that remains of a once-busy café and gas station on the north side of Route 66 near Bridgeport, Oklahoma. The business is located across from a triangular roadside park (also noted in the Rittenhouse book) formed where U.S. 281 meets Route 66. Just west of here are traces of Leon Little's Phillips 66 station, café and motel, a well-known business that occupied several locations along this stretch of Route 66 in western Oklahoma.

source of Route 66 trivia, sharing her photographs and recollections with travelers on the Mother Road for almost 60 years.

The highway jogs to the south and west, and entering the town of Weatherford on Main Street. Weatherford is site of the Owl-Cotter Blacksmith Shop, dating to 1900 and now on the National Register of Historic Places.[108] The Owl-Cotter is at 208 West Rainey Street, one block south of Business Route 40 and a block west of Broadway. In the days before gasoline filling stations and auto garages, blacksmiths were not only the first auto mechanics but also the first retail outlets to sell gasoline to the public, until standardized brands took over. Old 66 makes a left turn south onto Fourth Street, crosses the interstate and follows the south side of I-40. The route continues west for about 11 miles until it crosses the interstate and follows the north side of the interstate toward Clinton.

The highway here, a modernized four-lane, crosses the Washita River as it enters the eastern outskirts of Clinton. The bridge spanning the Washita River, named the Louis Tuttle Bridge, is of the same concrete-and-steel

Opposite, top: Lucille Hamon's Station and Motel, Hydro, Oklahoma (1941). This vine-covered service station with carport sits on Route 66's north shoulder near Hydro, just north of Interstate 40. Lucille Hamon was the sole owner of the station and a small motel called Hamon Court since its beginning, and she often showed historical photographs and newspaper articles to travelers who stopped by her gas station. Unfortunately, "The Mother of the Mother Road" (as she was often called) passed away in late 2000. *Bottom:* Roller-Coaster Hills, Western Oklahoma. A rare stretch of original highway west of Hydro and the Canadian River with sloped curbing, a common feature of the early paved highways. The curbs were intended to keep vehicles from leaving the roadway and divert rainwater toward the ditches, and the pavement in several locations has a distinct pink coloration. These two-lane time capsules are found in the hilly terrain of western Oklahoma.

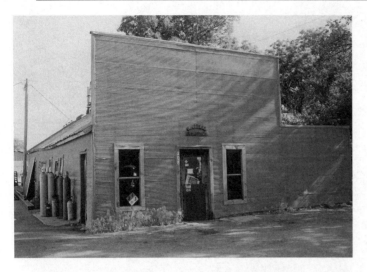

(SEE COLOR SECTION C-19.) Owl-Cotter Blacksmith, Weatherford (1900). Located at 208 West Rainey Street in downtown Weatherford, the Cotter Blacksmith shop opened for business when the horse and buggy still ruled the nation's byways. Despite the advent of the automobile, this landmark has survived long enough to celebrate its centennial birthday and still serves the local community.

style as the Turner Turnpike, and both of them date to 1953 (a monument visible to westbound drivers commemorates the bridge's completion). Clinton had a few old businesses, notably Pop Hicks Restaurant, which served many customers from 1936 until it was torn down after a fire in 1999. The Calmez Hotel was likewise razed, but the Glancy Motor Hotel next to Pop Hicks is still open. The Best Western Tradewinds Motel and Restaurant was operated by Gladys Cutberth, the wife of Jack Cutberth, known as "Mr. 66" for his years of promoting the famous highway. It is now owned by Walter Mason and his wife, who also donated the land for the glitzy Route 66 Museum in Clinton.[109] The road zig-zags through town, first on Main Street, then left onto 4th Street, right at Frisco, then left at 10th Street, which becomes Neptune Street as it leaves the south side of town. The post–1934 alignment continues on Main Street past 4th Street, then turns left onto 10th Street. The route turns right at a shopping area and goes under the interstate to the south side of I-40. Just outside of Clinton is an old roadhouse at a Y-junction, with Route 66 staying right of the building. Just past the roadhouse is a triangular roadside park known to veteran Route 66 travelers as the "Bessie Wye," a popular rest stop for travelers for many decades.[110] A sign posted recently at this historic location calls it Neptune Park, with a date of November 30, 1936. The route passes the Clinton Cemetery on a vintage stretch of roadway with its original curbing, then goes under a railroad trestle, up a hill, and continues west.

Oklahoma has many preserved sections of original alignments, and the western portion of the state has ex-

cellent examples of early roads and bridges. Highway 66 crosses two fencepost-styled concrete bridges next to I-40 which are among the few that have not been yet replaced by the state highway department. The road passes under I-40 and is again on the south side of the freeway, turning west. The highway again has a pinkish tinge and follows a series of roller-coaster hills. The road ends at Oklahoma 44-South, and the route takes a right turn north. U.S. 66 arrives at Foss on the north side of the freeway, crosses a concrete bridge and passes an abandoned gas station (Kobel's Place). After another section of pink roadway, the road ends but reappears on the south side of I-40 and arrives at Canute. The old alignment passes a park built in the 1930s by the WPA. At the intersection of U.S. 66 and Main Street visitors can see several old structures. On the southwest corner was the Tip Top Night Club, later Thelma's Sundries.[111] On the west edge of are the remnants of the Washita and Cotton Boll motels. The owners of the Cotton Boll property have left the motel's handsome sign, even though business is now ancient history. The road comes to another dead end, then reappears on the north shoulder of the interstate. The old highway here still retains its vintage curbing and pinkish hue. The road heads straight into Elk City, home of the National Route 66 Museum, on a four-lane highway with a grass median. From the interstate, 66 can be picked up by taking the Stafford exit where the old alignment serves as a frontage road.

Elk City is the last major town before Amarillo, so seasoned travelers heading west secured lodging here before proceeding. Elk City's original motel row was at the west end of town, where the Royal, Elk, Bungalow, Star and Motor Inn auto courts, now replaced by modern-day motels, once stood.[112] The Cozy Cabins haven't been demolished yet—although they've been vacant for years—and are still standing along Main Street. Route 66 crosses a cement bridge into town and makes its usual winding path, first passing under a railroad viaduct on Country Club Road, then making a left-hand turn onto Main Street. A commercial zone with car lots and the National Route 66 Museum come next, and the route continues west out of town. A later alignment of Route 66 bypasses downtown Elk City by following a diagonal path from the intersection of Third and Main streets and uses Third to leave town. The pre–1933 alignment still exists in the center of town and has its original brick pavement. This short stretch is one block south of Main Street and is typical of city routes that predate later alignments, which bypassed central business districts to get highway traffic around cities more quickly. As it leaves Elk City, the route passes where the Dodge City Trail took cowboys and longhorns north to Kansas during the great cattle drives of the Old West (near the final exit for Elk City at Oklahoma State 34).

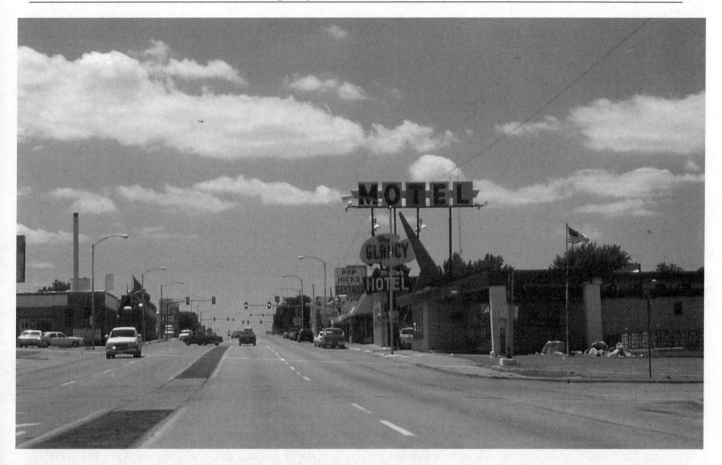

Clinton, Oklahoma. A four-lane version of U.S. 66 enters Clinton from the east as Choctaw Avenue, and leaves town on the south side. The Glancy Motor Motel and the once-popular Pop Hicks Restaurant (1936) are on the north side of the highway in this view looking west on the eastern side of Clinton. Unfortunately, Pop Hicks burned down in 1999.

(SEE COLOR SECTION C-19.) Rock Island Railroad Depot, Elk City. "Modern" Route 66 cuts across the north side of Elk City, Oklahoma, while the original route was located to the south, following Third Street and Broadway. In the center of town is this abandoned railroad depot for the Rock Island Railroad, which was officially merged out of existence in the late 1970s. This neat brick structure is a reminder of the changes in the nation's transportation needs from the 1800s when the railroad reigned supreme across the country before giving way to the automobile and the interstate freeway.

Leaving Elk City, the road heads west for several miles past some abandoned motels, then turns southwest. The road cruises right onto I-40, so drivers must watch for Old 66 branching off to the right before the interstate. The road hugs I-40 for several miles until it arrives at the long-gone town of Doxey. U.S. 66 crosses over to the south side of the freeway for a short distance before returning to the north side. A truss bridge, painted yellow, can be seen on the segment south of the interstate.

Highway 66 continues along the north side of I-40 and enters Sayre from the north as 4th Street. Route 66 passes some railroad tracks and makes a right turn west at Main Street. Proceeding several blocks farther west on Main, the route takes Fourth Street south (left) past more of Sayre and crosses the half-mile long Carmichael Bridge (1958) over the Red River. A few miles south of town, U.S. 66 makes a sharp turn west again, following on old rail line. Old maps show a small town named Hext midway between Sayre and Erick, although Rittenhouse's guide book describes Hext as "not a community — just a gas station," while further advising travelers that many of the "towns" west of this location are often only a single building.[113] Route 66 becomes a four-lane highway as it

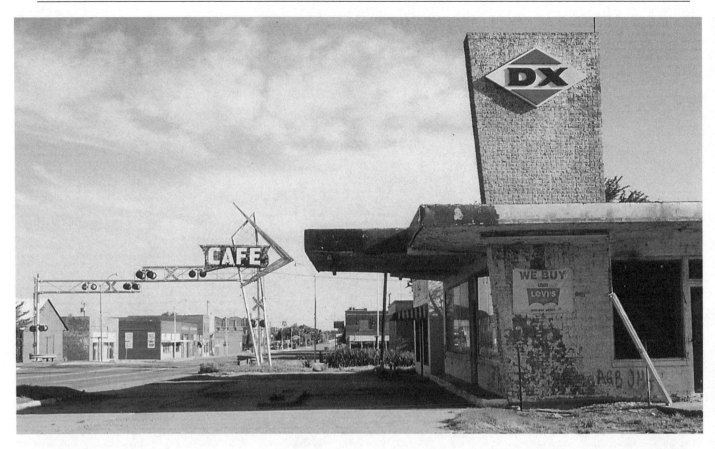

Café and DX station, Sayre. U.S. 66 makes several right-angle turns through the town of Sayre, as it does in most larger Oklahoma cities along its route. On the south side of Sayre is this abandoned café and filling station, one of several closed businesses that couldn't compete with the newer establishments that grew up along the interstate. In the distance is the Carmichael Bridge, a half-mile bridge built in 1958, during the final years of Route 66.

passes south under Interstate 40 and bends west into Erick as Roger Miller Boulevard. The route proceeds on an east–west heading through the heart of Erick. Tourist courts such as the De Luxe Court and the Erick Court and Trailer Park once flourished here, but vanished years ago.[114] On the west side of town, the West Winds Motel, an early motor court, is now closed. Continuing west, the road reaches the last town in Oklahoma, Texola, which sits on the Texas-Oklahoma state line.

Texola has had several names over the years: Texokla, Texoma, and now Texola.[115] As recently as the 1940s, Texola was an authentic western settlement — reminiscent of the days of cowboys, Indians, ranchers and cattle rustlers, with wooden plank sidewalks and awnings supported by posts to shield people from the hot sun.[116] Texola was the location of the Longhorn Trading Post, which is gone now. Little remains of the town today, a victim of the interstate.

Route 66 enters Texas on a deserted stretch of four-lane highway that was built in the 1950s. The route passes a line of old elms, then crosses a steel truss bridge just a few yards south of I-40. The highway runs straight west through the Texas Panhandle, with Amarillo located in the geographic center, passing through some dusty old

towns on the way. Rittenhouse describes Texas's highways as "wide, splendid roads, with excellent shoulders." In 1946, when his famous book chronicling Route 66's roadside monuments, services, and historical anecdotes was published, Rittenhouse recorded that oil derricks for the Phillips Petroleum and Magnolia Petroleum Companies were the first sights seen inside the Texas border.[117] The Panhandle's economy still relies heavily on petroleum and natural gas production. After crossing the state line and passing a rest area, Route 66 follows the north side of the interstate, crossing a fencepost-style concrete bridge (a design found in most places in the U.S. and common in western states). In the 1950s, Texas began modernizing its road system by converting its two-lane roads to four-lane highways, adding a new two-lane highway next to the old alignment. The old road stays on the south side of I-40 from the Oklahoma state line to Amarillo and is on the north side from Amarillo to the New Mexico state line, with few exceptions. The state also built rest areas adjacent to the highway with concrete and brick picnic tables protected by a sturdy canopy. Several of these 1950s shelters are still found along I-40 in areas where the interstate completely replaced Route 66.

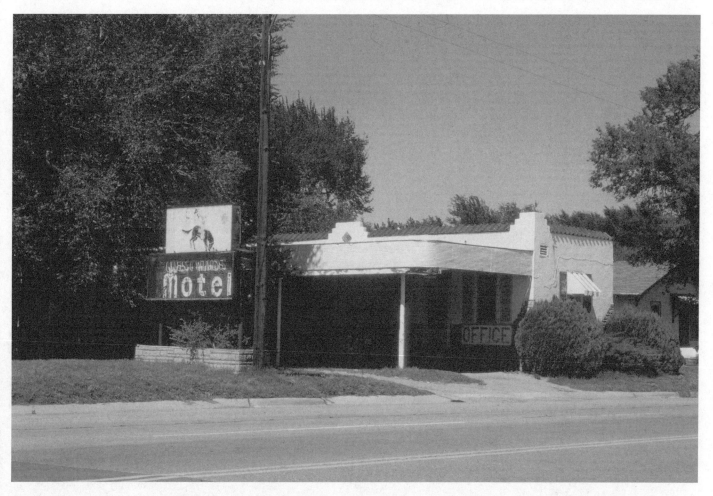

West Winds Motel, Erick, Oklahoma. Highway 66 enters Erick as Roger Miller Boulevard and passes a string of gasoline stations and motels that died during the years after I-40 bypassed the town in the early 1970s. On the west side of town was the West Winds Motel, which outlasted most of the others but recently joined the long list of fallen businesses along the Mother Road.

Heading into Texas, travelers first encounter the town of Shamrock. Although still an active urban center for the surrounding area, Shamrock is littered with the skeletal remains of numerous old filling stations and other businesses, closed due to loss of customers caused by I-40. However, Shamrock is home to one of Route 66's surviving gems, the art deco Tower station and U Drop Inn. Originally a Conoco filling station and café, the business was designed and built by J. M. Tindall in 1936. Tower Conoco and U Drop Inn was originally operated by the Nunn family, who sold the business after some years, only to buy it back again in 1950. The restaurant was renamed Nunn's Café in 1950, but was sold again some years later, when it again became the U Drop Inn. The filling station sold several brands of gasoline over the years; it was still operating as a Fina station until the late 1990s but finally closed.[118] Currently, the entire structure is being taken over by the state for a planned tourist center, so this historic site at the junction of Route 66 and U.S. 83 will be preserved for future travelers.

The road heads due west, but is difficult to navigate. To follow the easier route, continue on the interstate and take the exit for McLean. Old 66 is a four-lane that divides before town, with east and westbound lanes separated by one city block. The town's main street is between the east and westbound lanes. The blank marquee of the old Avalon Theater sits among the businesses lining the old Main Street, some of which have decided to capitalize on Route 66. McLean once had a hotel (the Hindman) and three auto courts (the H & H, the 20 Trees, and the Last Chance Court).[119] The remains of the Watt Court are on the north side of the westbound alignment of 66. Towns such as McLean were once busy outposts on Route 66, as evidenced by the scattering of abandoned filling stations and vacant businesses lining the road through town. At the western edge of McLean is a restored Phillips 66 station, complete with vintage gas pumps and an oil tanker truck, reputed to be the first Phillips gasoline filling station in the state of Texas and dating to 1930. The Cactus Inn still operates on the west side of town, as it has for

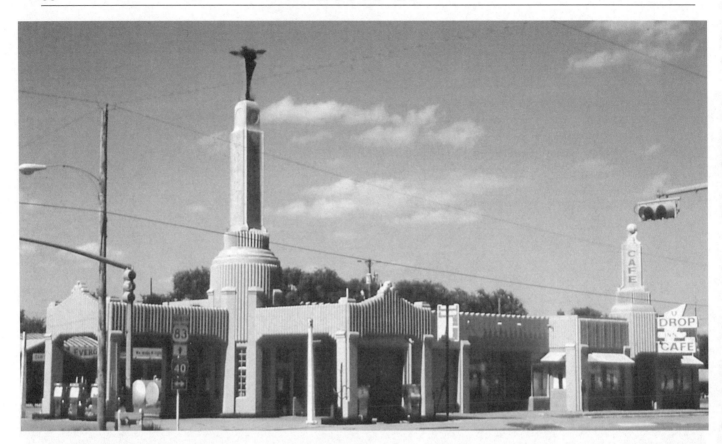

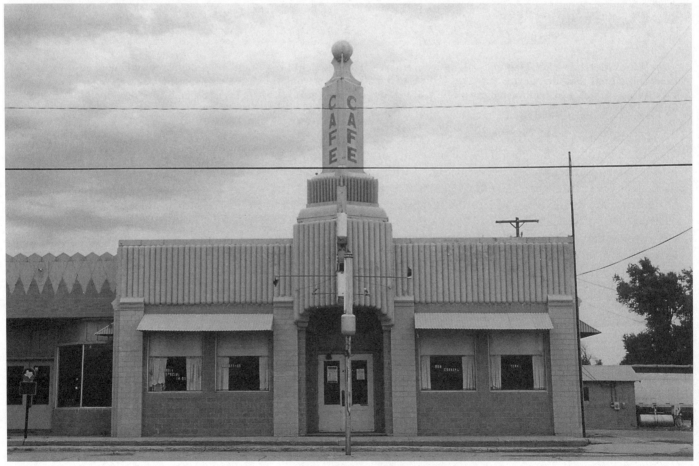

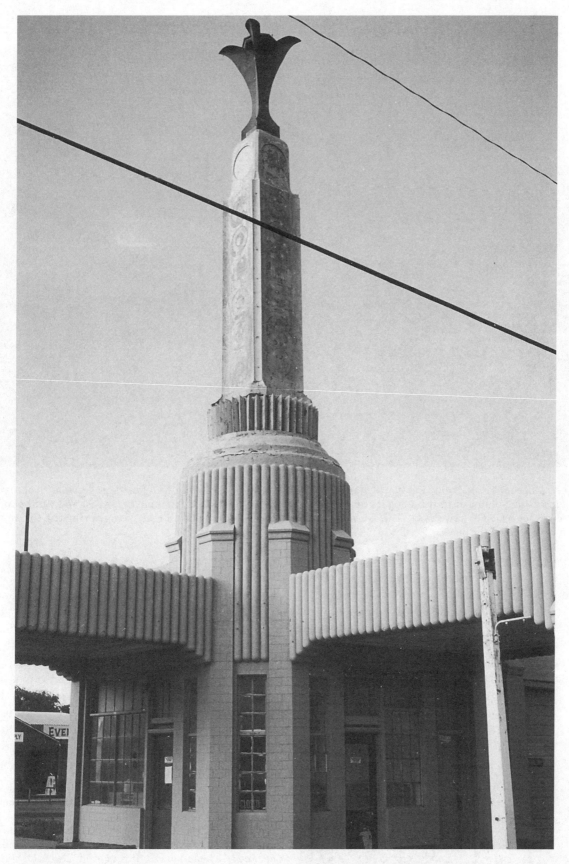

Opposite and above: Tower Conoco and U Drop Inn Café, Shamrock, Texas (1936). This is the most outstanding example of art deco styling that still remains on Route 66. Opened in 1936, the Tower Conoco and U Drop Inn Café was first owned by John Nunn, who sold the business and then repurchased it years later and renamed it Nunn's Café. The business closed several years ago, but the state of Texas is planning to turn it into a tourism center, so the old landmark will still be open to visitors at the corner of U.S. 66 and U.S. 83.

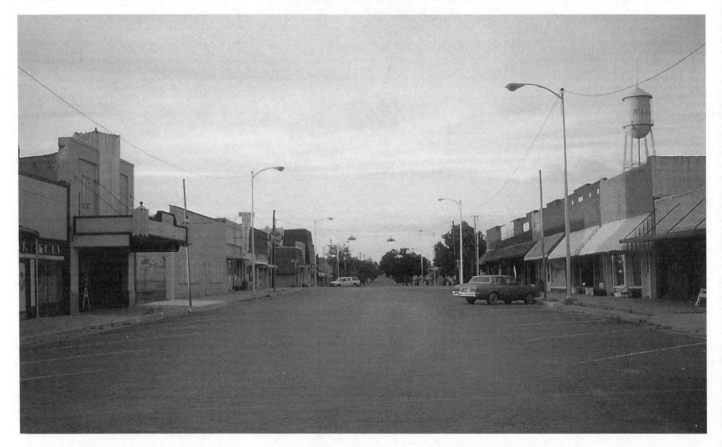

Main Street, McLean, Texas. Following World War II, much of Route 66 was rebuilt into four-lane versions to accommodate the ever-increasing volume of traffic along its route. Some states, like Texas and Arizona, made east and westbound routes through towns separated by a city block. This is a view of McLean's brick-paved Main Street, facing north, with the west-bound alignment at the end of the block.

quite some time despite being off the interstate. West of town, off of the freeway exit for Lake McLean, is a piece of Route 66 history: a road heads north two miles to a grove of trees which was a campground on the original road, and which is still in use today. The path of the old road is visible through the area.

After leaving McLean, the road passes over to the south side of I-40 and proceeds toward Alanreed. On the

north side of the freeway exit, an old alignment heading back east is marked near a vacant 1950s-era porcelain enamel filling station. The route crosses to the south of I-40 to Alanreed, where two alignments once ran through town. An abandoned station with red tile roofing, typical of Spanish Mission architecture in the southwestern United States, is on the southernmost alignment. The old station has two carports and a double-bay garage in an adjacent building. This is a very early example of the standardized filling stations that were used by the larger regional and national brands. As part of the building's restoration, the words "66 Super Service Station" have

(SEE COLOR SECTION C-20.) Vintage Phillips 66 Station, McLean (1930). Built in 1930, this restored Phillips 66 filling station was the first retail outlet for the Phillips Petroleum Company in the state of Texas. In 1929, Phillips Petroleum had just settled on a trade name for its brand of gasoline, called Phillips 66, and had begun marketing its products in the Midwest. In the late 1920s, national brands began using standardized filling station designs and some, like Phillips Petroleum and the Pure Oil Company, used the "cottage-style" architecture for their early filling stations. This station is on the westbound alignment of Route 66 in McLean, Texas.

(SEE COLOR SECTION C-20.) **66 Super Service Station, Alanreed, Texas (1930). Just west of McLean and south of I-40 is Alanreed, where two alignments for Route 66 once passed through town. This old twin-carport station with tile roof is in the process of restoration and currently is marked with a sign naming Bradley Kiser as the station's original owner. This photograph dates to 1987, before restoration work began on this historic gasoline station.**

been painted on the carport and a small sign posted on the building states that the station was opened in 1930 by Bradley Kiser.

Route 66 ends at the western edge of Alanreed and the interstate must be taken once again. The section of I-40 between Alanreed and Groom passes another fixture of Route 66 history; "Jericho Gap," named after a town south of the interstate, can be found between Exits 135 to 124. By the early 1930s, U.S. 66 was completely paved through Texas except for an 18-mile section from Rutledge Station — a stop for the Rock Island Railroad a few miles west of Alanreed, near the Gray and Donley county lines — to Groom. The soil here turned into a black quagmire after heavy rains, stranding many motorists until U.S. 66 was paved in the area. This unpaved stretch of U.S. 66 was treacherous, and unlucky travelers were forced to hire wreckers from nearby Groom or area farmers and ranchers to pull their vehicles from the gooey morass, sometimes delaying their trip for a day or two. Texas Department of Transportation records show that the state began building a new paved bypass from Groom east to close the Jericho Gap in 1928. The project was completed by 1931 and thankful motorists were finally able to travel through this notorious area with relative ease.[120] Surviving dirt sections of the old Jericho Gap route can still be traced using old maps, and it generally follows the Rock Island rail line from Alanreed to the town of Jericho. From there, it heads west several miles, does two zig-zags north to the remains of Boydston, then west again toward Groom. Today, Jericho Gap is a folk legend remembered mainly by old timers and Route 66 enthusiasts.

Old Route 66 heads toward Groom, marked by the town's grain elevators in the distance. The terrain is pancake-flat in this region, broken occasionally by a small creek or wash. The route passes under I-40 and comes to a T-intersection, and 66 is a right turn onto a four-lane road west toward Groom. The route through town is still four lanes and passes a few gaunt buildings. On the way out of town, a rare auto court with an abandoned 1930s-era gas station out front sits perpendicular to Route 66, on the north side of the highway. The "66 Courts," its units empty for many years, somehow survived the ravages of time and progress, as has its inoperable neon sign. Nowadays, there's always a vacancy at 66 Courts.

Leaving Groom, the road still follows the south side of I-40 but is easy to miss, and drivers can easily end up on the freeway. A lone telephone pole along the south shoulder road is a clue that this is the genuine Route 66. The tiny village of Lark was midway between Groom and the next town, Conway, and had a grain elevator, a filling station–store, a post office and a few railroad buildings, but nothing significant is left. After Lark is Conway, which had the only gas station until Amarillo, some 25 miles away.[121] The road moves away from I-40 on a vintage stretch of road, crossing over to the north side of the interstate near a rest area where I-40 must be taken. In the late 1920s, the original route from Conway to Amarillo was a dirt road which ran south of the interstate through the town of Washburn, then followed U.S. 287 into Amarillo via 10th Street. U.S. 66 can be picked up again by leaving the interstate and heading north at Exit 85 (Business Loop 40), where the route is four lanes all the way into Amarillo.

At Folsom, B. L. 40 is joined by U.S. 60 from the north and the two highways follow the same route into Amarillo. The road enters the northeastern quadrant of the city as Amarillo Boulevard. Virtually all of the auto courts in Amarillo, which once lined this stretch of Route 66 on eastern Amarillo Boulevard, are gone. At Fillmore Street, the original alignment turns south, then west again (right) at Sixth Avenue at the Potter County Courthouse. Just off of Sixth (at the northwest corner of Michigan and Jackson at the beginning of Route 66) is the old Santa Fe Railroad building, once the tallest building between Fort Worth and Denver. The building was constructed between 1928 and 1930, and its art deco design is similar to other regional headquarters built at the time in Topeka, Fort Worth, and Chicago. The stark economic times of the Great Depression did not deter the railroad from completing these grand projects, which were meant to symbolize the company's dominance in overland transportation in the western United States, and the Santa Fe Railroad spared no expense in erecting this architectural masterpiece. The final cost of the project was $1.5 million;

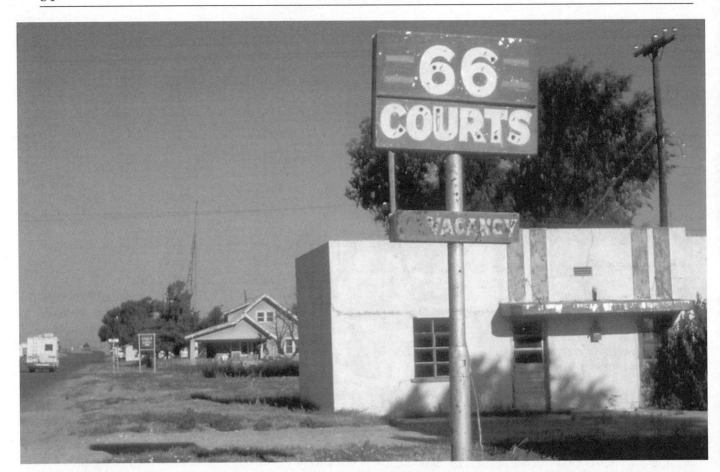

Top: 66 Courts. A fine example of auto courts dating to before the Second World War, the 66 Courts is on the western outskirts of Groom, 16 miles west of Alanreed. In the late 1920s and early 1930s, Groom was a busy place, especially when dozens of motorists were towed into town after being mired in mud on the unpaved section of Route 66 east of here known as Jericho Gap. The Gap was closed by 1931 when 66 was finally paved. The town is now a quiet place, as Groom itself was bypassed by I-40 in 1974. *Bottom:* Abandoned Phillips 66 Station, Groom. Also on the western edge of Groom and across the highway from 66 Courts is this abandoned Phillips 66 station and truck stop. Numerous vacant filling stations can be found in the towns along U.S. 66 in Texas, where time seems to stand still. A 1953 Mercury sits beneath a sign reading "Truck Terminal," with the town's grain elevators in the distance.

Top: Conway, Texas. Only a few empty structures mark the town of Conway, east of Amarillo and south of I-40. This portion of U.S. 66 in Texas has been assigned several state highway designations, but the route of Old 66 is often marked by modern signs to keep 66 pathfinders on course. This view faces north at the main intersection in Conway, south of Interstate 40. *Bottom:* Trail Drive-In Theater, Amarillo. The Trail Drive-In Theater is on the eastern outskirts of Amarillo on the section of U.S. 66 that is shared by U.S. 60. The theater has been closed for years. Other drive-ins have likewise disappeared along the Mother Road during the past 20 years, including the Cowboy Drive-In in nearby Shamrock, which closed in the 1980s.

Triangle Motel, Amarillo. Route 66 and U.S. 60 enter the city of Amarillo as East Amarillo Boulevard, an improved four-lane highway. This area was where most of the city's auto courts and motels were once located. The Triangle Motel is positioned in the center of a Y-junction on East Amarillo Boulevard. The Triangle was a large auto court with separate motel units, similar in style to the Coral Court in St. Louis, with rounded corners and a brick exterior. It derives its name from the shape made by its buildings, which formed an inner courtyard to keep highway traffic noise at a minimum for sleeping guests.

the building was known as "the Jewel of the Texas Panhandle" throughout its productive life, but eventually was closed as a cost-saving measure by the railroad. The building was put up for sale for $8 million in 1989, but remained unsold until Potter County purchased it in 1995 for $450,000. The Santa Fe building is now on the national and state registries of historic buildings and was re-opened in 2000. Currently, the building houses county government offices, but tourists can visit the main lobby and admire the exquisite Georgia marble interior and paneled ceiling depicting the building's history.[122] Sixth Avenue was a main business district in Amarillo until development moved traffic away from the downtown area.

Proceeding west on Sixth, the route turns south onto Western Street, which becomes Ninth Avenue near the Amarillo Golf Course, and meets up with Business Loop 40. The City 66 route can be avoided by taking the later alignment, which continues west on Amarillo Boulevard from the intersection with Fillmore Street. This route contains post-war motels, restaurants and other auto-related businesses, although some are now showing their age. The highway continues as a four-lane and turns southwest until it meets up with City 66 at Ninth Avenue on the western edge of Amarillo.

From Amarillo to the new Mexico border, portions of Route 66 appear on the north side of I-40 as a frontage

Opposite: Santa Fe Railroad Building, Amarillo (1930). Appropriately called the "Jewel of the Texas Panhandle," the Santa Fe Railroad building was designed by E. A. Harrison in the art deco style of the period and built at a cost of $1.5 million, a hefty sum in those days. The 13-story structure's exterior is covered in glazed terra cotta, and it was designed to allow for the addition of three extra floors. Four giant red "Santa Fe" signs at the top of the building symbolized the strength of the mighty railroad as it served neighboring states in four directions from Amarillo. The building escaped demolition in the 1990s thanks to local citizens and preservationists and is on the national and state registries of historic buildings.

(SEE COLOR SECTION C-21.) Sixth Avenue Auto Company, Amarillo (1916). The city route for U.S. 66 through Amarillo follows Fillmore Street and Sixth Avenue. Sixth Avenue was one of Amarillo's main thoroughfares and is where the city's car dealers and other businesses were once located. The Sixth Avenue Auto Company is one of the few original businesses remaining on the old alignment, and according to its faded neon sign, has been operating here since 1916.

road. Bushland, on the north side of the freeway, consists mainly of a tall white grain elevator and a few houses. The shoulder road on the north side of I-40 is still Route 66, marked by another old telephone pole. The interstate passes the first town, Wildorado, on a freeway overpass for the exit to town. On the right is an old neon sign for Jessie's Café with a "V" pointing south across the freeway toward the café. The interstate barely misses a few homes on the north side, while on the south side there is a row of businesses, including an old gull-wing Phillips 66 station and Jessie's Café, whose original location was 28 miles west in Adrian.

The next town, Vega, is the largest city between Amarillo and New Mexico. The gleaming white Co-op grain elevator is the first visible landmark and the road curves past a row of trees and the old Robinson's Texaco station, now Anita's Longhorn Gas and Cafe. The road passes the old Bonanza Motel, which has a swimming pool and is still in business. The road into Vega is a wide four-lane which follows the original alignment and makes a right turn north at the intersection with U.S. 385 (Main Street).[123] After World War II, the state improved all of Route 66 into four-lane highway. At the junction of U.S. 66 and U.S. 385, the only traffic signal in town, are a number of gas stations and cafés, all within a short radius of the intersection. On the southwest corner is Groenman's Service, the busiest station in town. A sign spelling "CAFE" hoisted on high pillars across Route 66 marks the Hickory Inn Café. Heading north on U.S. 385 through downtown Vega, 66 once made a left turn at the town's

second Main Street, which has a view of the town's modest skyline (dominated by the municipal water tower, painted with the name "Vega Longhorns"). However, the road comes to a dead-end a few blocks west, near a reproduction road sign in the federal aid shield design reading "Old Route 66" and marked "End." A locally-made sign states that original dirt sections of U.S. 66 can be found west of Vega and north of the interstate, crossing abandoned cement bridges. Dot's Mini Museum, a recent addition to the growing Route 66 preservation movement, is nearby at 105 North 12th Street and houses a collection of folk art and antiques dedicated to Route 66. Dot has saved the original wooden gazebo that was once in front of the courthouse and plans to restore it. Backtracking to the intersection of U.S. 66 and U.S. 385, the newer four-lane alignment continues west to the interchange with I-40.

The Texas Panhandle was the last part of the state to be settled, and the majority of the cities and towns here date only to approximately 1900. Vega's original downtown business block burned early in the second decade of the 1900s, so most of its buildings were constructed between 1915 and 1924. The town suffered a second major fire in the 1930s during the dry Dust Bowl years, and the Oldham County Courthouse (1915) is now the oldest structure in Vega. The railroad didn't come through Vega until 1908, and the farm-to-market road that was the forerunner of U.S. 66 was a dirt road until the late 1920s. The tracks have been removed but the railroad right-of-way is noticeable as it crosses U.S. 385 between four-lane 66 and Main Street. Just north of the right-of-way is a vacant two-story brick building that was a Magnolia gasoline station, completed in 1924 by Colonel J. T. Owen. It was leased to Edward R. Wilson, became a Phillips 66 station and later sold Conoco gasoline and oil products. It became the Slatz Barbershop in 1953 and was owned by Edward R. Wilson until he moved out in 1965. A large canopy once stuck out from the station but was removed when U.S. 385 was realigned. The Oldham County Chamber of Commerce and the citizens of Vega are hoping to restore the historic Magnolia station one day. Restoration projects require a great deal of fundraising, and unexpected problems often surface. One obstacle to a faithful restoration of the Magnolia station are state requirements for a maximum right-of-way, under which the building's canopy would be prohibited since it is too close to the road.[124]

Vega also has a real turn-of-the-century hardware store — Roark Hardware, located on First Street — which is the oldest on all of Route 66. Most of the other old businesses in Vega closed long ago, like the Roadrunner Drive-In and Krahn's Café, where ex-oil man Ervin "E. M." Pancoast met his wife in 1948, the year after he opened the

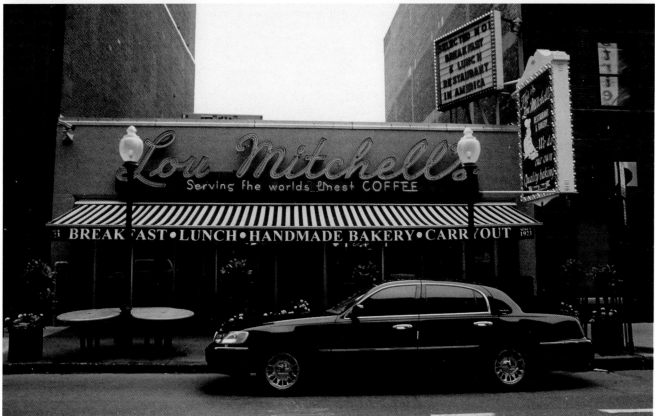

Top: Intersection of Michigan Avenue and Jackson Boulevard, Chicago, Illinois. *Bottom:* Lou Mitchell's, Jackson Boulevard, Chicago, Illinois.

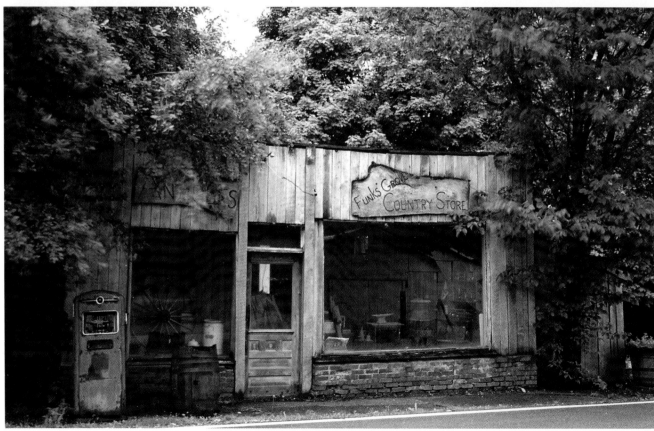

Top: Sinclair Station, Odell, Illinois. *Bottom:* Funk's Grove Country Store and Antiques, Funk's Grove, Illinois.

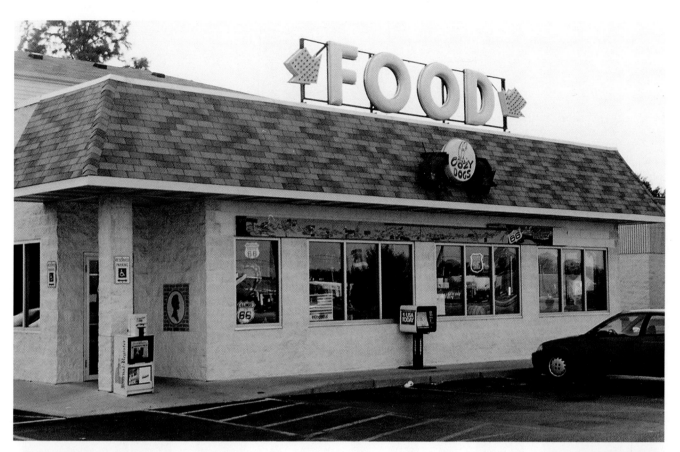

Top: Cozy Dog Drive In, Springfield, Illinois. *Bottom:* Brick pavement on Illinois State Route 4.

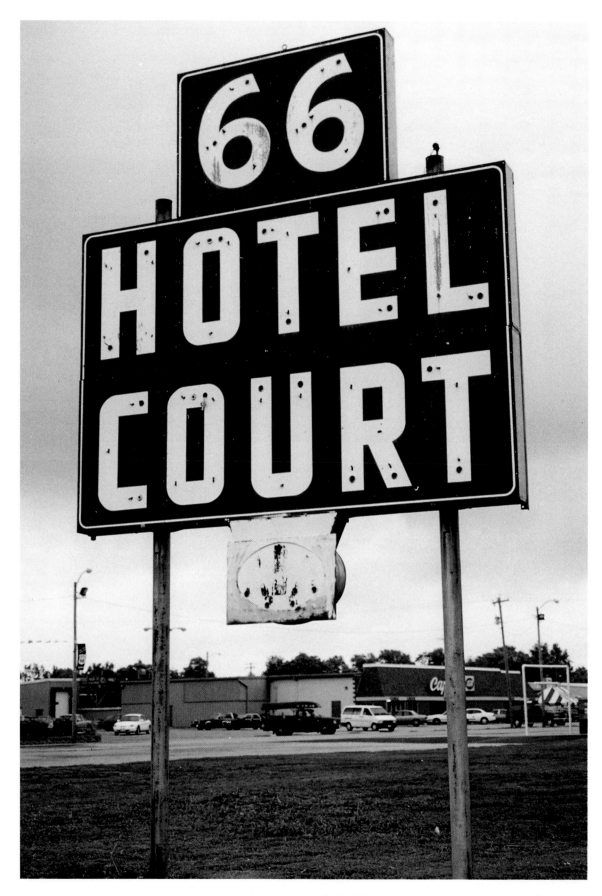

66 Hotel Court, Litchfield, Illinois.

C-4

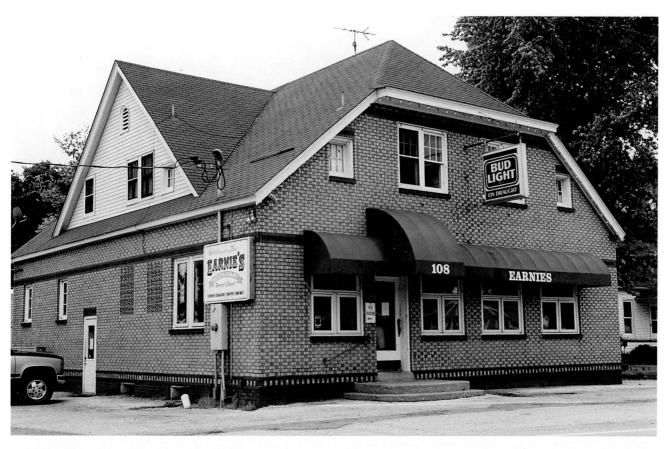

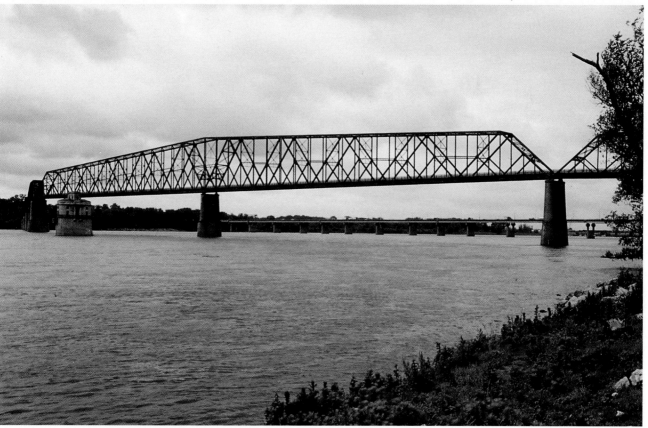

Top: Earnie's Restaurant, Hamel, Illinois. *Bottom:* Chain of Rocks Bridge over the Mississippi River.

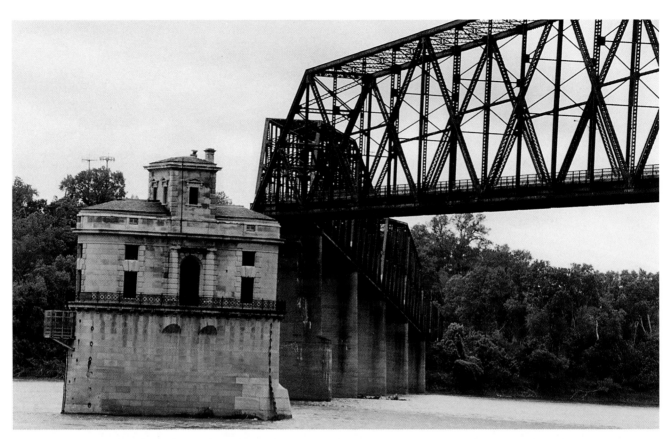

Top: Chain of Rocks Bridge and #2 intake tower over the Mississippi River. *Bottom:* Ozark Court near Sullivan, Missouri.

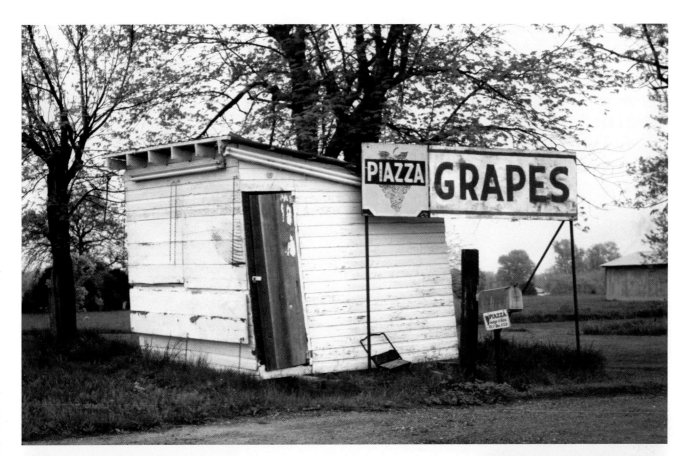

Top: Piazza Grapes roadside stand, Rosati, Missouri. *Bottom:* Devil's Elbow Bridge, Hooker, Missouri.

Big Piney Creek and Devil's Elbow, Hooker, Missouri.

C-8

White Sands Motel vintage billboard, east of Lebanon, Missouri.

A rusting sign, west of Springfield, Missouri.

Top: Eisler Brothers Riverton Store, Riverton, Kansas. *Bottom:* Brush Creek Bridge, Riverton, Kansas.

Ed Galloway's Totem Pole Park, Foyil, Oklahoma.

Opposite: Top Hat Dairy Bar, Foyil, Oklahoma.

Top: Round-Up Motel, Claremore, Oklahoma. *Bottom:* Twin Bridges over the Verdigris River, Verdigris, Oklahoma.

Top: Animal Reptile Kingdom and Catoosa Alligator Ranch, Catoosa, Oklahoma. *Bottom:* Boston Avenue Methodist Church, Tulsa, Oklahoma.

C-16

Townley milk bottle, Oklahoma City, Oklahoma.

Opposite: Round Barn, Arcadia, Oklahoma.

Top: Yukon Flour Mill, Yukon, Oklahoma. *Bottom:* Abandoned Café and Truck Stop, Hinton Junction, Oklahoma.

Top: Owl-Cotter Blacksmith, Weatherford, Oklahoma. *Bottom:* Rock Island Railroad Depot, Elk City, Oklahoma.

Top: Vintage Phillips 66 Station, McLean, Texas. ***Bottom:*** 66 Super Service Station, Alanreed, Texas.

Top: Sixth Avenue Auto Company, Amarillo, Texas. *Bottom:* Rio Pecos Truck Terminal, Santa Rosa, New Mexico.

Top: Club Café, Santa Rosa, New Mexico. *Bottom:* Ruins of Pigeon Ranch, Glorietta, New Mexico.

C-22

Top: Aztec Motel, Albuquerque, New Mexico. *Bottom:* Zia Motor Lodge, Albuquerque, New Mexico.

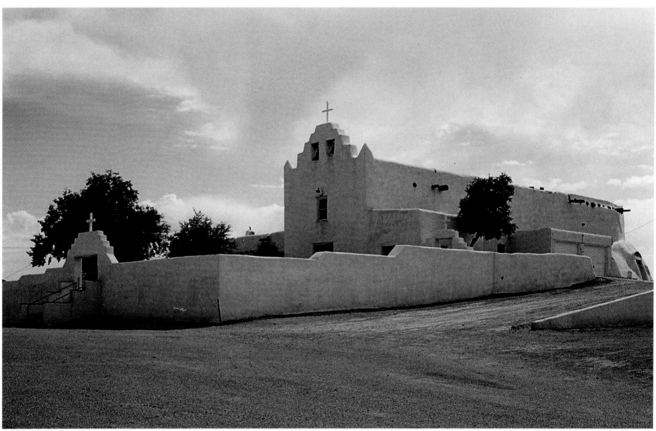

Top: Pre-1937 Route 66, east of Los Lunas, New Mexico. *Bottom:* Church at Laguna Pueblo, New Mexico.

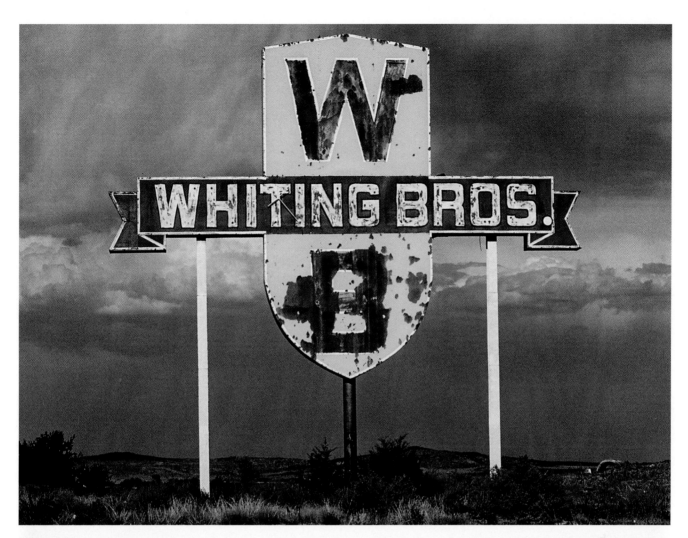

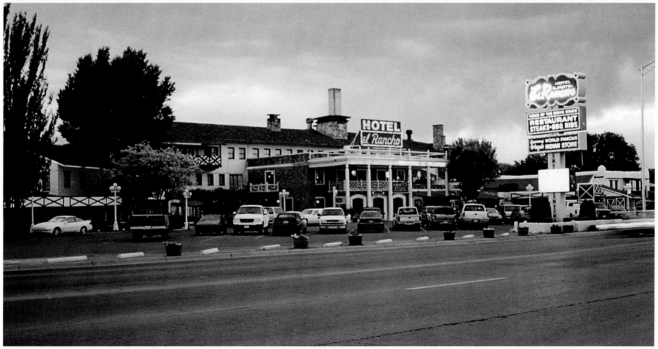

Top: Whiting Brothers Station sign, west of San Fidel, New Mexico. *Bottom:* El Rancho Hotel and Motel, Gallup, New Mexico.

Top: Avalon Restaurant, Gallup, New Mexico. *Bottom:* Devil's Cliff, Manuelito, New Mexico.

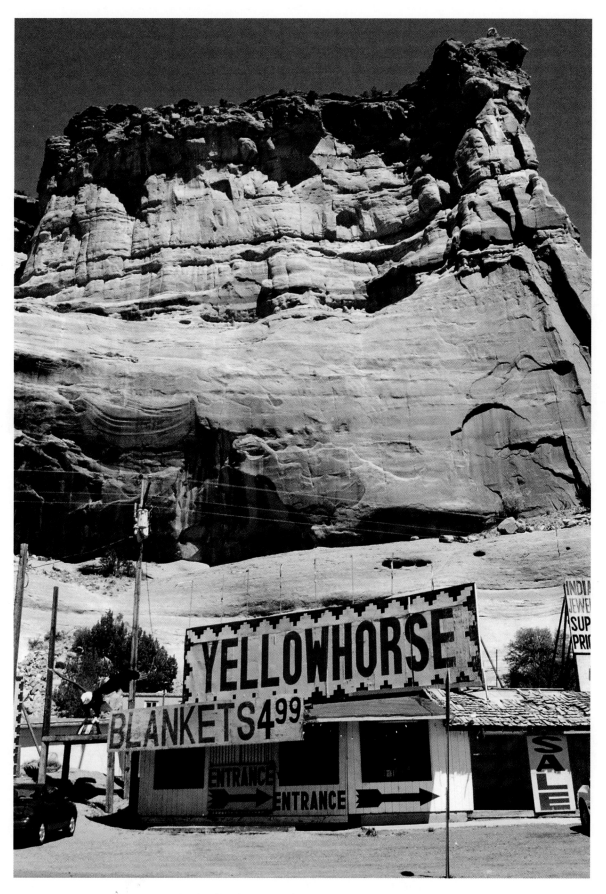

Chief Yellowhorse Trading Post, Lupton, Arizona.

C-27

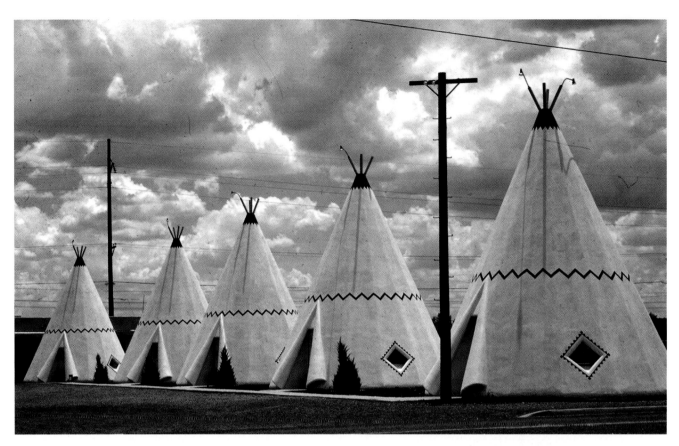

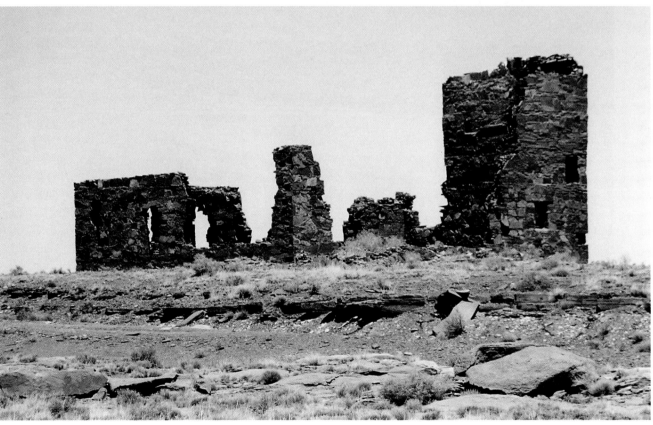

Top: Wigwam Motel #6, Holbrook, Arizona. *Bottom:* Ruins of Meteor Crater Observatory and Museum, west of Meteor City, Arizona.

Top: Downtowner Motel, Flagstaff, Arizona. *Bottom:* Rod's Steak House, Williams, Arizona.

Top: Storefronts in downtown Williams, Arizona. *Bottom:* Delgadillo's Snow Cap Drive-In, Seligman, Arizona.

Top: Chief's Motel, east of Hackberry, Arizona. *Bottom:* Santa Fe Railroad Depot Logo, Kingman, Arizona.

Top: Old Trails Bridge crossing the Colorado River to enter California. *Bottom:* Desert Market, Daggett, California.

Top: Westbound Route 66 approaching Vega, Texas. Route 66 through Vega is a four-lane highway that crosses the south side of town. The original Route 66 was a dirt road until the late 1920s, and ran parallel to the current four-lane alignment near the telephone phones to the right in this photograph, facing west. The road ahead curves left before it reaches Vega's Co-op elevator, passing a former Texaco station. *Bottom:* Downtown Vega, Texas. Looking north on Main Street in central Vega, several blocks north of the second alignment for U.S. 66. This view also shows the original route, which ran between the water tower and the abandoned Magnolia gas station in the foreground, to the left and west toward Texas. The water tower was recently replaced by a new one and the town is presently raising funds to restore the Magnolia station, which dates to 1924.

Vega Motel. The Vega Motel is the best-preserved motel dating to the post-war era and was operated by the Pancoasts until they sold it in 1976 to E. G. Betts. Betts passed away not long after taking over the motel, and his family ran it until 1988, when current owners Harold and Teresa Whaley purchased it. Fortunately, the Pancoast and Betts families never remodeled or refurnished the rooms, and the Whaleys have likewise kept the original furniture and interior. The motel has three separate wings arranged in a "U" pattern, as is typical of many motels. The east and south wings were the first to be completed. A small house that served as the residence of Pancoast and his wife was once in the center of the motel, which was affectionately called the "Alamo." The home was eventually torn down and the motel office was moved into one of the motel units. Just stepping into one of the Vega Motel's rooms is truly a trip back in time to the late 1940s. The Whaleys have been slowly renovating the exterior of the motel to original condition, and one day the Vega Motel's neon sign will be flashing again in the Texas Panhandle.[125]

The road continues west on the north side of I-40 approximately 15 miles to Adrian, where piles of railroad ties lie adjacent to the abandoned rail line. The asphalt road surface is rough and sections of "Dirt 66" can be spotted north of the railroad tracks. Two old culverts mark the old alignment, although it is difficult to spot. At the exit for Landergin, a vacant building on the north side of the freeway exit was until recently the Route 66 Antiques and Museum. Owned by George and Melba Rook until George's untimely death in 1999, the museum contained the finest collection of Route 66 road markers anywhere, with designs from each state, and other artifacts from the highway's past. A gift shop selling road-related collectibles and Route 66 souvenirs was attached to the museum. Melba put all of the items up for sale and a man from the east coast bought the entire collection of road signs, so the Rooks' fabulous collection is now far from the great road.

The last town of any size in Texas is Adrian, located at the geographic center of Route 66 and home of the Midpoint Café, the oldest café between Amarillo and Tucumcari, New Mexico. The original café was built in 1928 and was renovated several times over the years. It was run by Zella Prin and named Zella's Café, then became Jesse's Café, which relocated east to Wildorado. Jesse took the original sign to Wildorado where it now stands on the north side of I-40 at the Wildorado exit. The Midpoint Café is now owned by Fran Hauser, and the building

Vega Motel (1947). Ex-oilman Ervin "E. M." Pancoast settled in the Vega area and built a motel on the south side of town west of the junction of U.S. 66 and U.S. 385. Pancoast and his wife operated the motel for almost 30 years until 1976, when they sold the property to E. C. Betts. The Vega Motel's rooms still have their original furnishings, including classic 1940s-era bathrooms, and its current owners, Harold and Teresa Whaley, are restoring the property.

Midpoint Café, Adrian, Texas (1928). The Midpoint Café is the latest name for a restaurant which was once Zella's Café, then Jessie's Café. It is the oldest café remaining between Amarillo and Tucumcari and is presently owned by Fran Hauser. Next door is a deserted Humble Oil filling station and café. A sign across the highway marks the geographic center of Route 66, where the "End of the Road" is 1,139 miles in either direction.

contains a gift shop as well as a restaurant. The café is a recent addition, while the gift shop portion of the business was built in 1947. An old Humble station and café are next door, while to the east is the site of Kamp's Kozy Cabins, which also had a Phillips 66 station.[126]

Adrian is smaller than Vega, and Rittenhouse's guide warned that this was the last chance for gasoline for the next 56 miles and that the next roadside park was 61 miles away, with no water.[127] The region ahead was named the Llano Estacado (Staked Plains) by the Spaniards, after a trail of wooden stakes the Comanches used to mark the path to water sources in this parched region. The Ozark Trail, a forerunner of U.S. 66 conceived and promoted by William Hope Harvey in 1913, followed Fifth Street, turned onto Walnut, crossed the railroad tracks and finally headed west on Business Loop 40.[128] From Adrian, the route continues west but ends after a few miles and is replaced by the interstate for the final 23 miles to the New Mexico border. Another section of Dirt 66 can be found just north of Exit 18, where a faint path follows the

CRI & P railroad tracks until it deadends at I-40, then reappears on the south side of the freeway. Old maps show a natural rock formation known as Cap Rock in the area, and a settlement called Boise, with a water tank section house for the railroad on the south side of I-40, but the road is suitable only for all-terrain vehicles.[129] Six miles west of Adrian off of Exit 18 are the remains of Percy Gruhlkey's filling station. Gruhlkey came to this area in the early years of the twentieth century, and built this gas station out of cinder blocks in the late 1920s. After many years on the Mother Road, however, the station closed.[130] The route next arrives at the final outpost in the Lone Star State: the town of Glenrio.

Glenrio is one of those enigmas that has puzzled amateur and veteran Route 66 scholars for years. While most highway road maps (including those dating to the early days of U.S. 66) show Glenrio within the New Mexico state line, the town actually lies in the state of Texas. To further confuse motorists, some maps showed Glenrio as straddling the border. Glenrio is just south of the interstate

Circa 1950s shelters at rest area, Texas. During the 1950s, Texas converted Route 66 into a divided four-lane highway and built rest areas with well-constructed picnic shelters, some positioned between the east and westbound lanes east of Amarillo. Many of the original rest areas and shelters still exist, such as these now located on present-day I-40 in western Texas.

off Exit 0, the last freeway exit in Texas. The freeway access road heading south into town ends at a T-intersection with the original Route 66. This is the center of Glenrio, with the entire town consisting of a row of businesses on the north side of U.S. 66. A vacant filling station sits at the corner where the old 66 heads east and to the west toward New Mexico. Here, Route 66 is a road to nowhere, as both ends of this forgotten stretch of road disappear into the arid southwestern plains. Most of town is to the west of the T-intersection with the freeway access road, where the remnants of the "First/Last Motel/Cafe in Texas" sit idle, its café empty for several decades now. The Rittenhouse Highway 66 guide book does show Glenrio in Texas, with a small town called Endee just inside the New Mexico border.[131] Today, westbound U.S. 66 reaches a dead end just a few hundred yards after it enters New Mexico.

Route 66 cuts straight across northern New Mexico and Arizona, with Albuquerque 225 miles from the Texas border. From here to the west coast, service facilities for travelers were scarce in the days before the interstate high-

way system and were usually located in larger communities. The old road can be picked up by leaving the interstate at Exit 364 in New Mexico and following the old alignment north of the interstate. However, AAA roadmaps from the 1930s show the first route on the south side of I-40, heading through Endee to San Jon, although that road is now in very poor condition. Only the post office for Endee, which only had slightly over a hundred residents in its heyday, remains. Old road maps document at least three separate alignments leading from the border to San Jon during Route 66's history.[132] The easiest alignment to find in San Jon is the final four-lane version south of I-40, which today passes a handful of shuttered establishments along what was once one of America's busiest thoroughfares. Rittenhouse describes a historical marker eight miles past San Jon marking the Comanche Trail, which originally ran from St. Louis to Santa Fe. The marker mentions that bootleg traders used this route in the 1850s.[133] The road reaches I-40 and crosses over to the north side of the interstate, heading northwest, then west, toward Tucumcari.

Glenrio, Texas. The Texas town of Glenrio lies just south of I-40 and east of the New Mexico border, although some road maps show it within the state of New Mexico. The entire town is on the north side of old Route 66, which makes a wide path through Glenrio, the site of the popular "First/Last Motel/Café in Texas." The business consisted of a Phillips 66 service station, cafe, and motel with a sign reading "First" on the west side of the sign for eastbound travelers and "Last" of the east side for those heading west. It closed in the 1980s after I-40 diverted motorists away from Glenrio.

The city of Tucumcari has advertised itself for years as a major tourist destination. It once placed numerous billboards along U.S. 66, advertising the town as having over 2,000 hotel and motel rooms to accommodate the overnight traveler. With at least 165 miles to go before Albuquerque, many motorists found Tucumcari to be a logical place to stop for the night. The current signs have reduced the number to 1,200 rooms, due to the closure of a number of motels. Approximately 12 miles west of the Comanche Trail marker is another historical monument, at Tucumcari Mountain, which recounts a tale told by legendary Chief Geronimo. Two young braves, Tocom and Tonopah, squared off in a duel for the right to succeed the ailing Chief Wautonomah and marry his daughter, Kari. The story has a tragic ending reminiscent of a Shakespeare play, with Tonopah stabbing Tocum and Kari, and Kari fatally stabbing Tonopah. Grief-stricken, Kari ends her own life, and Chief Wautonomah commits suicide over the incident, exclaiming "Tocom — Kari."[134]

Route 66 continues west into Tucumcari as a four-lane (originally Gaynell Street), with Business Loop 40 joining 66 on the east end of town. The road first passes the contemporary gas station, motel and fast food district, then the older post-war motels, many with western-sounding names, such as the Lasso, the Palomino, the Pony Soldier and the Buckaroo. The Blue Swallow Motel is one of Tucumcari's oldest, built in 1939 by a Mr. Huggins, who ran the motel until selling out to Floyd Redman in 1958. Redman reportedly purchased the Blue Swallow for his wife, Lilian, who operated the motel until 1998. The Blue Swallow has only 12 units and is currently owned by Dale Bakke.[135] Farther down the road on the south side of Route 66 is Tee Pee Curios, originally Leland's Gulf station when it opened in the 1940s. The station's gas pumps were taken out when U.S. 66 was widened into a four-lane through town in the late 1950s, and the cement tee pee was added in the early 1960s when the business was converted into a curio shop. Mike and Betty Callens have owned the Tee Pee since 1985 and sell a wide variety of Native American and other souvenirs. The Tee Pee

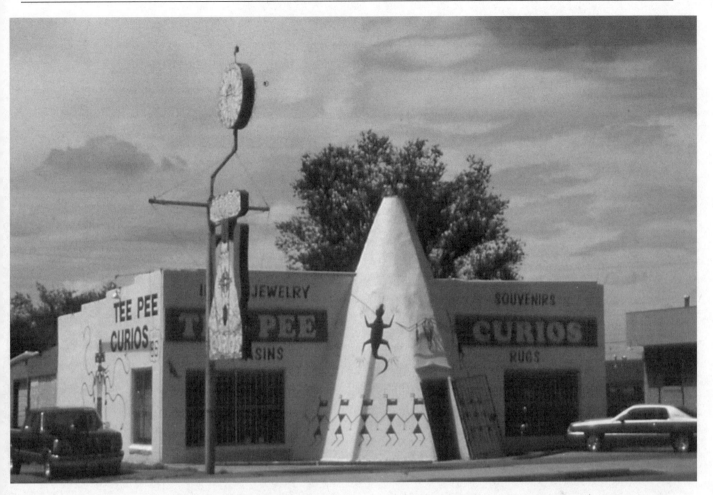

Tee Pee Curios, Tucumcari. An archetypical western souvenir shop, the Tee Pee Curios is on the south side of Route 66 in Tucumcari, a short distance west of the Blue Swallow Motel. Originally called Leland's (named after Leland Haynes, its first owner), it operated as a combination Gulf filling station, food store and meat market. The Tee Pee has been operated since 1985 by Mike and Betty Callens, who inherited the store from previous owners Jean and Erlene Klaverwiden.

Curios' fancy neon sign featuring an Indian is inoperable, but the Callens hope one day to be able to afford to repair it. Numerous other neon signs along Highway 66 are darkened, due to the high cost of removing and shipping them for restoration.[136]

Route 66 leaves Tucumcari as Business Loop 40 and ends at I-40, replaced for the next 10 miles by the interstate. The freeway climbs past the bluffs of the Llano Estacado, an area of weathered, craggy rock formations frequented by cattle thieves and other lawbreakers who plagued the vicinity in the 1860s and 1870s.[137] Route 66 reappears at Montoya on the north side of I-40. This part of U.S. 66 was New Mexico's first federal-aid highway project, begun in 1918.[138] Montoya never had more than 110 or so people, and only a few buildings are left. Among them, however, is Richardson's Store and Good Gulf (later a Sinclair station), now closed. The building is protected by a chain link fence like a museum piece. Just west of town is a nicely-preserved concrete fencepost bridge, with its metal plaque designating this as a federal-aid project completed in 1936, when this section of U.S. 66 was finally paved. Three similar bridges, all dating to 1936, are located east of Montoya before the road ends at the Llano Estacado.

Continuing west from Montoya, the route follows stretches of telephone poles (some in the process of being

Opposite, top: Del's Family Restaurant, Tucumcari, New Mexico (1956). This restaurant was opened in 1956 by Del Akin and has been in operation ever since. Del's Family Restaurant was run by Akin for several decades; today, it's owned by sisters Yvette Peacock and Yvonne Braziel. *Bottom:* Blue Swallow Motel, Tucumcari (1939). Built just prior to World War II by a Mr. Huggins, the Blue Swallow Motel is an often-photographed landmark on Route 66. The motel was purchased by Floyd Redman in 1958 and given to his new bride, Lillian, who ran the motel until 1998. The Blue Swallow's classic neon sign has been a pleasant sight 21 in Tucumcari for 50 years and current owner, Dale Bakke, is gradually restoring the motel and its 12 units to their original condition.

Richardson's Store and Good Gulf, Montoya, New Mexico (1918). The oldest surviving service station on all of Route 66, Richardson's Store and Good Gulf opened years before the creation of the great road. The station later sold Sinclair Oil products, as evidenced by the fading mural on the west side of the building. Richardson's Store is now closed.

removed) and the Southern Pacific Railroad. Approximately ten miles west of Montoya, U.S. 66 passes the vanished town of Newkirk, followed by another old hamlet, Cuervo ("raven" in Spanish). The town contains a string of weathered businesses and homes to the north of the old 66, with I-40 just to the south. A few miles past Cuervo, 66 ends again. The old route headed south from Cuervo for four miles, then made a 90-degree turn west, following the south side of the interstate. This portion of 66 was bypassed in 1937 after the alignment to the north was constructed. It continues into Santa Rosa, following the east–west runway of the Santa Rosa Airport. The route passes the Blue Hole, a deep pool carved out of rock, then makes a left turn at Park Lake and enters downtown Santa Rosa on Fourth Street. It then turns left and heads west on Will Rogers Drive, the four-lane post–1937 alignment.[139]

The post–1937 path of 66 resumes farther down the interstate at Exit 277 and follows the north side of the freeway as a four-lane, passing the Silver Moon Motel and the Silver Moon Restaurant. The café has been operating on the eastern outskirts of town since Elena Wills opened it in 1935.[140] The motel was built in the 1960s; its neon sign depicts a smiling crescent moon. The route is named Will Rogers Drive and passes first the Plains Motel and then the La Mesa Motel, one of Santa Rosa's oldest. It was built by the Massey family in 1946, and Avaristo Gallegos took over ownership in 1962. After running the motel for three decades, Gallegos sold it to his son Michael and his wife Colleen, who bought the motel after careers in the U.S. Navy. The Gallegos family is currently restoring the motel to its 1946 appearance, a project which requires considerable amounts of money.[141] The road descends toward town from a high hill, the Shawford Motel on the right, and passes under Interstate 40.

Santa Rosa is on the famous Pecos River, which flows south all the way to the Rio Grande in Texas. The river is mentioned in many a western tale and saw a lot of action during the pioneer days. The Spanish explorer Francisco de Coronado was the first European to visit New Mexico, and his army camped here for four days in the spring of 1541. Coronado's army built a log bridge across the Pecos

Cuervo, New Mexico. Looking west at Cuervo, 20 miles west of Montoya. Almost the entire community is captured by this photograph, which lies on the north side of Route 66. Interstate 40 is just to the left of this view.

River here before proceeding farther west.[142] A scene from John Ford's 1940 film *The Grapes of Wrath* shows the Joad family crossing a concrete bridge over the Pecos, with a Route 66 sign in the foreground. As usual, the bridge replaced later by a bland, more modern design. Before reaching the Pecos River and the old downtown section of Santa Rosa, four-lane U.S. 66 passes a modern business strip. The Sun n Sand Motel and Restaurant and the Sahara Motel and Sahara Lounge are on this section on the south of four-lane Route 66. The old Club Café is farther north of the highway, a Route 66 stop famous for its

Rio Pecos Truck Terminal, Santa Rosa. Route 66 enters the east side of Santa Rosa as a four-lane. Along the route is the abandoned Rio Pecos Truck Terminal and café, a sprawling facility that used to be crammed with big rigs. The building and this sign are still standing, with the jolly truck driver saying "Howdy" in broken neon.

home-made sourdough biscuits from 1935 until it closed its doors in 1995. First opened by Newt Epps, the business was sold to Phillip and Ruby Craig in 1939, who operated the Club Café for several decades. In 1973, the Craigs sold out to Ron Chavez, who added spicy Mexican dishes to the menu. Chavez' tasty recipes were a hit with customers for the 20+ years that he ran the restaurant. The café's gift shop once sold postcards commemorating the sale of its two millionth sourdough biscuit in addition to Route 66-related items.[143]

Down the road is the Comet Restaurant and Drive In, which began in 1950 as a tiny shack serving mainly hot dogs and soft drinks. In 1955, a drive-in called Mucho Burger was built, then it was purchased in 1961 by Johnny Martinez and renamed the Comet Drive-In. Martinez still works in the kitchen of the drive-in, while his wife Alice runs the always-busy restaurant. (Martinez and his father also ran the Club Café for a time.) Johnny recently refurbished the building but the drive-in's canopy still showcases its symbol, a speeding neon comet.[144] The road bypasses Santa Rosa's downtown business district, where Fourth Street followed the original route until the 1937 realignment. The old Coronado Court lies ahead on the south side, followed by the Rancho Lodge and the Pecos River Bridge (the site of the scene from the John Ford film). The road comes to an intersection (the Surf Motel lies ahead) and turns right, heading west out of town. The final stretch leaving Santa Rosa passes some fading remnants of old businesses and comes to an end at Interstate 40.

La Mesa Motel, Santa Rosa (1946). America's post-war prosperity encouraged thousands of Americans, including the Massey family of Santa Rosa, New Mexico, to enter the growing tourism industry. The Masseys built a small eight-unit motel on the east side of town called the La Mesa Motel and served legions of travelers on Route 66 until selling out to Evaristo Gallegos in 1962. Mr. Gallegos added nine more units in the 1960s and ran the motel until 1999, when he turned the business over to his son and daughter-in-law, Michael and Colleen Gallegos. The Gallegoses are in the process of an extensive renovation project and are restoring the motel's furnishings, carpeting, and neon to their original 1946 appearance.

(SEE COLOR SECTION C-22.) Club Café, Santa Rosa (1935). For years, the most well-known eatery in Santa Rosa was the Club Café, opened in 1935 by Newt Epps. The café's specialty was its sourdough biscuits, which were heavily advertised on billboards for miles outside of town. The Club Café closed in the mid-1990s, but its signs still advertise for the café as if it were open.

The next portion of Interstate 40 was built over Route 66, so travelers must follow the freeway for the next 16 miles. The original highway crossed a series of steep grades for the next several miles, climbing to an elevation of approximately one mile above sea level. One surviving remnant of the old road can be seen a few miles west of Santa Rosa, on the north side of the interstate. At Exit 256 for U.S. 84, a pre–1937 alignment spurs off of I-40 to the north. Before 1937, Route 66 took this route northwest to the city of Las Vegas, New Mexico, and through Santa Fe on its way to Albuquerque. This out-of-the-way route from Santa Rosa to Albuquerque is a 132-mile loop road through difficult mountainous areas, and highway planners built a straighter route between the two cities in 1937. The pre–1937 alignment heads northwest from I-40 on U.S. 84 and passes by the towns of Dilia and Tecolotito and through Los Montoyas and Charles River Ranch. Only Dilia is shown on older maps; the other three are

Comet Drive-In Restaurant and Café (1961). The Comet Drive-In began as a tiny shack, then expanded into a drive-in restaurant in 1955 called "Mucho Burger," and is now being remodeled by current owner Johnny Martinez. When Martinez and his wife Alice purchased the property in 1961, the name was changed to the Comet Drive-In. Despite the recent work on the canopy and main building and the passage of time, the Comet hasn't lost its *American Graffiti* atmosphere.

more recent settlements. However, the first route for U.S. 66 from Santa Rosa actually started near freeway Exit 273, west of Santa Rosa, and took a direct northwest heading to Dilia; this old road was never paved and has long since been abandoned.[145] Outside of Romeroville, a dirt road heads off to the right toward the remains of the town. The easier route continues north on U.S. 84 until it ends at I-25 at Exit 335. Just before I-25, the old asphalt section of 66 goes west and ends at a KOA campground, where it becomes a gravel road through private property. This road continues and begins a downgrade, sweeping to the right around a hill and crossing an old bridge near freeway Exit 339.

The pre–1937 Route 66 served the city of Las Vegas and can be driven by entering I-25 at Exit 335 and proceeding northeast. Since the old alignment here was replaced by the interstate, 66 starts as the first exit takes the motorist to the north of I-25 and into town. The original route entered the city as South Pacific Street, then turned right at Prince Street. Drivers can return to the pre–1937 route by heading back west on I-25. The interstate retraces U.S. 66 (formerly called the Las Vegas Highway) and makes a giant "S" on its way to Santa Fe. This portion of Route 66 was once part of the Santa Fe Trail, and the area is loaded with western myths and legends. Most of Highway 66 on this leg was replaced by I-25 and was a continuous downgrade through the Pecos River Canyon, which made this a treacherous stretch of road for travelers during the early years of the century. The scenery is

breathtaking as the route passes the Santa Fe National Forest.

The next chance to drive the old Route 66 occurs at interstate Exit 335 for the town of Tecolote, where a monument once marked the location of the Santa Fe Trail. The road is in poor condition as it winds through the small village, and it ends where the bridge over Tecolote Creek once stood. Today, only four concrete piers and the bridge's approaches remain. To continue west to Santa Fe, and to view more old pieces Route 66, the freeway frontage road on the north side of the freeway can be followed. The frontage road served as U.S. 84/U.S. 85 after it was improved when U.S. 66 was relocated in 1937, and first crosses Tecolote Creek on a bridge constructed in 1940. Down the road, the old 66 alignment crosses the frontage road and the interstate to the south, then re-crosses U.S. 84/85 after passing through a tunnel underneath I-25. The road makes a cut through a hill, with the old 66 off to the north, where another old bridge can be found by those with a sturdy vehicle or good hiking shoes. Finally, 66 re-crosses the highway and I-25 to the south just before Bernal, a small town south of the freeway. A mountain south of town called Starvation Peak derives its name from an incident that occurred in the 1800s, when early Spanish settlers died of hunger after being trapped on the mountaintop by Indians.[146]

Continuing west on U.S. 66 from Bernal, the road becomes gravel and takes a tunnel under I-25 to the north side of the freeway and back to the upgraded U.S. 84/85,

Dilia, New Mexico. Prior to 1937, the section of Route 66 between Santa Rosa and Albuquerque followed a route north through Las Vegas (New Mexico) and Santa Fe. The only real town between Santa Rosa and Las Vegas is Dilia, which lies on the west side of old U.S. 66, now designated as U.S. 84. This route was relocated to a new highway that took a more direct route between Santa Rosa and Albuquerque.

which still serves as a frontage road. Just before reaching the tunnel, the old route stays on the south side of the freeway and heads off to the left, running roughly parallel to I-25. The road is in bad repair, so the frontage road is the best alternative. It continues west over two cuts, after which the old 66 rejoins this alignment from the left. After passing the junction of NM 3 (which leads to I-25 and Exit 323 south) and an old winery, the road reaches a junction with a dirt road, then veers off to the left, crossing the road and re-crossing again, heading south and under I-25 to San Jose near Exit 319. Old 66 is not driveable at this location but can be picked up by proceeding west on the frontage road. After crossing the Pecos River, the old alignment is the first left turn and leads to San Jose. The old alignment goes under I-25 and over a wooden bridge with an asphalt deck, and into San Jose. The town is basically a post office with a scattering of homes, and the poorly maintained road leads to a dead end at a vintage steel truss bridge, circa 1921, beyond which the road disintegrates as it nears the interstate.[147]

Leaving San Jose, U.S. 84/85 continues west briefly but ends at Exit 320 for Sands. Just before the exit, Old 66 branches off to the left and crosses I-25, following the south side of the freeway. At Exit 307 travelers will find

the town of Rowe, then Pecos. The frontage road continues east and passes a historical marker for a major Civil War battle, just to the north of the road. A short distance east is a vacant building, next to the north side of the roadside. This is the site of the Pigeon Ranch, an old mail and stage stop established in 1879 when the railroad came through the area. During the Civil War, the ranch was owned by a Frenchman who allegedly spoke "pigeon" English, hence the name. The Pigeon Ranch became an early tourist attraction on Old 66, featuring the "Most Wonderful Old Indian Spanish American Well — Nearly 400 Years Old" to entice tourists. No one can precisely pinpoint the well's age, but Spanish explorer Francisco de Coronado is reputed to have stopped here in the early 1500s. Just behind the building is the foundation of the main building at Pigeon Ranch, with the old well just across the road, surrounded by a two-foot-high circular stone wall. Ahead is Exit 299, where the old road crosses I-25 as a shoulder road for the interstate. Both roads end at Glorietta, and only a short piece of Old 66 remains past the town, at Exit 297 as the interstate passes through Apache Canyon. Old 66 can be found again at Exit 294 for Canoncito, where it follows the Pecos and Santa Fe Trails as U.S. 84/85 into Santa Fe.[148]

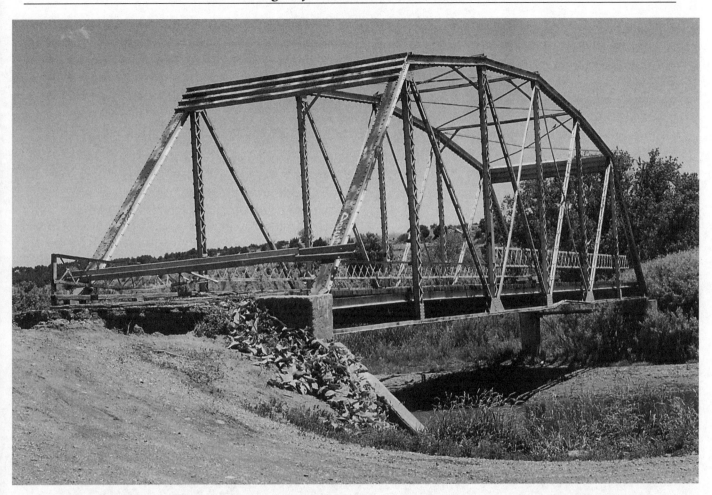

Truss Bridge at San Jose, New Mexico (1921). The route of U.S. 66 from Las Vegas to Santa Fe follows the old Santa Fe Trail, immortalized by pioneers and trailblazers such as Kit Carson. This bridge is closed to traffic and is on the east end of San Jose. It can be reached by exiting off I-25 at Exit 319.

Santa Fe is one of the oldest colonial settlements in the United States. Historic sites found there include the Palace of Governors on the original town plaza, the oldest house in America (circa 1200), the San Miguel Church, and the La Fonda Hotel, with its fine southwestern décor. The route through Santa Fe follows College Street and crosses the Rio Santa Fe to the old district. The route takes a left turn on Water Street, then left again at Galisteo. The road re-crosses the Rio Santa Fe, jogs one block to the right, then left onto Cerrillos as it heads south and leaves town. Approximately ten miles south of Santa Fe, Highway 66 abruptly ends at Interstate 25.

The final leg from Santa Fe to Albuquerque contains four bypassed sections of pre–1937 Route 66, two which are still driveable and two that are too rugged for ordinary motor vehicles. The first is a 1926–32 alignment between Exits 276 and 270, near the Santa Fe and Sandoval county lines. It lies to the west of I-25, and passes over the once-deadly La Bajada Hill. The road over La Bajada Hill climbs a steep grade, and a series of sharp switchbacks were the only way to safely get motorists past the summit.

In windy or inclement weather, La Bajada Hill could become a formidable obstacle. Farther down the interstate, a second piece of Old 66 is found on the east side of the freeway between Exits 276 and 267. A short, undriveable section of U.S. 66 is also found on the east side of the interstate between Exits 259 and 248. Another hard-to-find alignment can be reached via Exit 252. This vintage stretch of Highway 66, known as the "Big Cut," was carved through a large mountain and was another trouble spot for early motorists. The next opportunity to travel Route 66 is at Algodone (Exit 248), where the old road follows the west side of I-40 between the interstate and the Rio Grande. This ancient route has been used for centuries by Native Americans, Spanish explorers and westward migrants, and continues south to Albuquerque. Algodone is a welcome respite from the noisy interstate, and Old 66's path through town is a quiet tree-shaded lane. The Santo Domingo Trading Post was once located in Bernalillo, the last major settlement between here and the northern perimeter of Albuquerque. A man named Fred Thompson operated the trading post.

(SEE COLOR SECTION C-22.) Ruins of Pigeon Ranch (1879). A few miles east of Glorietta, New Mexico, are the ruins of the Pigeon Ranch, a mail and stagecoach stop along the Santa Fe Trail. The Pigeon Ranch became a tourist attraction and flourished for many years until the interstate came through. The building in this photo is the only structure remaining at the site (the crumbling foundation of the main building is to the right).

The pre–1937 alignment of Highway 66 enters the north side of Albuquerque as New Mexico State 556, then Fourth Street. The city route passes I-40, Los Lomas Boulevard and Central Avenue, the latter being the post–1937 alignment for City 66. The original route continues south on Fourth Street, but Fourth becomes a one-way heading in the opposite direction, so drivers must take Third Street. Third intersects with the old Bridge Boulevard, now named Cesar Chavez Boulevard, and Route 66 turns right (west) and crosses a bridge over the Rio Grande. The current bridge is of newer construction and replaced the original Barelas Bridge. The route turns south at Isleta Boulevard (also NM 314) to leave the city. U.S. 66 passes through the towns of Isleta and Los Lunas, while an even older alignment forms a loop road by crossing the Rio Grande (east) at the town of Isleta, then south through Peralta and back west over the Rio Grande to Los Lunas. From Los Lunas, the pre–1937 route proceeds west 33 miles on what is now called NM 6, back to I-40 and to Suwanee (once named Correo), west of Albuquerque. This final segment of the pre–1937 alignment has some

Old Well, Pigeon Ranch. Across the highway from the Pigeon Ranch is this old well, which dates to the mid–1700s, although no one is certain of its actual date of origin. The well was a part of the Pigeon Ranch and once had a canopy above it. This old landmark is hidden behind some trees and lies on the south side of the Santa Fe Trail.

(SEE COLOR SECTION C-24.) Pre-1937 Route 66, east of Los Lunas, New Mexico. A second pre–1937 loop road heads south from Albuquerque to Los Lunas and continues west to rejoin the post–1937 alignment and I-40. This view is looking west near the Rio Puerco approximately ten miles west of Los Lunas.

very old sections of U.S. 66, which can be spotted on either side of the road.[149]

The more direct post–1937 U.S. 66 between Santa Rosa and Albuquerque is preferable for travelers in a hurry. The "Santa Rosa Cut-Off" (as it was called by early travelers) was started in late 1936 after Governor A. T. Hannett lost a bid for re-election against Richard Dillon. Angered at the losing the election, Hannett ordered district highway engineer E. B. Bail to move all of the state's road-building equipment north of U.S. 60 (an east–west transcontinental highway bisecting the state) to build a new highway directly from Santa Rosa to Albuquerque, bypassing the Santa Fe loop of U.S. 66, before the new governor could take office. Naturally, the governor claimed that politics had nothing to do with his decision, and that he chose the route to provide a more direct path across the state to boost tourism. Despite bitter opposition from towns and businesses on Route 66, the work proceeded, aided by an assortment of war surplus caterpillars, tractors and graders, through rough terrain and snowstorms. It was a project of monumental proportions, as Hannett had only 31 days to complete the 69-mile road before Governor-elect Dillon could be sworn in. Irate citizens living along U.S. 66 and U.S. 60 (the latter also believed that the new highway would siphon off traffic) sabotaged equipment by putting sugar in gas tanks and sand in the engines. The construction crew was given blankets so that they could sleep near their equipment. Despite the odds, the work continued through the end of 1936. Governor Dillon took over on January 1, 1937, and immediately sent an engineer to the construction site, but he arrived too late to stop the project. "Hannett's Joke" had just been finished and eager motorists were already using the new route.[150]

The interstate between Santa Rosa and Albuquerque

wiped out much of the Santa Rosa Cut-off, but a few old pieces can still be found off the freeway. West of Santa Rosa, the highway climbs a series of steep hills to an elevation of approximately one mile. The weather in this part of northeastern New Mexico, particularly during the winter months, can catch travelers off guard, with sudden blizzards often stranding unwary motorists. Very few services exist on the 50 miles between Santa Rosa and Cline Corners. Strategically located at the junction of U.S. 66 and U.S. 285, Cline's Corners (named for its founder, Ray Cline) began in 1934 as a way station for tired, thirsty travelers, with a gas station and café.[151] Today, it's a giant Shell service station, store and gift shop, selling an endless assortment of trinkets and curios. Old highway maps don't even show Cline's Corners, but a tiny "town" named Palma with population of 20 (now just a gas station, like Cline's Corners) is found on some maps and was once located eight miles east of Ray Cline's establishment.[152]

After Cline's Corners, the road climbs to an elevation of almost 7,000 feet, then makes a steady 20-mile descent. At Exit 203 rests a Route 66 relic: the remnants of the Longhorn Ranch Café. The Longhorn Ranch Café was one of many Route 66 success stories, beginning as a small café and gradually expanding into a major tourist attraction. In the 1940s, the Longhorn added a Western museum and later a hotel and restaurant.[153] Unfortunately, the Longhorn Ranch met the same fate as many mom-and-pop businesses, which closed after the completion of interstate freeways. Also found at Exit 203 is the first city after Santa Rosa, Moriarty, named for a man who emigrated from Indianapolis to start a ranch nearby. Locating the old portions of Route 66 is not easy, but a few isolated alignments can be seen as visitors pass through withered towns such as Buford, Edgewood, Barton, and Tijeras. The road winds downhill after the town of Tijeras and through a canyon of the same name, another tough route for travelers of yesteryear. Finally, the road comes to flatter terrain as it heads into Albuquerque.

Route 66 enters the east side of Albuquerque as Central Avenue, the city's main thoroughfare, bisecting the city and continuing west toward Arizona. Albuquerque is located on the east bank of the Rio Grande, and has an old town square near the river where the original settlement started. Central Avenue is a busy four-lane street crammed with businesses. The route passes the First Security Bank (formerly the First National Bank of Albuquerque), the city's tallest building for decades until several new skyscrapers were built downtown. The city is a chock-full of delightful streamline moderne, art deco and southwestern architecture, and an excellent assortment of motels and an occasional tourist court can still be found on Central Avenue, some dating to the 1930s. During the peak years of the 1950s, Albuquerque's Central Avenue

had 98 tourist courts and motels. Today, some 40 vintage motels built before 1955 have survived. The names of some vanished establishments along eastern Central Avenue include the Lo-La-Mi, the El Dorado, Rodeo Court, El Rey, and the Coronado.[154] The Aztec Motel (1931), the oldest in the city, and Zia Motor Lodge (1940) are still on Central, as well as the Nob Hill Motel (1937), formerly the Modern Auto Court, and the De Anza Motor Lodge (1939).[155] The cylindrical tower of the art deco Hiland movie theater (1950) has made it through to modern times, as has Lindy's Coffee Shop at 500 Central Avenue S. W., open continuously since 1929.[156] Lindy's is in downtown Albuquerque, and its exterior facade now has a modern look to blend in with the surrounding neighborhood. Central Avenue was also the site of the famous Iceberg Café and Gas station, now gone, which was across the street from the Tewa Motor Lodge, a few hundred yards west of the intersection with San Mateo. The station was made of wood and metal covered with plaster, in the shape of a large iceberg. Unfortunately, this amusing old landmark was removed, and sat near Bernalillo for many years before finally being destroyed.[157] Air conditioning was relatively new and reserved for the wealthy even in the 1950s, and motorists probably felt a few degrees cooler when passing the Iceberg Café and Gas station.

Continuing west on Central, the pre–1937 alignment joins the route from the north at Fourth Street. The older alignment continued south as Fourth Street past Central

Avenue as mentioned, while the newer route continued west on Central to cross the Rio Grande. Most of the tourist courts that once lined this route have been either torn down or renovated, including the Beach Court, the Pueblo Bonito, the Tower Court, and the Will Rogers. Some have changed names, such as the Safari Lodge (formerly the White Way Court, 1946) and the Prince Motel (Country Club Court, 1937).[158] A few, such as the Monterrey and El Vado motels, have survived unaltered, although the motel district in central Albuquerque is now pretty run down and many motels and courts rent by the week for transients. The El Vado Motel—a picture-perfect example of the pueblo revival style—was opened as the El Vado Court by Patrick O'Neal in 1936. The motel has garages between units, and the property has changed little since the late 30s, its bathroom and shower floors retaining their original tiling.[159]

The post–1937 route crosses the Rio Grande on the Old Town Bridge and heads towards the western outskirts of town, up a gradual incline that old timers dubbed "Nine Mile Hill" and past the area where western Albuquerque's original motel row once flourished. Gone now are the Stop In, the Rainbow, the Blue Bell, the California, the Sky Court, El Rancho, the Alamo, the Royal, the Mile-Hi, the Sundown Trailer Park, and others.[160] The old El Campo Tourist Court (1939) and the 66 Court (1940) are now rented apartments, and are currently named the Sena Village Apartments and Gerald's Apartments, respectively.[161] A few old motels and businesses still line

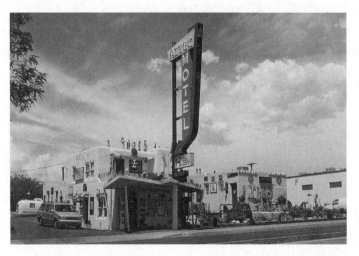 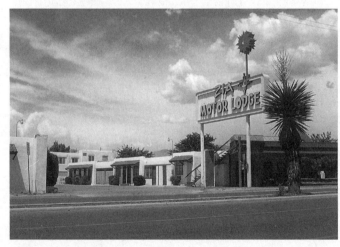

Left: (SEE COLOR SECTION C-23.) Aztec Motel, Albuquerque (1931). The largest collection of classic pre- and post-war motels on Route 66 is on Albuquerque's Central Avenue, which became the city's main business thoroughfare after the completion of the "Santa Rosa Cut-off" in 1937. Among those still operating is the Aztec Motel, now a national historic site, currently owned by the Mohammed Natha family, who purchased the motel in 1991. Under the Nathas' ownership, the motel's exterior has been decorated with an eye-catching collection of Indian statuary, sand paintings, windmills, and memorabilia, and it has survived despite competition from the newer motels on Interstate 40. *Right:* (SEE COLOR SECTION C-23) Zia Motor Lodge. (1940). East of the Aztec Motel on Central Avenue is the Zia Motor Lodge, in Albuquerque's Nob Hill district, where an outstanding collection of classic motels still exist, some in bad shape, others looking quite new. The Zia Motor Lodge is styled in the Southwest vernacular architectural design. Other examples of this period architecture can be found along Central Avenue, including the Nob Hill Motel (1937) and the El Camino Motor Hotel on the pre–1937 U.S. 66 north of downtown Albuquerque.

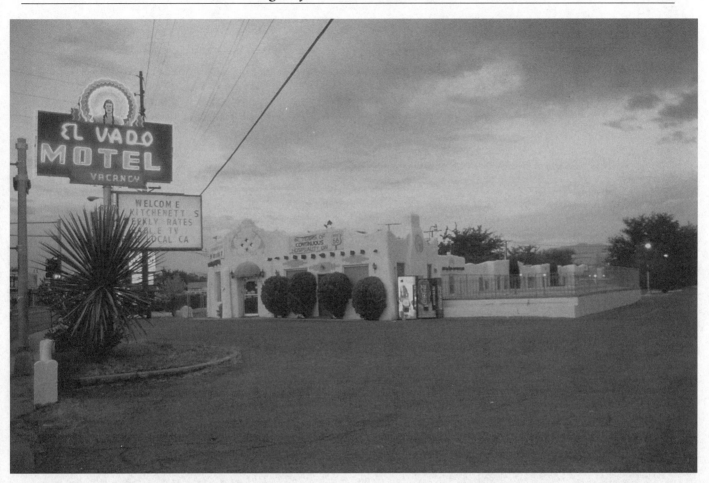

El Vado Motel, Albuquerque (1936). The El Vado Motel is one of the last motel/courts of the pueblo revival style, once a common site across the American West. Originally the El Vado Court, the motel was opened in 1936 by Patrick O' Neill and is east of the Rio Grande, near where the city was founded in 1706. The El Vado has 32 units with their original interior, right down to the vintage tile bathrooms. The motel is currently owned by Shiraz "Sam" Kassam, who has been instrumental in keeping the spirit of Route 66 alive in the Albuquerque area.

West Central Avenue, including the Rainbow Inn Apartments, an old sign for the Super 6 Motel on the south shoulder, the Cipola Motel, the Hill Top Lodge (its neon sign shows a snow-capped mountain and reads "air-conditioned"), the Western View Steakhouse, and Mack's Sierra Coffee Shop (with a steer in neon). Many of these old buildings have the same white-washed look and southwestern architectural style as the El Vado Motel. The Hubbele Motel once stood on the southeastern corner of Central and Coors, but all that remains is its turquoise-colored sign. The Westward Ho Motel is nearby as the highway begins its climb up Nine Mile Hill. On the right is the French Quarter Motel, and across the street is the Grandview Motel. One of the most important landmarks in Albuquerque was on the western edge of town on the northeast corner of West Central Avenue and 98th Street N.E. Here there was a genuine "Last Chance Gas Station" (circa 1936), passed by countless travelers on their way west from Albuquerque as they prepared to cross the arid region ahead. The old station was converted into a video rental store and was just recently demolished, another loss for Route 66 history.[162]

The route makes the long climb up Nine Mile Hill and eventually meets up with I-40 west of town. The old alignment has been replaced by Interstate 40 for the next 40 miles. A short piece of old 66 can be seen running along the north shoulder of I-40, approximately ten miles west of Albuquerque where an old steel truss bridge crosses the Rio Puerco. The bridge can be investigated by leaving I-40 at the nearest exit, near a modern-day filling station. This rare one-lane bridge lacks a date plaque, but was probably built in the late 1930s, after this segment bypassed the southern pre–1937 loop through Los Lunas. After reaching the crest of Nine-Mile Hill, I-40 passes Exit 126, where the pre–1937 alignment (NM 6) meets the interstate. However, a mile or so before this junction is another small section of U.S. 66 where a settlement named Correo (Spanish for "mail") once stood. A railroad crossed 66, and two businesses and a post office once stood beside the tracks.[163]

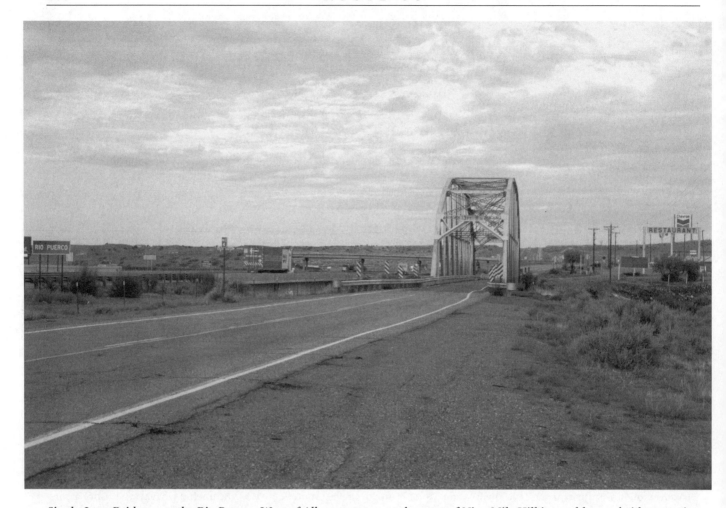

Single-Lane Bridge over the Rio Puerco. West of Albuquerque past the crest of Nine Mile Hill is an old truss bridge crossing the Rio Puerco. The bridge is north of Interstate 40 at Exit 140 near a service station on the north side of the freeway. Approximately 12 miles west is the site of Suwanee (formerly Correo Post Office), where the pre–1937 alignment joins the later route of U.S. 66.

(SEE COLOR SECTION C-24.) Church at Laguna Pueblo (1800). Northwestern New Mexico is a major center for Native American history and culture, with four reservations in the vicinity. The Laguna Pueblo sits on a high hill with this 200-year-old church at the summit, the last such structure built after the Spanish came to the southwestern United States. The more recent settlement of Laguna is one mile east of this location.

The next opportunity to find Route 66 comes at Laguna, some 13 miles down the interstate. The highway here is four-lanes but deserted. The road heading east back toward Albuquerque crosses a number of small washes and dead-ends at the interstate. After doubling back, the road reaches Laguna, just north of the highway, with the town of Old Laguna a short distance to the west. Laguna is a more recent settlement, so the town does not appear on highway maps from the '30s. Old Laguna is the site of the Laguna Pueblo, the last pueblo built by the Spanish in America, which includes a church constructed about 1800. A store and gas station lie on Old 66 at the turnoff for Old Laguna, where a loop road proceeds left at the station and up a hill. After turning at the station, the route takes the first right turn at a sign reading "Road Closed to Thru Traffic." At the crest of the hill visitors will find the Laguna Pueblo and a sparkling-white church surrounded by a stone wall. The 200-year-old landmark is the only church on Highway 66 which dates to the era of Spanish influence in the southwest, and has been

visited by countless tourists during the life of the great road.

A gas station/town named New Laguna, mentioned in Rittenhouse's guide, once stood three miles to the west, but no evidence of this settlement exists today.[164] The red cliffs of an ancient river valley, carved by the Rio San Jose many millennia ago, flank the highway for miles. The Acoma Pueblo (called the "Sky City" by the ancients), located approximately ten miles south, is the oldest pueblo in North America to be continuously inhabited.[165] Several miles past Laguna is Budville, too small to be on most road maps. Nothing is left of Budville on the highway except for an old gas station, with signs reading "Budville Trading Company." No fuel is for sale, however, as only a single gravity-style gas pump dating to the 1920s sits out front. The business used to be a Phillips 66 station and was first opened in 1928 by H. N. Rice.[166]

Shortly after Budville comes Cubero—just a few buildings, most looking abandoned, straddling the old road. The only real sign of life in town is the Villa de Cubero Trading Post, mentioned by Rittenhouse as a "good café and tourist court."[167] This oasis in the midst of stark, arid western New Mexico began in the late 1930s when Route 66 was completed through the area. A cou-

ple named Wallace and Mary Gunn owned an authentic trading post, bartering supplies with nearby Acoma and Laguna Indians for everything from cattle, sheep, and wool, to pottery and other Indian curios. Like so many people living near the new federal-aid highways in the 1920s and '30s, the Gunns sensed an opportunity to substantially increase their income, so they relocated their business to its present location soon after 66 was completed. The Gunns built a Spanish-styled main building for a new trading post and added a ten-unit tourist court for overnight guests. On July 4, 1937, Sidney Gottlieb and the Gunns officially opened the Villa de Cubero Trading Post. Almost overnight, the Gunn's store and tourist court were doing a thriving business, with no shortage of customers. The motel portion of their business only accommodated ten patrons a night and some unfortunate travelers were turned away, so they cleared an area for a trailer park some years later. The Gunns lived just across the highway, and as business continued to improve, they added a café to the main building. The café was operated by Sidney Gottlieb's sister Lily until 1939, when E. Lee Francis and his wife took over. In 1941, Mary Gunn, an accomplished cook known for her excellent homemade pies, stepped in and ran the café until the 1970s, when Kurt

Budville Trading Company, Budville (1928). West of the Laguna Pueblo is tiny Budville, named after N. H. "Bud" Rice, who opened a Phillips 66 station and trading post here in 1928. The settlement is not on most highway maps, including the official AAA roadmaps of the 1930s. Bud Rice's original business still fronts on the old highway, and a few scattered homes remain to mark the location of this vanished community.

Villa de Cubero Trading Post, Cubero (1937). When Route 66 was hard-surfaced in the 1930s, Wallace and Mary Gunn operated an authentic Indian trading post a short distance off the new highway. The Gunns relocated the business to its present location to take advantage of the burgeoning traffic on U.S. 66 and, with Sidney Gottlieb, opened the Villa de Cubero Trading Post on the Fourth of July, 1937. The business included a ten-unit tourist court along with a new trading post, while the Gunns lived just across the highway. In the 1940s, this isolated area was used for the filming of several movies and became a hang-out for artists and other eccentric types passing through the area, among them writer Ernest Hemingway, who stayed here for several weeks while he was writing *The Old Man and the Sea*. The Villa de Cubero is currently owned by Keith Gottlieb, son of co-founder Sidney Gottlieb.

and Hans Gottlieb and E. Lee Francis purchased the property. During the 1940s, Hollywood directors called on Cubero, filming several movies there, including *Sundown* starring Gene Tierney and Bruce Cabot. Since the Villa de Cubero was the only place between Albuquerque and Grants to eat or spend the night, it became a popular hang-out, attracting celebrities such as Desi and Lucy Arnaz, Vivian Vance (who lived nearby for a time), Sylvia Sidney, and the Von Trapp family. Artists, poets and writers stayed here also, including Ernest Hemingway, who lodged here for several weeks while writing *The Old Man and the Sea*. The Gottliebs' son Keith now owns the business, although only a Conoco station still operates at the site. Hemingway would still find this a serene setting to reflect on life, amid the timeless scenery of New Mexico.[168]

A short distance west of Cubero are the remains of the Mount Taylor Hotel, named for a mountain considered sacred to Native Americans that is visible to the north of town.[169] Highway 66 (marked as NM 124) remains

north of the interstate and next comes to San Fidel. A vacant café is followed by the White Arrow Garage, a bit cluttered but still open. Farther west is an old Whiting Brothers gas station — part of a chain of filling stations in the southwest that is no longer in business. The road crosses to the south side of I-40, then comes to a small truss bridge constructed in 1936, when the highway had just been paved through this area. This is the location of McCathys, a town not mentioned in Rittenhouse's travels, although he does document a small settlement named Santa Maria in this vicinity.[170] The road re-crosses the interstate and continues on the north side of I-40, following the Rio San Jose and entering Grants as a four-lane.

Grants has quite a few motels for a town of its size, including the Leisure Lodge, the Franciscan Lodge ("Your Home on the Road"), the Desert Sun, the Sands, the Western Star, the Western Host, and the Zia. The route passes the marquee of the West Theater and the closed Roarin' 20s Bar and Steakhouse. The best place to eat in Grants is the Uranium Café, in business since 1956 and offering

Café, San Fidel, New Mexico. West of Cubero is the dusty town of San Fidel, a group of buildings abutting the old highway. San Fidel's café and other businesses are shuttered today, closed years ago. Across the highway is the old White Arrow Garage, still open.

a superb, reasonably-priced menu. The café was named for uranium deposits discovered 20 miles from town, which were of strategic importance to the United States for both its atomic energy and weapons programs. Johnny Callahan has owned the café since 1997 and has continued this Route 66 tradition. The Uranium has seen numerous owners, but its original sign still hangs out front. The neon for the "café" lettering on the building and the sign are not currently operating. When lit, a neon "magic wand" moves sideways at the top of the sign. Grants had a population of over 35,000 during the peak years of uranium mining and exploration in the 1950s, with at least 35 restaurants and cafés. The federal government closed the mines in 1983 and many of the town's businesses closed. Many residents left Grants, but the town has managed to survive.[171]

U.S. 66 continues west along the north side of the interstate. Approximately three miles past Grants is Milan, a town that post-dates the early years of Route 66. Just north of the freeway is a wooden building, where they have been selling hub caps for several decades. The place is easy to spot, as the building is covered with dozens of shiny chrome discs. The route passes Bluewater and Blue-

water Lake, just south of the highway. This area has some of the finest scenery on Highway 66, and shares the east–west route with Interstate 40, the old Atchison, Topeka and Santa Fe Railroad, and an ancient river valley formed by the Rio San Jose. To the north, miles of spectacular sandstone cliffs follow the highway for miles, glowing a deep red at dawn and dusk. Between Albuquerque and here there are four Indian reservations: Islet, Canoncito, Laguna, and Acoma. During the early decades of the century, Native Americans sold jewelry, pottery, and artifacts, some genuine, some not, to auto tourists in this vicinity. The road is designated as New Mexico State 122 and goes through Milan, Anaconda, Prewitt and Thoreau, all small settlements. Only Thoreau is shown on the old road maps. Herman's Garage is one of the few original businesses left.

U.S. 66 continues northwest, passing a vast lava flow south of the highway that was formed only 1,000 to 2,000 years ago. This region is at a high elevation, with Lookout Mountain (elevation 8,110 feet) ten miles to the south and the road crossing over the North American Continental Divide just west of Thoreau. Between Prewitt and Exit 36 is another original alignment of U.S. 66, to the

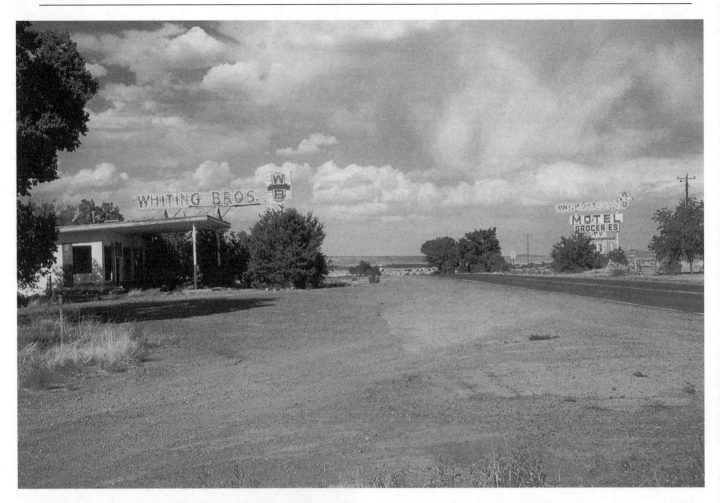

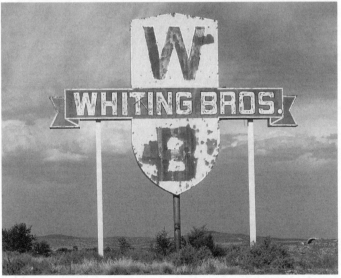

Whiting Brothers Station, and sign (SEE COLOR SECTION C-25). West of San Fidel is an abandoned Whiting Brothers station. The chain of discount gas stations was started by four brothers in St. John, Arizona in 1926, who then added more locations along Route 66 and elsewhere, using a standard red and yellow color scheme for its stations and billboards. Whiting Brothers went out of business some years ago, but a few vacant stations are still visible along Old Route 66.

north of the paved highway. The old roadbed lies near the railroad tracks and can be seen coursing over several old culverts. After Thoreau, the road ends at I-40 but resumes a few miles later. Exit 47 is on the Continental Divide, and an abandoned piece of the old road runs parallel along the north side of the interstate just off the exit. The Continental Divide Trading Post still stands, and of area busi-

nesses has the most history, dating prior to the Second World War. The Great Divide Trading Company and the Top O' the World Hotel and Café once existed here, but are gone now.[172] Across the road is a wooden historical marker erected by the state of New Mexico, providing a brief history of the area and a roadmap (still showing Route 66!). Immediately east of the Continental Divide Trading Post are two other tourist stores, the Indian Village and Indian Market. This once-busy location is quiet now, and the old road ends to the east. To the west of the trading posts are several abandoned businesses, and the road ends here as well. A dead motel, a closed Whiting Brothers station, and a few vacant buildings make up this modern-day ghost town.

To continue on Route 66, drivers must take the interstate west for several miles. The old road appears again

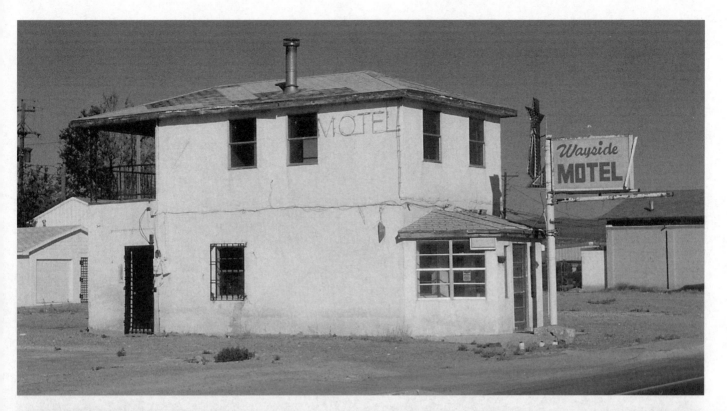

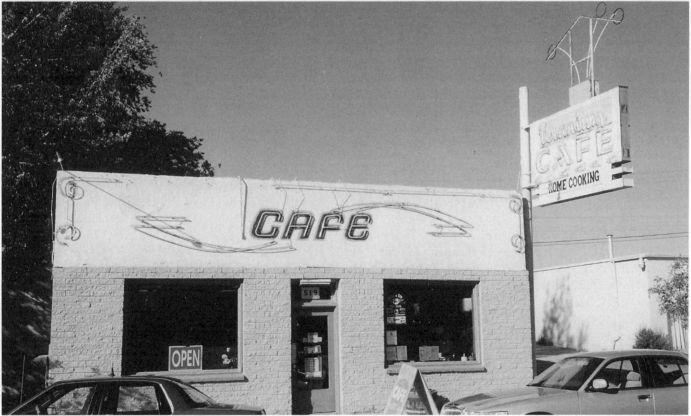

Top: Wayside Motel, Grants, New Mexico. Route 66 passes through the town of Grants, which had a population of over 35,000 during the 1950s. Route 66 is a divided four-lane highway through this vicinity, following I-40 to the north. A few old motels still cling to life on the old road, but others, such as the Wayside Motel, are now closed. *Bottom:* Uranium Café, Grants (1956). One of 66's most enduring eating places is the Uranium Café, named for uranium deposits 20 miles from Grants, New Mexico. The café was built by the Thigpens for the Woo family, who owned it for 10 years, after which it went through a succession of owners before being purchased by Johnny Callahan in 1997. The Uranium Café appears much the same as when it first opened nearly 50 years ago.

Continental Divide Trading Post. The Continental Divide was a popular tourist stop on U.S. 66. The Continental Divide Trading Post was built prior to World War II and is one of several businesses that have existed at this location over the years. Just to the east are two newer "trading posts" and a New Mexico historical marker with a map of the area. The Continental Divide Trading Post is just off freeway Exit 47 along the north side of Interstate 40; it closed in 2001.

on the north side of the freeway. This final section continues northwest toward Gallup, passing an occasional shuttered business. Route 66 can be accessed by taking Exit 33 and following it along the north side of I-40 past Red Rock State Park, where it crosses the interstate to the south at Exit 26. The route continues west as a four-lane highway, running parallel to the Atchison, Topeka and Santa Fe railroad. The highway through western New Mexico and eastern Arizona follows a centuries-old route used by southwestern Indian tribes. This corridor is still a major east–west thoroughfare, as evidenced by the numerous trains that roar past Gallup every few minutes, and the road was originally named Railroad Avenue. The route first passes through East Gallup, a city of recent origin that has grown up along Gallup's original motel row. On the south side of the highway are both the 1950s-inspired Roadrunner Motel and Earl's restaurant, with its modern postwar architecture, in business since 1947. To the west is the Avalon Restaurant, opened in 1945, originally owned by a Greek family who named the restaurant after an island off the coast of Greece.[173] Old 66 runs along First Street just a block south of four-lane 66 and passes through the old part of town. The road takes Coal Street west and rejoins the newer four-lane 66 farther west. Several historic landmarks are on Coal Street, such as the circa–1920s El Morro Theater, an ornate movie house with a terra cotta facade of towering finials and lively coloration. The White Café (1938) is on the long list of closed Route 66 businesses.[174] Several blocks away is Jerry's Mexican-American Restaurant and the Paramount Café; Coal Street then merges into four-lane Route 66.

The later alignment of Route 66 just north of Coal Street should not be missed, since it dates to the late 1930s and has a few spots of historical interest. At the junction of U.S. 66 and U.S. 666 is the El Rancho Hotel and Motel, opened in 1937 by the brother of film mogul D. W. Griffith. Now owned by Armand Ortega (who also owns several stores selling native crafts farther west down the highway), the El Rancho is a showpiece of southwestern architecture. A number of Hollywood movies were filmed in the Gallup area during the 1930s and 1940s, so movie stars and other notables naturally stayed at the luxurious El Rancho. The lobby of the hotel is an eclectic mix of native art and furnishings, and has been preserved in its original form. Gallup has been a center for Native American arts and crafts in the Southwest since the turn of the century, and the city holds an annual art festival where people from all over the United States gather to buy and

Left: (SEE COLOR SECTION C-25.) El Rancho Hotel and Motel, Gallup, New Mexico (1937). Built by the brother of movie mogul D. W. Griffith, the sumptuous El Rancho Hotel has been a favorite watering hole for Hollywood celebrities and others since it opened on December 17, 1937. The El Rancho is now owned by Armand Ortega, who has kept the premises in period condition. *Right:* (SEE COLOR SECTION C-26.) Avalon Restaurant, Gallup (1945). To the first-time visitor, Gallup appears to be little more than a six-mile strip of stations, motels and restaurants, with Route 66 as the town's backbone. The Avalon Restaurant, opened by a Greek family, was first called the Island Paradise. The Avalon Restaurant is currently owned by George and Sau Fong.

sell locally-made handicrafts. The Zuni Reservation is south of Gallup, while the Navajo Reservation is to the north, across the border in northeastern Arizona. Numerous wholesale and retail outlets line U.S. 66 as it leaves the city, passing a seemingly-endless strip of contemporary highway-related businesses. On the very outskirts of Gallup are the last outposts of civilization, Bergie's Mexican-American Food and the vacant El Hopi Motel.

After leaving Gallup, the road passes under I-40 and continues on its relentless journey west. Just past the interstate is a small sign for the town of Mentmore, a right turn off the main road. The highway passes through Mentmore, Dilco, Defiance, and Manuelito, towns that are mere shadows of their former selves. According to a roadside historical marker, this route was used by Coronado's expedition as he searched for the mythical "Seven Cities of Cibola."[175] At Manuelito, Route 66 is in excellent condition, with Devil's Cliff towering above the highway on the north side. At one time, ads were painted on the rock cliffs. A few miles later, U.S. 66, the rail line and the Rio Puerco pass under I-40, but the road trails off into the desert and ends. A newer road stays on the north side of the interstate and ends at Exit 357, the first exit for I-40 in Arizona.

The border of New Mexico and Arizona is an important point on the route, with some historical significance of its own. During the Great Depression, many states, including Arizona, set up border checkpoints on main highways to prevent insect-contaminated fruit and vegetables from entering the state. The Joad family received some rather rude treatment from Arizona border inspectors when they reached this location in *The Grapes of Wrath*. A more recent movie entitled *Hallelujah Trail* was also filmed here. In the 1930s, a giant arch-

way was erected over the highway inscribed with the words "You Are Now Leaving New Mexico—Come Again," with a Route 66 shield at the top. The archway was taken down decades ago, though the sign's cement footings remained for a time. The town of Lupton is west of this location, inside the Arizona border.

Back in the '30s and '40s, a small settlement called State Line was located on the border, where today there stands a cluster of souvenir dealers selling more native crafts. As U.S. 66 approaches the Arizona border and I-40, a series of billboards appear for the Yellowhorse Trading Post, advertising itself as the oldest on Route 66. The Yellowhorse family has been selling Native American

(SEE COLOR SECTION C-26.) Devil's Cliff, Manuelito, New Mexico. The final leg of Route 66 in the state of New Mexico passes rugged scenery as the road approaches the Arizona border. This view is south of Manuelito, with Devil's Cliff on the right. Years ago, advertisements were painted on the cliffs. In the distance, 66 ends at Interstate 40 at the Arizona state line near the town of Lupton.

jewelry in this vicinity for over 60 years. They opened their first store 15 miles west of the Arizona–New Mexico border; later, a new location at the state line was opened in a building shaped like a giant teepee. An arsonist burned the teepee, but this did not deter the Yellowhorse clan, who built another structure near a cave in the red sandstone hillside. The construction of I-40 necessitated another relocation in 1970, this time to its current site approximately 300 yards inside the Arizona border. Today, the business is run by the original founders' three sons, John, Frank and Shush Yellowhorse (a fourth brother, Juan, passed away recently).[176] The Yellowhorse store is the westernmost structure in a row of souvenir shops. The old highway is interrupted by the interstate, so the freeway must be taken to continue across the border to Arizona.

Route 66 continues on the south side of I-40 until it is cut off by the highway at Allentown. Billboards for tourist traps appear, as does the wooden stockade of "Fort Courage." This attraction opened in the late 1960s and capitalized on the popular 1960s television series "F Troop." Today, references to the TV show are absent, possibly due to copyright considerations. In 1857, Lieutenant Edward Fitzgerald Beale led a caravan of camels through here, charting a route roughly following the 35th parallel for approximately 130 miles. Beale believed that imported camels might be an ideal means of crossing America's vast western expanse. Beale's party endured excruciating hardships during their journey. This route was used by the Santa Fe Railroad when train travel eventually came to the Southwest. From 1857 to 1882, this route was called the Beale Wagon Road; it was designated the National Old Trails Road with the advent of auto touring, and finally U.S. Route 66.[177]

Proceeding west into Arizona on the interstate, the freeway replaces Route 66 for a few miles, passing Allentown. The first piece of Highway 66 is found north of the freeway beginning at Exit 348 for Houck. Rittenhouse

Souvenir stores, New Mexico–Arizona border. Lupton, Arizona, has been the focal point of tourist activity since Route 66 was paved through here in the early 1930s. This was the location of the famous archway that spanned the highway at the border, and where the Joad family was forced to stop in *The Grapes of Wrath* by border inspectors looking for produce infected with insects and plant diseases. Today, a group of stores selling Native American curios and artifacts crowd the border, and 66 disappears as it crosses the Arizona state line into the Navajo Indian Nation.

(See color section C-27.) Chief Yellowhorse Trading Post, Lupton, AZ. The best-known of the souvenir shops at the New Mexico–Arizona border has been owned by the Yellowhorse family for over three decades. The location has changed several times over the years; the current building is 20 years old and portions of the structure are made of discarded railroad ties. The Yellowhorse is jointly owned by John, Frank and Shush Yellowhorse and is just off I-40 Exit 357.

mentions that a curio shop and the White Mountain Trading Post were located in Houck, followed by the Querino Trading Post, Tipton Brothers' Store and two gas stations in Sanders, and Riggs Café and two more filling stations in Chambers.[178] The highway ends, but it resumes on the south side of I-40, passing through Navajo (another ghost town), then back on the north side again. The route enters the Painted Desert at the Dead River and arrives at the entrance to the Petrified Forest National Monument. This region has long been a favorite stopping place for tourists, to both rest and take pictures of the colorful desert scenery and fossilized remains of an ancient forest. The Painted Desert Inn was once located several miles northwest of here. The Inn was a popular at-

traction, even before World War II; it had a ranger station, museum, and trading post, and an excellent vantage point to view the Painted Desert. A road to the southern section of the park was built in the late 1920s and is a worthwhile detour.

Leaving the Painted Desert, Route 66 follows the north side of I-40 for several miles, crosses I-40 to the south, then re-crosses the freeway to the north. The road is interrupted by I-40 east of Holbrook, and Exit 286 takes the old 66 into town as Hopi Boulevard (Business Loop 40). The modern motel-fast-food–gas station strip comes up first, followed by the older businesses. The route through downtown Holbrook is divided into east and westbound lanes separated by a city block. Holbrook once had nine auto courts, among them the Navajo, the El Moderno, the El Sereno, the El Patio, and the El Rancho. The Green Lantern Café was once located where U.S. 66 turns right (west) in the center of town. The Green Lantern was recommended by Rittenhouse back in 1946, and was marked on old AAA maps dating from the 1930s.[179] Holbrook's oldest café, Joe and Aggie's Café (1943), still operates on the eastbound alignment of 66. The café was opened in 1943 by Joe and Aggie Montano, who sold the business to their daughter Alice and her husband, Stanley Gallegos, in 1978. In 1998, the Gallegos sold their interest in the business to their children, Kimberly and Troy Gallegos. Today, Joe, Aggie and Alice are still involved in running the restaurant. They have kept the family tradition alive, even though I-40 siphoned off business after Holbrook was bypassed in 1977.[180] The road leaves Holbrook and continues west, but soon comes to a deadend. On the way out of town, however, is one of the most famous attractions remaining on the Mother Road: Wigwam Village #6.

The Wigwam Village is a survivor of a chain of motels dating to the 1930s that were archetypical examples of classic American roadside architecture. The Wigwam Village's individual units are made of cement and are designed to resemble Indian teepees. The motel is one of seven that were built in the southern and southwestern United States between the 1930s and the 1950s. The Wigwam Village originated with Frank Redford, who designed and built the first two Wigwam Villages at Horse Cave and Cave City, both in Kentucky. Today, only two other original motels remain: Wigwam Village #2 at Cave City, Kentucky and #7 in Rialto, California, also on U.S. 66. Holbrook's Wigwam Village was built in 1950 by Chester E. Lewis after visiting Wigwam #2 in Cave City, Kentucky. The Wigwam's 19 teepees were booked solid for several decades, until the interstate killed business and it closed in 1974. Chester Lewis passed away in 1986 and the Wigwam appeared headed for destruction, but three of Lewis' children renovated the premises in 1988 and

Top: Pow Wow Trading Post, Holbrook, Arizona (1952). The Pow Wow has been operating as a trading post along Route 66 since the early '50s. *Bottom:* Joe and Aggie's Café, Holbrook (1943). Mentioned in Rittenhouse's 1946 guide book, Joe and Aggie's is still open in downtown Holbrook, Arizona, serving American and Mexican-American food. The business is in its third generation of ownership and is run by Kimberly and brother Troy Gallegos. Joe and Aggie's Café (named for its founders, Joe and Aggie Montano) has outlasted all of the other local cafés and restaurants in town that existed in Rittenhouse's day.

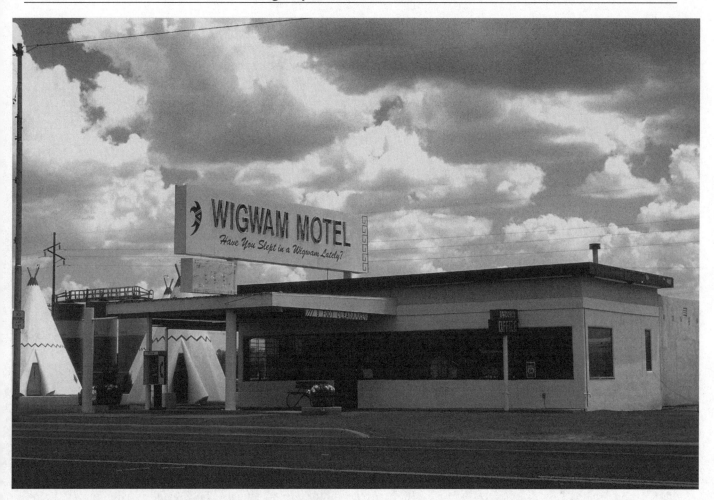

Wigwam Motel #6, Holbrook (1950). On June 1, 1950, Chester E. Lewis opened the sixth Wigwam Village (SEE COLOR SECTION C-28), which was based on the plans of Wigwam #2 in Cave City, Kentucky. The Holbrook Wigwam Motel closed in 1974 but reopened in 1988 after it was restored by three of Lewis' children, and its sign still advertises the motel's original slogan "Have You Slept in a Wigwam Lately?" This is one of the few Wigwam Village Motels still in existence and the Lewises have carefully kept their 19 units in vintage post-war condition, complete with their original tile bathrooms and hickory furniture.

City states that the town was named after Mormon leader Joseph Smith, and was founded when William C. Allen erected Fort Brigham Young here. Geronimo's Trading Post was located off of Exit 280 but is only ruins today. Just west of Joseph City, a smattering of bright yellow billboards along the interstate advertise the Jack Rabbit Trading Post, established in 1949 by James Taylor. Following World War II, more businesses started using standardized billboards to pull in customers, and Taylor blanketed Route 66 with small yellow signs featuring a black jack rabbit. Taylor's advertising campaign paid off, and the business enjoyed years of success. A mainstay of the Jack Rabbit was their famous cherry cider, which they sold to legions of thirsty travelers. In 1961, Taylor leased

now run the enterprise along with their mother. Today, the Wigwam's neon sign still advertises a good night's sleep for travelers, bearing the friendly slogan "Have you Slept in a Wigwam Lately?"[181]

The original alignment for Route 66 ends west of Holbrook, and drivers must take the interstate to proceed. The route continues on its westerly heading and slowly climbs in elevation. At Joseph City, Old 66 is a loop road for I-40 through town between Exits 277 and 274. A stone and cement marker on the east side of Joseph

Jack Rabbit Trading Post, Arizona (1949). During the heady days of the post-war tourism boom, James Taylor opened the Jack Rabbit Trading Post on U.S. 66 west of Joseph City and covered the route with small yellow billboards featuring a black jack rabbit. The mainstays of this tourist spot are its trademark cherry cider, a Jack Rabbit original, and a large jack rabbit statue sitting out front. The Jack Rabbit Trading Post is on the south side of Interstate 40 and is still a popular stop for travelers who find time to pull off the Big Slab.

the Trading Post to James G. Blansett, who ended up buying the enterprise in 1969. He and wife Pat ran the business until 1995. Currently, the Jack Rabbit is operated by the Blansetts' daughter Cindy and her husband, Antonio Jaquez. They still sell the same cherry cider and a myriad of curios, keeping this a favorite attraction on Old 66.[182]

The towns of Manila and Havre were found approximately 18 miles past Holbrook, but Rittenhouse's guide book warned motorists they were not really towns at all but a merely a group of yellow shacks built for railroad workers. A gas station/café named the Painted Desert Hideaway was once located eight miles past Manila.[183] Unfortunately, this leg of U.S. 66 no longer exists, having been replaced by I-40. The Little Colorado River runs parallel along the south side of the interstate and crosses an isolated stretch of the old alignment east of Winslow between Exits 264 and 257. From the interstate, Route 66 can be taken into Winslow by exiting at Exit 286 on Business Loop 40 (North Berry Street). A residential area is followed by the downtown businesses. The route through

downtown is divided into west and eastbound one-way streets, with Second Avenue leading west towards freeway Exit 285. Just north of Second Avenue is a yellow sign marking the route of the Beale Wagon Road (the route is marked by these signs at other points in Arizona). Winslow, like Holbrook, has lost most of its original Route 66 cafés and other businesses. Gone is the Lorenzo Hubble Company (a curio shop) and the Two Stars Café.[184] However, the La Posada (a Fred Harvey Hotel) is still open and is now a bed-and-breakfast. The Arrowhead Bar (circa 1933) is also open. It is run by Gilbert and Guadalupe "Lupe" Lopez, whose parents owned the business for 37 years before the Lopez brothers took over in 1990. The Arrowhead Bar is a bright turquoise with "Arrowhead Liquors" in pink neon, so it's easy to spot.[185]

The road west from Winslow to Winona was once a hazardous one. It evolved from a "two-rut road," to an oiled-dirt path, and finally asphalt. The original roadway had a steep crown in the middle for drainage which made it tricky to drive on, especially for top-heavy vehicles.

Arrowhead Liquors, Winslow, Arizona (1933). Built in 1933, Arrowhead Liquors (also known as the Arrowhead Bar) is located on eastbound Route 66 in downtown Winslow. The bar was first owned by a Mexican-American family and was later bought by the sheriff of Navajo County, who ran it for approximately eight years. In 1963, ownership changed hands again, this time to the Lopez family. In 1990, the Lopez's two sons, Guadalupe and Gilbert, became the proprietors.

The road made a 1,000-foot rise in altitude which, combined with the numerous potholes, made the trip through this area quite slow. Older vehicles like the Model T had gravity-fed fuel systems which caused them to stall on inclines, so motorists had to drive backwards over the steeper grades, resulting in transmission breakdowns. Over the years, the state highway department improved the road, to the relief of many motorists.[186] After Winslow, U.S. 66 crosses into Cononino County, following the south side of the interstate until it dead-ends. Ten miles farther is Leupp Corner. In the early days of Route 66, Leupp Corner was nothing more than a single building—the Hopi House Service Station. About six miles after Leupp Corner is Meteor City (at Exit 233), a jumping-off point for the mile-wide Meteor Crater, which is approximately six miles south of I-40. Travelers on Old Route 66 had a good laugh when arriving in Meteor City, whose sign once read "Population 1."[187] Such tiny "towns" were once common. Meteor City was a large tourist attraction, filled with the usual curios and crater-related knickknacks, but it closed recently. Some road maps show

a town named Rimmy Jim at this location instead of Meteor City. A gas station, lunchroom and tourist cabins owned by James Giddings once stood here. Giddings earned the nickname "Rimmy Jim" because he lived near the rim of the Meteor Crater and sold tickets to sightseers to tour the crater. Another old tourist stop that capitalized on the giant crater is located just a half-mile east of the junction of Old 66 and Meteor Crater Road. At Exit 233 for Meteor Crater Road are the crumbling remains of the Meteor Crater Museum and Observatory, built during the Depression. The Museum's tower can be seen just south of I-40 and can be reached by following a rutted road to the east. Abandoned years ago, the museum and its three-story tower were made of stonework, and visitors paid 25 cents to view the meteor crater through a telescope. The enterprise was the work of a man known only as Dr. Niniger, who added the observation tower in the early 1940s. Tourists must drive six miles south of I-40 and pay a fee of $10.00 (children $5.00) to see the crater and visit the current museum.[188]

From Meteor City, Old 66 continues west on Meteor

Meteor City, Arizona. From a reported population of one in Rittenhouse's day, Meteor City grew into a full-fledged modern-day tourist attraction. Today, Meteor City is just a stone's throw from I-40, west of Winslow, but it was closed in 1999 after its owners retired.

(SEE COLOR SECTION C-28.) Ruins of Meteor Crater Observatory and Museum. West of Meteor City off the freeway exit for Meteor Crater Road are the remains of the Meteor Crater Observatory and Museum, built by a Dr. Nininger in the early 1940s. Visitors could view the mile-wide meteor crater from telescopes at the top of the observation tower. A few hundred yards west is the Meteor Crater Museum, where visitors can examine an amazing display of astrological items and arrange to tour the meteor crater six miles to the south.

Crater Road about four or five miles toward Two Guns. The road through here is dirt and gravel and rumor has it that this stretch of U.S. 66 was never paved. The road is also blocked by several gates and it is advisable to get the permission of the local ranchers before crossing through. This portion usually must be bypassed in favor of the interstate, where Two Guns lies just south of I-40 at exit 230. An abandoned gas station is all that remains of Two Guns. In more recent times, Two Guns was nothing more than a gas station, restaurant, and a small zoo. Two Guns was founded in 1880 when the Atchison, Topeka and Santa Fe Railroad was built through here on its way west, and the town quickly grew from a railroad camp into one of the meanest centers for mayhem in the Wild West. During its heyday, Two Guns was a wild place where shootings were a common occurrence. Adding to the town's grim notoriety was the "Apache Death Cave," named for forty Navajo who were trapped and killed in a cave nearby by Apache warriors. The ghosts of the men, women and children who were massacred supposedly haunt the area today. In the 1930s, U.S. 66 ran behind the

Two Guns.[189] Old 66 now passes in front of the decaying station, heading east and west and disappearing into the Arizona landscape. A short distance west are the ruins of one of the old tourist attractions in Two Guns: the words "Mountain Lions," painted on a stone storefront on a hilltop, are visible from the interstate. Today, a monument near the ruins record the origins of the defunct town. An interesting site lies just west of Two Guns where Old 66 crosses the Diablo ("Devil") Canyon, a 100-foot-deep ravine that appears suddenly: the Diablo Canyon Bridge, opened on March 17, 1915, when the route was still the National Old Trails Highway. Now on the National Register of Historic Places, the bridge has been well-preserved by the dry southwestern climate and, unlike the highway, has hardly aged. A short distance beyond are the ruins of the first site of Two Guns, originally named Canyon Lodge. Apparently, the frequent misuse of firearms among its citizens prompted the name change to "Two Guns" early in the town's history. West of this location is another bridge, identical to the Diablo Canyon Bridge, crossing Padre Canyon. The road comes to an end a few hundred yards past the bridge.[190]

A few miles west of Two Guns is Twin Arrows, more of a tourist stop than a town. The old Twin Arrows Trading Post still faces north on the old alignment, with the interstate just yards away. Along this stretch was another phantom town called Toonerville.[191] At Exit 211, the old road reappears at the town of Winona, which didn't appear on maps until 1924. The town got its start in the 1920s, when Billy Adams built a small building that he called the Winona Trading Post using rock found near some ancient Indian ruins. Unlike the typical tourist trap that uses the term "trading post" strictly as an advertising gimmick, Adams did trade staples such as flour and gasoline for Indian rugs and jewelry, which he then sold to tourists. Billy's wife Myrtle ran the town's post office and became Arizona's first postmistress. Gradually, the population increased, as did traffic on U.S. 66, and the Adamses soon added tourist cabins to their filling station. The cabins were crude 10-by-14 foot wooden structures with a wood-burning cast iron stove, a wooden box, and an enamel wash stand with an oval mirror. The sleeping facilities were simple: an iron bed-stand was all that greeted guests, who were expected to furnish their own mattress. The Adamses named their roadside business the "Winona Motel" and they enjoyed many years of success, until their fortunes gradually declined after the interstate bypassed the town in the late 1970s. The Winona Motel succumbed to the familiar boom-to-bust cycle, a fate suffered by scores of businesses that depended on highways for their livelihood. The property was inherited by the Adams' children, Ralph and Roy, and was still for sale at last report. One of Adams' original tourist cabins stood

just a short distance off the highway until recently, a reminder of the early days of auto touring on Route 66.[192]

Highway 66 passes through Winona as a four-lane and crosses a truss bridge on a divided four-lane separated into east and westbound one-way streets, where a number of older motels are still operating. Leaving Winona and continuing west, the roadway, in near-perfect condition, begins a steady rise in elevation. The route enters the western outskirts of Flagstaff, the largest city in northern Arizona and a favorite stopping point for long-distance travelers. Most of the auto courts found here in bygone days have left the scene.[193] Before it reaches Flagstaff, U.S. 66 comes to a T-junction, where U.S. 89 joins the highway from the north and takes vacationers toward the eastern entrance to Grand Canyon National Park. The combined route of U.S. 66 and U.S. 89 continues into Flagstaff on a divided four-lane. The number of businesses begin to increase and several motels dating from 1945 to 1970 appear: the 66 Motel, the Frontier Motel, the Western Hills Motel (its sign shows a nice covered wagon), and the Whispering Pines Motel. The original auto courts that once lined this route are gone, like the Cactus Gardens, Rock Plaza, Arrowhead Lodge, El Pueblo, Motor Village and the Sunset Court.[194] At interstate Exit 204, Business Route 40 joins U.S. 66 from the south. The route into Flagstaff is called Santa Fe Avenue and is marked with "Historic Route 66" signs as it parallels the interstate. The road bears northwest away from I-40 and past another cluster of motels, and the name changes to East Route 66. To the south and across the railroad tracks stand two neon signs atop steel derrick-like towers, advertising the Motel DuBeau and the Downtowner Motel. This sky-high technique of roadside advertising was a forerunner of the tall signs used for McDonald's, Mobil, Best Western, and others, a fixture on today's interstates. Both can be reached by turning off of East Old Route 66 onto San Francisco Avenue and crossing the railroad tracks. The Downtowner is now rented apartments, but the Motel DuBeau still sees overnight guests. The Motel Sierra Vista, inconspicuously hidden on a side street on the same block as the Downtowner Motel, is a quaint Spanish-styled motor court of a type once common in the southwestern United States.

San Francisco Avenue is the main street in Flagstaff, but Highway 66 bypasses the downtown business district, continuing west as West Route 66. At 110 East Route 66 travelers will find the Grand Canyon Café (1946), which has a neon sign plus some great neon on its façade.[195] Many travelers made a detour and visited downtown Flagstaff because it had many businesses and services, including the Babbitt Motor Company and Babbitt Brothers Trading Post, located on the west side of the street across from the old Monte Vista Hotel. Bypassing down-

Four-lane U.S. 66 on east approach to Winona, Arizona. Route 66 thorough Winona is divided into east and westbound lanes separated by a city block. This view is looking west as Route 66 enters Winona's east side, with a Whiting Brothers service station in the foreground.

town, West Route 66 passes the Hong Kong Café (a vintage Chinese restaurant), Joe's Place, and the old railroad station. At Milton Road, the route turns left and goes under a concrete railroad overpass, then turns right at a road marked as U.S. Route 66, heading for the entrance to the interstate. The original route turned left one block west of San Francisco onto Beaver Avenue, then right (west) onto Phoenix Avenue to leave town. The route currently marked continues west from Flagstaff past a strip of modern motels, then turns right, onto a two-lane highway that goes into the Kaibab National Forest. The route ends at Interstate 40, and drivers must proceed west on the freeway.

Continuing west on I-40, the interstate replaces Old 66 for approximately the next ten miles. One isolated section on the south side of I-40, near the Picacho Butte, serves the town of Bellemont. At 7,130 feet above sea level, Bellemont is at the highest altitude of any town on Route 66. The old road ends west of town, so the interstate must be taken to the next section of 66, at exit 178 for the town of Parks. The pavement through this area is a foot thick,

thanks to a WPA project that improved the highway during the Depression.[196] Congressionally-funded highway projects meant to improve the nation's primitive roads were common during the 1930s and early '40s, when the unemployment rate hovered at 20 percent. Parks is referred to by Rittenhouse as "another of those one-establishment towns" with few amenities.[197] The road ends about five miles past Parks and drivers must take the interstate to proceed to the next segment of Route 66, a loop road serving the city of Williams.

The first exit into Williams follows Old 66 south of Interstate 40 and enters town on the east side. Before reaching the city limits, however, the original route went straight, while "Bypass 66" headed south, then west through the south side of Williams. In 1955, the highway department made the Route 66 bypass into a four-lane highway, with a city block separating the east and westbound lanes. This area still has many of its post-war motels. The old Williams Motel comes first for those traveling westbound; next door is Rod's Steak House. Rod's is the West's answer to Lou Mitchell's, except that steaks are

Top: Grand Canyon Café, Flagstaff (1946). The main intersection in Flagstaff is at San Francisco Avenue and Route 66, where the Grand Canyon Café (and Chop Suey) opened right after World War II. The café is currently owned by Fred Wong. *Left:* (SEE COLOR SECTION C-29.) Downtowner Motel, Flagstaff. Motels and tourist courts all jostled for the attention of customers as the roadside scene evolved through the post-war era. The more affluent motels placed large neon signs, which flashed at night, atop derrick-like structures for added visibility. A few of these advertising behemoths still survive, like the Motel DuBeau's and the Downtowner Motel's in Flagstaff.

the main course here. Opened in 1946 by Rodney Graves and his wife Helen, the business gained a reputation for fine beef (the steer-shaped menus are even a registered trademark) in the decades of Route 66's glory years during the post-war era. Rod Graves was something of a legend himself in these parts, first operating a café in nearby Seligman for seven years before starting his steak house in Williams, and later operating a ranch which he purchased in the 1950s, where he raised Herefords. Graves formed the original Bill Williams Mountain Men and the city's first rodeo in 1941, finally retiring from the restaurant business in 1967. The restaurant went through several owners after Graves sold the business and was purchased by Lawrence and Stella Sanchez, who have owned Rod's since 1985. Today, Rod's Steak House, including the building's classic neon, remains much the same thanks to the Sanchezes' careful management.[198]

(SEE COLOR SECTION C-29.) Rod's Steak House, Williams, Arizona (1946). On the east side of Williams is Rod's Steak House, established in 1946 by Rodney and Helen Graves. After 20 successful years, Rod left the business in August 1967 and the restaurant went through several owners. A long-time employee and his wife, Lawrence and Stella Sanchez, purchased Rod's in 1985 and continue its tradition of fine beef and made-from-scratch recipes in Williams, the "Gateway to the Grand Canyon."

During the 1920s, the Old Trails Highway followed a crooked path through Williams and made a dangerous railroad crossing. Proposals for a safer route were met with strong opposition, especially from the newly-built businesses that sprang up along the roadside. Progress prevailed, and a straighter route was built, eliminating the railroad crossing in favor of an underpass. The rerouting claimed some casualties along the old route, including Greene and Cureton's auto camps.[199] However, they were quickly replaced by new businesses catering to the tourist trade. Williams, like Flagstaff, serves as a gateway for tourists visiting the Grand Canyon and the town is still a busy stop-off. Williams once had three hotels, including the exquisite Fray Marcos, a joint venture of the Santa Fe Railroad and Fred Harvey. Frederick Henry Harvey started an early hotel-restaurant chain. Harvey Hotels and Harvey House restaurants emphasized customer service and their "Harvey Girls" became known throughout the United States for their high standards of cleanliness and service. Williams once boasted nine tourist courts, including the Hull's Motor Inn, Sal's, the Sun Dial, the Del Sue Court and the West End.[200] The current route continues west past the old Mountain Spring Ranch, then comes to a dead end at I-40.

Williams, Arizona has a special place in Route 66 history: On October 13, 1984, the final section of interstate freeway from Chicago to Los Angeles was completed north of town, meaning the entire length of Route 66 had been bypassed. The 5.7-mile section of U.S. 66 through Williams has been placed on the National Register of His-

toric Places in order to preserve its basic character (six other segments of Route 66 in Arizona also have been awarded this status). Since much of U.S. 66 was already bypassed by interstates and the road was seeing fewer and fewer travelers, the American Association of State Highway and Transportation Officials (AASHTO) voted to "decommission" U.S. 66 as a federal-aid highway the following year. Following AASHTO's action, individual states assumed responsibility for the repair and maintenance of the old road, and U.S. 66 has since been assigned state and county route designations. This mirrors a national trend in which federal-aid routes running parallel to interstate freeways fall into disuse due to marked decreases in traffic volume after being bypassed by interstates. After the decommissioning of Route 66, the old road's federal-aid highway markers were taken down, and many were auctioned off as souvenirs to collectors. However, new signs are gradually reappearing along many portions of the old route, directing another generation of travelers toward new adventures on this historic highway.

The 19 miles of Highway 66 between Williams and Ash Fork cover rough terrain, dropping some 1,700 feet in elevation over winding roads. This area, called Ash Fork Hill, was particularly dangerous during winter and motorists were advised to take caution, especially if traveling at night.[201] The hill had a very steep grade, and although the original road has been completely replaced by Interstate 40, the freeway still has a six percent grade. The town of Ash Fork lies to the west at the bottom of Ash Fork Hill; Highway 66 can be found again off of Exit 146.

(SEE COLOR SECTION C-30.) Storefronts in downtown Williams, Arizona. West from Rod's Steak House are several pre–1900 buildings that comprise downtown Williams. On the westbound alignment of U.S. 66 is Williams' infamous "Saloon Row," where area cowboys, loggers, and railroad workers came to carouse, drink, and gamble. The Red Garter Bed and Bakery (originally a bordello with a two-story outhouse) was the Cabinet Building when it was first constructed in 1893; the building to the left is the Tetzlaff Building, circa 1897.

Route 66 enters Ash Fork with the same one-way street configuration as in Winslow, Winona, and Williams, with Park Avenue heading west and Lewis Avenue going east. A sign at the edge of town boasts that Ash Fork is the flagstone capitol of the U.S.A. The vintage Hi-Line Motel first greets visitors, followed by the tidy White House Hotel. The Oasis Lounge and Ted's Bull Pen Restaurant are on the eastbound route through Ash Fork. As the route leaves town, acres of flagstone, stacked and tied in neat bundles, flank the highway. The road ends at I-40, so the interstate must be used again.

Route 66 disappears again for a short distance, then reappears at Exit 139. The old alignment continues parallel on the north side of I-40 and heads west for Seligman. The road passes a very old concrete bridge that has been bypassed by a newer routing. This is perhaps the last of several such bridges built during the earliest years of Highway 66 along this desolate stretch in western Arizona. The bridge has oblong holes in the bridge rail and is of the same style as the Diablo Canyon Bridge at Two Guns. The interstate and a line of telephone poles lie to the south. The next stretch of Highway 66 goes from Seligman to Kingman, and at 159 miles, is the longest stretch of the old road not interrupted by the interstate. It's a sparsely-populated region, with few filling stations or other services, so it's not a good place for unexpected car trouble.

In Seligman, the road through town is marked as "Historic Route 66" by local street signs, although a pre–1933 alignment exists one block south of the main highway. The aging Supai Motel still stands on the east approach to Seligman. The Delgadillos are the most prominent Route 66 boosters in Seligman. Their family came here in 1917, and opened a barber shop in an old pool hall in the 1920s. The circa–1914 structure still serves as a barber shop and is owned by Angel Delgadillo. Angel swaps stories with tourists (he always has a ready ear for people with highway trivia and gossip) and runs his own Route 66 museum, gift shop and visitor center at the location. He is also recognized internationally for rekindling interest in Route 66. On February 18, 1987, Angel held a meeting in Seligman, whose fortunes had died following the construction of the interstate in 1978. Since then, a movement to save the old road has grown unabated, with Route 66 organizations (Angel established the first state organization the same year) springing up across the United States and overseas. Angel's brother Juan Delgadillo, as owner of the Snow Cap Drive In, located in the center of town on the old highway, has also been instrumental in keeping interest in Highway 66 ongoing. A former worker for the Santa Fe Railroad, Juan built the Snow Cap in 1953 (three years after Angel took over their father's barber shop) using wood, sheet rock and sheet

(SEE COLOR SECTION C-30.) Delgadillo's Snow Cap Drive-In, Seligman (1953). The Snow Cap Drive-In was built by Juan Delgadillo, a railroad worker and son of a local family who emigrated to Seligman in 1917, using materials salvaged from the nearby Santa Fe Railroad yard. The Snow Cap has stayed open continuously since 1953 even though Seligman became a virtual ghost town when it was bypassed by I-40 in 1978. The Snow Cap Drive-In offers burgers, ice cream and other treats amid a collection of antique signage. Juan's brother Angel Delgadillo, a local barber, owns his own Route 66 museum, visitors center and gift shop in town.

metal that he salvaged from the railroad. The Delgadillo family can be credited with putting Seligman "on the map" and have made the town a focal point for Route 66 buffs throughout the world.[202]

Route 66 gradually pulls away from the interstate on a northwest heading on a 91-mile loop road from Seligman to Kingman. This segment of U.S. 66 is in excellent condition, and passes through a barren landscape. Occasionally, funnel-shaped dust devils created by swirling gusts of wind trail across the desert floor in the distance. The highway runs parallel to the Santa Fe Railroad and a line of telephone poles, traversing basically flat terrain. The interstate between Seligman to Kingman is much faster and shorter (only 78 miles) but the freeway's scenery is much less interesting. Old 66 skirts the Aubrey Cliffs on the east side of the highway and passes a town named Hyde Park (shown 23 miles west of Seligman on some roadmaps), although the town now seems to have vanished. As the highway begins to curve toward the west, it becomes a divided four-lane for a brief distance, passing a tourist attraction dating to the 1920s. Currently called Grand Canyon Caverns, this quirky establishment began in 1927, when Walter Peck accidentally discovered a "bottomless" hole in the ground while on his way to a poker game. Peck first thought he stumbled across a gold deposit, but instead found sparkling white calcium carbonate formations and two human skeletons, which he later claimed were prehistoric cavemen. Peck opened the cave to the public for tours, and his business soon became a different kind of gold mine. In the 1950s, during Hollywood's first dinosaur movie fad, Peck named the caves

"Dinosaur Caverns." Later, cave researchers forced smoke into the cave to find out where it might end, discovering another entrance near the Grand Canyon 60 miles to the north, so the business was given its current name, "Grand Canyon Caverns."[203] A few miles west of the Grand Canyon Caverns, U.S. 66 enters the Hualapai Indian Reservation.

Pushing farther west, the highway heads downhill through a mountain cut and enters Peach Springs. The road takes a sharp right turn at the bottom of the hill and passes the modern Hualapai Lodge. The only other facility in the tiny town is an old gas station made of sturdy stone masonry, on the south side of the road. This vintage filling station was built in 1927 by a Swedish immigrant named Osterman and has been continually open ever since. The building has been given a coat of white paint, and is currently owned by Robert Goldenstein, who still sells gasoline and repairs tires for local residents and the occasional traveler.[204] After Peach Springs, the road passes through Truxton, another tiny town, located only

15 miles south of the lower Grand Canyon. Truxton is home to the Frontier Motel and Café, owned by Mildred Barker since 1972. Mildred is something of an institution in the area, having once owned the Osterman station in Peach Springs and Truxton Station across the highway from the motel, along with some other properties. The Frontier Motel was built in the late 1940s by a Californian named Alice Wright, who purchased the land on which the motel sits with an inheritance. The business slowly evolved into a motel and café and now has seven units.[205] Directly across the highway from the Frontier Motel is the Truxton Station, owned by Chuck Radcliffe since 1994. The old station began as an outlet for Whiting Brothers when it first opened in 1951 and has sold an assortment of brands since then.[206]

Approximately 15 miles west of Peach Springs is the Crozier Canyon, where the last piece of Route 66 was paved in 1936.[207] The town of Crozier was located off to the left, and was served by the original alignment for U.S. 66. The town consisted of a few yellow railroad buildings

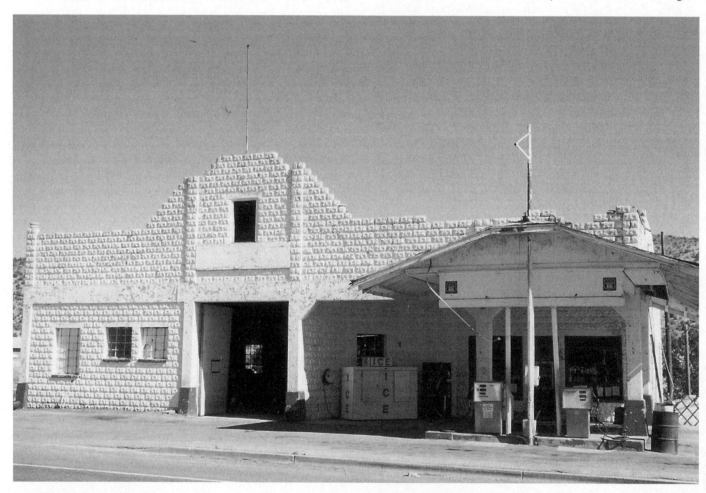

Osterman's Service Station and Garage, Peach Springs (1927). In the late 1920s, when the highway here was just a dirt road, a Swedish immigrant named Osterman built this stone filling station with garage in tiny Peach Springs, Arizona. Originally a Shell station, the business was purchased by several people over the years and is now run by Robert Goldenstein and his son Ralph. The station still sells gas and repairs tires at this isolated location on Old 66.

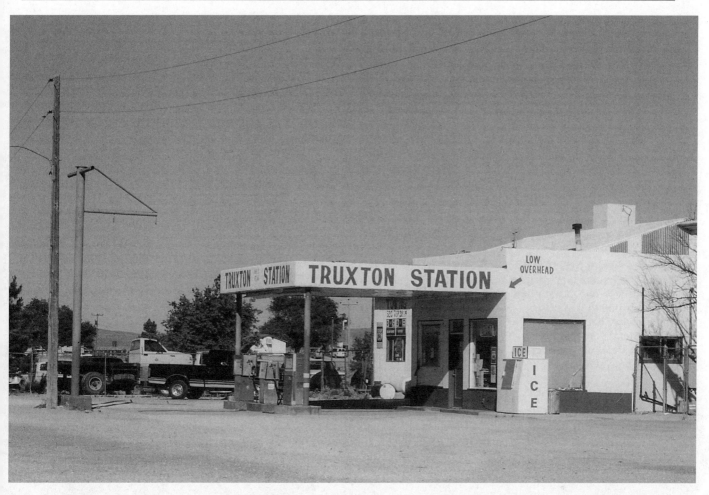

Truxton Station, Truxton, Arizona (1951). This station in Truxton first opened as an outlet for the Whiting Brothers chain in 1951. The business was once owned by Mildred Barker, who also operated the Ostermans' station in Peach Springs and who now runs the Frontier Motel and restaurant directly across the highway. The Truxton Station is currently under the ownership of Chuck Radcliffe.

and some cabins for tourists, but it is difficult to spot the tiny hamlet today. The highway goes through another man-made cut through solid rock and arrives at Valentine. This "town" is off to the south side of the highway and was never much more than a post office with a filling station, store, and some tourist cabins.[208] After Valentine, Route 66 curves south, then northwest towards Hackberry. Before Route 66 was paved here in 1936, a small wash crossed the highway, occasionally delaying motorists, who could not cross the torrent of water that rushed across the road after even a minor rainstorm. A bridge was eventually built to get travelers through the area safely.

The town of Hackberry lies to the west of the main highway near the Santa Fe Railroad and the storage tank, but it is only a scattering of homes. The Hackberry General Store (circa 1934), its exterior and grounds decorated with dozens of antique signs that remind passing travelers of auto touring in the good old days, is the only structure still on Old 66. The store was vacant for many years

until 1992, when Edwin Waldmire II (founder of the Cozy Dog Drive-In) bought it for his son, Robert. Bob Waldmire, an avid admirer of Route 66 for some time, turned the building into a Route 66 Museum, collecting Route 66 souvenirs and roadside artifacts to display for visitors. He added a pair of vintage gas pumps and operated his museum free of charge until selling it to Jim Pritchard in 1996.[209] Pritchard's goal is to restore the premises to original appearance, and he has revived its the original name, the Hackberry Store. Pritchard's red 1957 Corvette can sometimes be seen parked out front among his collection of roadside memorabilia, which includes original signs and gas pumps for the old business. The station was first a Conoco, then an Esso station in the 1960s, and finally an outlet for the Humble Oil Company in the 1970s before closing in 1978. The Hackberry General Store has a new lease on life and has outlasted two others just a short distance farther south. A boarded-up Union 76 station is found south of Hackberry, and the foundation of another filling station can be seen along Route 66 in town.[210] The

(See color insert C-31.) Chief's Motel, east of Hackberry, Arizona. The 91-mile loop road from Ash Fork to Kingman is a graveyard of old gas stations and other businesses. The Chief's Motel (out of business) sits on the north shoulder of the highway between Valentine and Hackberry, Arizona, a casualty of the completion of I-40. Today, this section of Highway 66 carries only local traffic and the occasional traveler seeking to experience the historic highway.

road leaves Hackberry via Crozier Canyon, and makes a long curve and bears southwest through the Hualapai Valley, heading arrow-straight toward Kingman.

U.S. 66 approaches Kingman from the northeast, passing under I-40 and into town on Andy Devine Av-

enue, named for the Hollywood actor, who lived here during his youth. Kingman (elevation 3,314 feet) was an important point along Highway 66 since few reliable services existed between here and California. The city was home to many now-vanished tourist courts and motels, including the Kit Carson Motel, the Gypsy Garden, White Rock Courts, Gateway Village, and the Wal-a-Pai Auto Camp.[211] The newer-generation motels, filling stations and fast-food restaurants first greet today's visitor, among them the new Route 66 Motel, with its huge neon sign. The road passes an open stretch of land and comes to some older motels: the Hillcrest, the Desert Lodge, the Orchard Inn, and the Siesta (with kitchenettes). At a stoplight is the City Café, in business here for 50 years. The road passes the Hill Top Motel, the El Trovatore, and the Brandin' Iron, all located in an area which overlooks the older part of town, called El Trovatore Hill. The El Trovatore Motel began in 1937 as a Chevron service station; by 1940, owner J. F. Miller added a large tourist court. The motel no longer serves travelers and only rents by the month. The Brandin' Iron was opened after the war in 1953 by Mr. and Mrs. R. A. Bewley but recently closed, so its neon sign with colorful cattle brands can no longer be seen. Rumors circulated that the Brandin' Iron would reopen as rented apartments, but it was demolished in 2001 and a new commercial structure is being built on the site.[212]

The route makes a steep descent through a rock cut

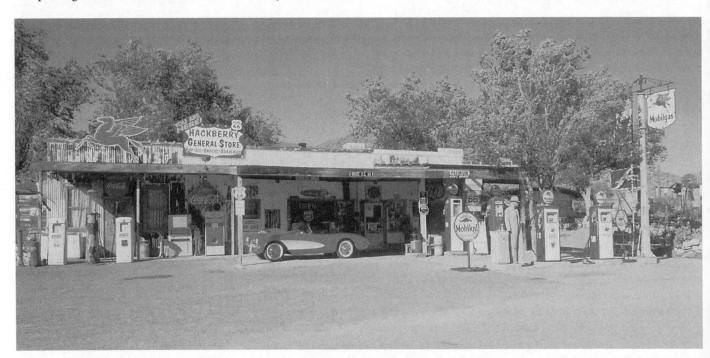

Hackberry General Store (1934). The lone survivor along Route 66 in Hackberry, Arizona is the Hackberry General Store, which outlasted two other service stations in this small settlement. Current owner Jim Pritchard, who purchased the old store and former Conoco station from Bob Waldmire in 1996, is working to restore the old general store to 1930s-era condition. This historic business was closed in 1978 but reopened in 1992, when Waldmire turned it into a Route 66 museum. The Hackberry Store was featured in two movies: *Easy Rider* (1969) and a late '70s film entitled *Roadhouse 66*.

Top: El Trovatore Motel, Kingman, Arizona (1940). The El Trovatore Motel is one of the few pre–World War II tourist courts left in Kingman, where 17 courts were listed by Rittenhouse in 1946. The business started in 1937 as a service station, with the tourist court added later, and was first owned by J. F. Miller. The motel is located on El Trovatore Hill overlooking the center of Kingman, on Andy Devine Avenue (also Historic Route 66) across the highway from the Hilltop Motel, whose neon sign reads "The Best View in Kingman." *Bottom:* Brandin' Iron Motel, Andy Devine Avenue, Kingman (1953). Situated just down the highway from the El Trovatore Motel was the Brandin' Iron Motel, originally owned by Mr. and Mrs. R. A. Bewley. The motel was also in the El Trovatore Hill district and closed only recently.

and passes Beale Street, Kingman's central business district, on the right. The road winds through Kingman as Andy Devine Avenue and is marked by street signs as "Route 66," turning west past the Ramblin' Rose Motel and the Spanish-styled Arcadia Lodge, both with outstanding neon signs. At Fourth Street and Route 66 is the old Atchison, Topeka and Santa Fe railroad station, built in 1907. The old route turned left at the railroad station, while the later alignment continues straight ahead towards I-40. The town's main street (Beale Street) runs parallel to U.S. 66 through the center of town. The historic Hotel Beale (319-327 Andy Devine Avenue) is across the road from the railroad station and has an interesting history, but is also closed. The hotel was built of brick and concrete in 1899 by local businessmen Harvey Hubbs and John Mulligan, both of whom owned other properties in town. Hubbs owned his own hotel, called the Hubbs House, and other businesses in Kingman. Mulligan built many of Kingman's commercial buildings, including the

town's first hotel in 1881, the Exchange Hotel and the Brunswick Hotel, and was also a co-owner of the Hubbs House. The hotel was named the Hotel Beale, in honor of U.S. Navy Lieutenant Edward Beale and his epic travels through New Mexico and Arizona in the 1880s.[213]

After the turn of the century, the Hotel Beale entered its most interesting years. In November 1906, Thomas Devine, the treasurer of Coconino County, purchased the hotel for $32,000. Two years later, Devine added a bar connected to the hotel; he also made other substantial improvements during his tenure at the Beale. In 1916, he built major additions to the hotel, doubling its room capacity and expanding the lobby. During the early years of its life, the Hotel Beale was the place to stay in Kingman, with fine interior detailing typical of the arts and crafts movement, a skylight, even a barber shop.[214] Devine's son Andy helped out with the business and local residents still recount some of Andy's youthful pranks. One story claims that when passengers disembarked at

Hotel Beale, Kingman (1899). The Hotel Beale dates to 1899 and was built by Kingman businessmen Harvey Hubbs and John Mulligan. The hotel was Kingman's finest hostelry in the early decades of the twentieth century, along with the rival Brunswick Hotel (1909), pictured just to the left of the Hotel Beale. The hotel's architecture is a blend of Queen Anne and mission designs and its interior is styled with rustic "craftsman" treatments endemic to the period. The Hotel Beale, closed now, is in the center of Kingman at the intersection where U.S. 66 turns to leave town.

Atchison, Topeka and Santa Fe Railroad Depot and Logo, Kingman (SEE COLOR SECTION C-31) **(1907). This Mission Revival railroad depot was constructed in 1907 by the Atchison, Topeka and Santa Fe Railroad and is still in use. The stucco and concrete building is Kingman's third depot, as the previous wooden structures were destroyed by fires. This historic building is in on Route 66 Boulevard between 4th and 5th streets in downtown Kingman.**

the train station and stopped by the hotel, Andy would nail their bags to the floor so that they would miss the train and be forced to spend the night.[215] In 1926, Thomas Devine sold the business to Mrs. L. R. Hall, who was already experienced in the hostelry business, and Hall took over the Beale on March 26 of that year. In the early 1940s, the hotel got itself into a bit of a controversy with the city over some slot machines, which were added to the bar to bring in some additional revenue (they were eventually removed, of course). Today, the hotel is closed and is

looking for new owners. However, still open just next door (at 313-315 Andy Devine Avenue) is the Brunswick Hotel, which for many years was the Hotel Beale's main rival in Kingman.[216] Kingman was a growing community in the early decades of the twentieth century, when Arizona was still a territory (Arizona became a state in 1912). There was a great need for more hotels and rooming houses in town, and the Brunswick Hotel was built between 1907 and 1909 by J. W. Thompson and John Mulligan. The Brunswick is faced with tuft stone hauled in from the nearby Metcalfe Quarry. When the three-story hotel opened for business in December 1909 it was the largest in town, with 80 rooms, and was lavishly furnished with expensive décor.[217] The Brunswick is still open and today includes a café.

Route 66/Andy Devine intersects with Beale Street and the route continues west (left) toward the entrance

of I-40. At this point, travelers can choose between two Route 66 alignments. The later U.S. 66, opened in October 1952 and referred to as the "Yucca Cutoff," proceeded approximately 50 miles due south from Kingman, then took a wide turn west to the California border. This route bypasses the old alignment but, alas, Interstate 40 has wiped out almost all traces of Route 66 through the area. The current route, using I-40, passes the towns of Griffin, Yucca, Haviland, Powell, and Topock, just before the California border. The only real town left on the Kingman-Topock stretch is Yucca, just off the interstate at Exit 25. To the east of the exit is Ford Motor Company's Yucca Flats Proving Grounds; to the west, the Honolulu Club, owned by Nancy Carmody. The business has a long history that begins in Oatman, where a Hawaiian man known as Honolulu Jim owned a bar called the Honolulu Club. In 1940, Nancy Carmody's grandparents, Juan and Mary Rodriguez, purchased the business with the stipulation that they retain the name. In 1950, as construction

of the Topock bypass around Oatman was progressing, the business was relocated to its present site to be on the new highway.[218] To this day it's still called the Honolulu Club, and now sits mere yards away from I-40. Across the highway is a shoulder road that was part of the original 66 bypass. The shoulder road is today deserted, and passes a row of vacant businesses that "bit the dust" decades ago.

To see the original alignment, pick up the route beginning in Kingman at I-40 Exit 44. A left turn here leads back to Kingman on the old alignment, while the route west is to the right. The road continues southwest into a desolate lunar landscape, with the Black Mountains dead ahead. Besides the Mojave Desert, this section was perhaps the most feared by motorists traveling Highway 66 in the days before modern freeways. The Bureau of Land Management has recently posted a sign here, designating this section of highway as a historic byway under a program started by the Department of the Interior to preserve

Honolulu Club, Yucca, Arizona. This is the later version of the Honolulu Club, originally owned by a Hawaiian known as "Honolulu Jim" in nearby Oatman until he sold out to Juan and Mary Rodriguez in 1940. Upon purchasing the business, the Rodriguezes promised to keep the original name after they relocated the business to Yucca in 1950, just before the new Route 66 was opened through this vicinity. The Honolulu Club is now owned by the Rodriguezes' granddaughter, Nancy Carmody, and is still open on the west side of post–1951 Route 66, now I-40.

Abandoned businesses along Route 66, Yucca, Arizona. The post–1951 alignment for U.S. 66 south of Kingman passes Ford Motor Company's Yucca Flats Proving Grounds at Yucca, off of Exit 26. On the east side of the freeway is a shoulder road that was part of the original highway built prior to I-40. This cluster of vacant businesses is south of the freeway exit and across the highway from the Honolulu Club.

the nation's scenic and historic highways. This route, called Oatman Road or Gold Hill Road, makes a long climb to Gold Hill Summit at the top of the Black Mountains. The climb was difficult and too steep for many early motor vehicles, and many unlucky travelers fell victim to mechanical breakdowns, flat tires and overheated radiators on the road ahead. Only a handful of facilities were available to aid stranded motorists, and old timers in the area recall how travelers sometimes had to pay locals to tow them over the Gold Hill Summit.

Old 66 first passes over Seven Mile Hill through a narrow pass that leads to the Sacramento Valley. The road climbs 1,400 feet through Sitgreves Pass (elevation 3,652 feet)—named after U.S. Army Captain Lorenzo Sitgreves, who explored and surveyed the area—then drops to flatter terrain. On the way to the summit, the site of Fig Springs Camp, once a way-station for tired travelers, is on the right shoulder. The road is narrow and the asphalt pavement is in poor condition. Highway 66 starts a long ascent over Gold Hill Grade (elevation 3,523 feet), the steepest section on all of westbound U.S. 66.[219] The road has some tricky switchbacks along the way and there are few signs to warn motorists of the numerous curves and grades. The road hugs a rock wall on one side, and there are no guardrails to prevent vehicles from leaving the road and plunging into the abyss on the other side.

Found along the route to Gold Hill Summit are the remains of Cool Springs Camp, and about a mile farther, Ed's Camp. Cool Springs Camp started as a gas station

built in 1927 by a local trucker named N. R. Dunton. Dunton saw the commercial possibilities of locating a business here—there was already traffic from nearby mines, and vacationers were slowly trickling into the area with the advent of the new U.S. Route 66. The area had no natural water source except for a mountain spring two miles away. Dunton and his investors built a pipeline from the spring across the desert leading to the gas station (the original pipe still exists today). Dunton dubbed his desert oasis "Cool Springs," which he thought would appeal to thirsty tourists traveling past his station. After adding a few cabins, he sold the business in 1936 to James and Mary Walker, who moved there with their four children from Indiana. That fall, some miners who were renting the Walkers' cabins came up with a way to cool the water leading from the spring, which was nearly boiling from the desert sun and unusable even for showering. A makeshift aerator was placed on top of the rest room building and the water was cooled as it trickled down an old washboard. The Walkers completely renovated the buildings, which were simple wood frame structures, and James used rocks found nearby to cover the walls of the buildings ("rocking" roadside structures was common during the 1920s and '30s, giving buildings a rustic appearance). The neon sign reading "Cool Springs—Cabins—Tasty Food" on the roof of the filling station carport was visible for miles around. James left his wife shortly thereafter, and Mary continued to operate Cool Springs Camp by herself until she married Floyd Slidell, a Kingman

Ruins of Cool Springs Camp (1927). On the east side of Sitgreves Pass, a local trucker named N. R. Dunton opened a gas station and a few cabins to capture some of the tourist trade that was rapidly increasing along the newly-designated U.S. 66. In June 1936, Dunton sold out to James and Mary Walker, who improved the business by adding a bar and restaurant. Her husband left her in the late '30s, but Mary stayed on and married Floyd Slidell in 1939, who built a repair garage and improved the premises. By the early 1960s, the property was abandoned, then later demolished for a Hollywood film. These stone foundations are all that remain of Cool Springs Camp.

resident who occasionally stopped by Cool Springs and other area restaurants and grocery stores to deliver produce. After they were married in 1939, Floyd further improved the business by adding a repair garage, using the same stone masonry as James Walker. Floyd also put in some air vents on the pipeline, which increased the water flow from the spring. Business continued at a brisk pace until the early 1950s, when the highway was rerouted between Kingman and Topock and Cool Springs Camp fell on hard times. Mary moved out first, then Floyd abandoned the property and moved to Kingman in 1964. In 1956, Floyd's niece, Nancy Schoenerr, her husband and four children moved to Cool Springs and raised chickens, but the tourist trade had all but disappeared. The Schoenerrs purchased the 40-acre site in 1963. The business met its demise when it was destroyed for a Hollywood movie. Today, only the stone foundations of the buildings are left (look for the inscription in the cement sidewalk reading "Floyd and Ada Slidell, January 1956").[220]

Although Cool Springs Camp is now gone, there are still signs of life at Ed's Camp, established in 1919. In the old days, Ed's Camp sold gasoline and groceries, and Pickwick Tour buses stopped here to let tourists relax and make purchases at the store.[221] At Gold Hill Summit, a gas station and ice cream parlor once stood, with a turn-out on the road for tourists to stop and enjoy the view.[222] After the summit, the road quickly bears southwest and goes through several sharp hairpin turns. The narrow roadway passes an aged white stone wall, built as a safety measure to keep cars away from a deadly drop-off, which has been repaired recently with cement. Two miles past the summit are the remains of the mining town of Gold Road. The road makes a 700-foot drop in elevation from the summit and passes through the area where the town, abandoned after the mines gave out, once stood. Back in the '40s, a garage here towed vehicles through the pass for a charge of $3.50. The road passes the abandoned Consolidated Gold Mine Company, continues its descent, and enters the town of Oatman.[223]

Ed's Camp (1919). West of Cool Springs Camp is Ed's Camp, where Ed Edgerton's place on 66 (also called Gold Road in this area) is still open. Both Cool Springs Camp and Ed's Camp were near mountain springs, valuable water sources in this thirsty region. Ed's sold gas until recently, although there are plenty of interesting items to pick through at this Route 66 time capsule.

Oatman is nestled in a small valley amid gorgeous desert scenery. The town was the scene of a latter-day gold rush during the first 20 years of the twentieth century, its population cresting at 3,500 by 1916. The town's fortunes have been up and down over the years. One day, in the fall of 1952, the Kingman Daily Miner reported that traffic was proceeding as usual over Gold Hill Summit — then the road fell silent. A new highway between Kingman and Topock, bypassing Oatman, had just had its ribbon-cutting ceremony. Seeing the handwriting on the wall, six out of seven filling stations in town closed the following day, along with some local businesses.[224] After being bypassed by the newer U.S. 66 and later I-40, this isolated settlement entered its own kind of time warp. Oatman looks like a typical Wild West town, with plank sidewalks and weathered wooden buildings lining its main street. The town plays host to a band of wild burros, which locals say are the descendants of those which escaped from prospectors years ago. The burros have become accustomed to tourists and are quite tame, and they roam the town's main street freely, in search of a hand-

out. The Oatman Hotel (formerly the Arizona Hotel) looks much the way it did when it opened in 1902. The proprietor will tell you that several well-known movie stars have come here to escape the Hollywood paparazzi, including Clark Gable and Carole Lombard, who checked in here for their honeymoon (they were married on March 29, 1939, in nearby Kingman). Overnight guests might encounter the hotel's resident ghost.

Leaving Oatman, 66 heads into the valley of the Colorado River. The last town in Arizona is Topock, some 26 miles past Oatman. Two pull-offs with water faucets where trailers could stop for the night were once located between Oatman and Topock.[225] As the road nears Topock, it passes under a wooden Santa Fe Railroad bridge but immediately runs into Interstate 40; the road makes a detour to get travelers across the interstate, taking a 90 degree left turn and crossing over I-40 to the west side of the freeway. A new road continues west toward the Colorado River, passing a natural gas facility before coming to a dead end. Clearly visible is a white steel arch bridge crossing the river into California. This is the

Oatman, Arizona. Oatman became a turn-of-the-century boom town when gold was discovered in the area; its population reached its apex in 1916 at 3,500 citizens. Tourism is the new "gold" in Oatman these days and the town's Main Street is lined with interesting shops and other businesses. Here, one of the town's resident burros strolls down Main Street past the Oatman Hotel, circa 1902.

famous Old Trails Bridge, built in 1916 when the National Old Trails Highway was built through the area. The bridge's opening was a major event for the entire region, and throngs of area residents dressed in their finest clothing converged on the bridge for the opening ceremonies. Also known as the Arch Bridge, the Old Trails Bridge served as U.S. 66 from 1926 until 1952. The new alignment from Kingman to Topock was finished in 1951.[226] The modern highway bridge serving I-40 today was built for the new Route 66; the Santa Fe railroad bridge runs parallel to the east. Some years after the new U.S. 66 bridge was completed, the roadway for the Arch Bridge was removed. The bridge now supports some natural gas pipelines. The Old Trails Bridge is shown in a scene from *The Grapes of Wrath*, with the Joad family eagerly crossing the bridge to enter the promised land of California. The I-40 freeway bridge has its own claim to fame; it was filmed during the opening sequence of *Easy Rider*, which showed Peter Fonda and Dennis Hopper speeding across the bridge heading east into Arizona to the tune of "Born to Be Wild."

(SEE COLOR SECTION C-32.) Old Trails Bridge (1916). Also known as the Arch Bridge, this forged iron and steel bridge served as U.S. 66 until the early 1950s, when the newer freeway bridge was completed north of this location. The graceful two-lane structure was filmed in a sequence in *The Grapes of Wrath* when the Joad family crossed the Colorado River to enter California. The bridge deck was removed in the early 1950s; it currently supports a natural gas pipeline.

Topock is a small settlement with little more than a filling station. This area, where the Colorado River separates the states of Arizona and California, has long been a focal point for Native Americans, and was attractive to late-nineteenth century pioneers. The Colorado River narrows here, making it a good location to ford the river. The word "topock" itself is Mojave for "many crossings." The town began in February 1883 with a post office and was called Needles, but the name was changed to Powell (after the famous explorer, John Wesley Powell) a few years later. When the Atchison, Topeka and Santa Fe Railroad was built through the area, the railroad constructed a bridge across the Colorado called the Red Rock Bridge. In 1890, the area was known as Red Rock and Red Rock Crossing, but became Mellon (or Mellen) a year later. Finally, the site was renamed Topock after the railroad found that "Mellen" and "Needles" got confused in train orders.[227]

Drivers must use the interstate to cross the border into California, since the Old Trails Bridge is closed to motor vehicles. The original alignment leading west from the Colorado River can be followed beginning at the exit for Park Moabird Road. The road bears north and ends at the west side of some old railroad tracks; the Red Rock Bridge stood here from 1947 until it was dismantled in 1966.[228] The next exit is for U.S. 95 and is marked by the California Route 66 Association as a second piece of the old road. It too comes to a dead end, and U.S. 66 can be rejoined by taking the first exit to Needles. Workers for the Santa Fe Railroad met the eastbound Atlantic and Pacific south of the present-day town, and a post office called "The Needles" was established there. (The settlement was named by Lieutenant A. W. Whipple, a surveyor for the railroad, after he noticed the sharp ridges of the Black Mountains across the river in Arizona.) The town was moved to its present location in 1883, but retained the name.[229] Gradually, the city of Needles evolved into a welcome haven for bedraggled travelers. Palm trees and other greenery have been transplanted to give Needles an oasis-like appearance. Motorists heading toward the west coast were well-advised to stop here for the night, as over 150 miles of unforgiving desert lie ahead.

The road into town passes some homes and a trio of deserted gas stations on the left. Most of the old auto courts are gone, replaced by motels built after World War II. The road comes to a Y-junction at the Old Trails Inn; the old alignment veers to the right on Front Street, while the newer routing via Broadway Street bears left. Front Street runs parallel to the railroad tracks and a line of telephone poles, and leads to old downtown Needles. The route passes the historic El Garces Harvey House and Santa Fe train station. This building was constructed of solid concrete in 1908, after a wooden building on the site

was lost in a fire and faces Santa Fe Park. It is named for Spanish missionary Francisco Garces, the first European to travel through the eastern Mojave Desert. The El Garces was the city's main attraction, since it was the finest hotel between Kingman and Los Angeles and also served as the town's railroad station and telegraph office. The hotel was part of the Fred Harvey chain of hotels. The El Garces hosted many important guests over the years, including General George S. Patton, who occasionally stayed there during the early days of World War II. The Mojave Desert was a training ground for the U.S. Army and military maneuvers took place nearby in preparation for the invasion of North Africa. Patton was making a name for himself as a brash, no-nonsense general at the time and his marathon poker games at the El Garces are still legendary in these parts. Fred Harvey Hotels closed the El Garces in 1949. The Santa Fe Railroad took over the hotel, tore down the north wing, and used the building for offices until recently. Lobbying by the city and residents has resulted in the building's placement on the National Registry of Historic Places, qualifying the project for a $2 million government grant. When restoration is completed, the El Garces will once again host guests in the eastern Mojave region.[230]

The original route for 66 went around Santa Fe Park, adjacent to the El Garces, and continued on Front Street before turning right onto K Street, left on Spruce Street, right on N Street, and finally left onto the Needles Highway. This route passes the Sage Motel, the Western Motel, Best Motel, and the River Valley Lodge. The Hungry Bear Restaurant, dating to the early 1970s, is located just before the entrance ramp for I-40. After crossing under the I-40 overpass, Needles Highway continues on the west side of the interstate and passes the LeBrun and Relax Inn motels. After following the west side of the interstate, the route crosses the freeway again to the east side and begins to leave town, passing the property of Maggie McShan, who has lived here since moving to Needles in the late 1940s with her husband. The McShans' first endeavor was to build a rock and mineral shop, which is still on her land today. The building's exterior is made of local rock; the rafters were salvaged from the nearby Old Trails Bridge when the roadway was removed after the new U.S. 66 bridge was built in the early 1950s. The bridge deck of the Old Trails Bridge was made of two-by-six-inch wooden planks that were mounted with the short side upward and screwed together. Maggie is the foremost historian and promoter of Route 66 in the eastern Mojave area. In addition to operating the Needles Regional Museum, she publishes *Footprints*, a local publication focusing on items of interest to both the Needles area and Route 66, and works to preserve all aspects of the highway's heritage. Recently, Maggie discovered a forgotten

Front Street (Old Route 66), Needles, California. The original path of Route 66 through downtown Needles was one block west of Broadway, the modern alignment for U.S. 66. In this view, facing north on Front Street, the route turns left at Santa Fe Park and the old El Garces Harvey House (the building in the center), where Old 66 snakes its way through the center of town. The El Garces, named for Francisco Garces, a Spanish priest who became the first European settler to visit the Needles area, was a Fred Harvey hotel and railroad station from 1908 until 1949 when the hotel was sold and the Santa Fe Railroad converted it into offices. The city of Needles, the "Friends of El Garces," and others are currently raising the funds to restore and reopen the historic hotel.

rest area on Route 66 on the western outskirts of town. The rest area is a half-mile west of McShan's home and a vacant lot on the west side of Needles Highway where there was once a Texaco station and Stuckey's store. At the center of a Y-junction visitors will find four cement picnic tables and a new nature trail with native plants. The trail was started by McShan, whose goal is to raise awareness of this important site and hopefully raise enough government and private funds for its renovation. A root beer stand was located across the eastbound lanes to the west, but the entire area was abandoned when the interstate bypassed Needles around 1970.[231] The Needles High-

way continues for approximately nine more miles before ending at I-40.

The modern alignment of Route 66 through Needles uses Broadway Street, beginning at the junction with Front Street on the south side of town. The route curves around the Old Trails Inn (after passing the Palms Motel), which is on the site of one of the oldest tourist camps in the Needles area. The historic camp was filmed by director John Ford for *The Grapes of Wrath* and has a lot of history. Across the street an eye-catching sign shaped like a covered wagon welcoming visitors to Needles; a few yards away a rock with a plaque marks this as part of the

Opposite, top: National Old Trails Marker, Needles, California (1923). The city of Needles, California was originally a railroad settlement and was founded near the Old Trails Bridge where the Atchison, Topeka and Santa Fe Railroad crossed the Colorado River. The town was moved to its present location in 1883 and is on the National Old Trails Road, which crossed northern Arizona and the Mojave Desert to Los Angeles. This marker is on the south approach to Needles on U.S. 66 near the official sign for the city, a covered wagon inscribed with the words "Needles California," and is across the highway from the Old Trails Inn, formerly the Palms Motel, featured in *The Grapes of Wrath. Opposite, bottom:* 66 Motel, Needles (1946/47). On the south side of Needles is the 66 Motel, which began as a motor lodge called Carty's Camp in the mid–1930s. In 1946 (or 1947), a family of Finnish descent bought the property and built a motel in front of the old auto court, which is still located behind the present-day motel, although it is in a state of disrepair. Today, the 66 Motel is the oldest continuously-operating motel in Needles and is currently owned by Marjut Paakkanen, a descendent of another Finnish family.

National Old Trails Road. Down the road on the left is the 66 Motel, the oldest motel in Needles, built after World War II by a family of Finnish descent. Before the war, this was the location of Carty's Camp, possibly the first of its kind in the United States. Carty's Camp was a 12-unit lodge and had six one-room cabins arranged back-to-back. Each unit was separated by an attached garage which kept the cars protected from the scorching desert sun. This little-known piece of American history is currently in poor condition and the motel only rents by the month since it can't compete with flashy, modern motels. The 66 Motel is owned by another Finnish family, and current manager Dave Deenick (a long-time Needles resident) plans to someday restore the old tourist court and revive the motel so that it will again appeal to overnight guests.[232]

Broadway continues through Needles, and has served as Route 66 for most of the highway's life. Virtually all of the original cafés and lodging are gone; a sec-

ond generation of circa–1960s and '70s motels lines the route, including the Desert Inn, the Overland Motel, and the Imperial 400 (a now-defunct motel chain). Modern 66 passes K Street and bends right near I-40, merging with Front Street, where the combined routes become N Street and follow the Needles Highway past the Hungry Bear Restaurant to I-40. Since U.S. 66 ends at I-40 approximately nine miles past Needles, drivers must take the interstate. The route ahead follows the path of U.S. 66 west through the South Pass. At the exit for U.S. 95 (Goffs Road), a very old pre–1931 alignment leaves I-40 and heads north on a 30-mile loop road that returns to I-40 west of Needles, while the post–1931 highway continues west, replaced by the interstate. The pre–1931 road follows the National Old Trails Road, which ran parallel to the Santa Fe Railroad across the Mojave. A portion of the route through here was once a wooden plank road linking sources of water found along the way. In the days of the National Old Trails Highway, and later Route 66,

Robinson's Motel, Needles. One block off of Route 66 is the quaint Robinson's Motel, dating to the late 1940s. The neat wooden structures are divided into four units and according to the sign in front of the office, are "Cooled by Refrigeration," a forerunner of air conditioning in which a fan moved air through water that dripped from ice that was brought in. The El Garces and the Needles Theater (circa 1929) also used this method to provide their guests with some welcome relief from the harsh Mojave climate.

many travelers hired the railroad to transport their vehicles across the desert on flat-bed rail cars.

After exiting I-40 and heading north on U.S. 95, drivers will come to a railroad junction where U.S. 95 continues north to Searchlight and Las Vegas, while Route 66 branches off to the west toward Goffs. The road to Goffs continues due west for 12 miles, running close to the Santa Fe tracks. The road crosses the tracks and arrives at the dusty town of Goffs, current population 23. The main point of interest in town is the old general store and school, circa 1914.[233] Leaving Goffs, the road bears southwest and crosses under the interstate, then passes the site where Fenner was once located. A few miles past Fenner, the post–1931 alignment joins the original route; it is marked as the National Old Trials Road. Next comes the tiny town of Essex, consisting mainly of a post office and café. Ahead is the vast Mojave Desert; even today, the Mojave is a formidable obstacle for travelers. During the scorching summer months when temperatures can exceed 120°F, some motorists opted to leave Needles early in the morning, before the mid-day heat; others, like the Joads, crossed the desert at night just to be safe.

At Essex, 66 continues southwest, with the Santa Fe about a mile south of the old road. The "towns" noted along the rail line on old road maps mark the locations of railroad stops, some of which were uninhabited. Approximately 10 miles past Essex is Danby, south of the main highway, followed by Summit, but nothing much remains of either town. After Danby, the railroad gradually diverges from U.S. 66 and the road climbs through the Marble Mountains. The town of Summit, consisting of a few tourist cabins with a café and gas station, was once found at the mountain pass. Today, only the empty shells of a few vacant structures remain. Leaving the Marble Mountain range, the highway heads west and passes the road to Cadiz, a town approximately three miles to the south. Cadiz was on the National Old Trails Road, which followed the Santa Fe railroad, and currently both is a few homes and a railroad stop. Just north of 66 is a white cement monument put up by a man named Billy Holcomb to commemorate Route 66 and the bypassing of 66 through the Mojave by I-40 in 1973. The old town of Chambless comes next; it had a market, filling station and cabins back in the 30s, and was one of the few places in the Mojave Desert with a grove of trees for shelter.[234]

Road scholars, notably Jerry McClanahan and Jerry Ross, have discovered that the section of Route 66 from Essex west to Ludlow is the second alignment for the

Goffs, California. The town of Goffs is at the northernmost point of a 34-mile loop road for U.S. 66 between Needles and Fenner, which was bypassed in 1931. This old loop road was the original National Old Trails Road, and followed U.S. 95 (formerly the Arrowhead Highway) west 13 miles to Goffs, then south to Fenner. Currently, only 23 people live in Goffs, bypassed two generations ago first by Route 66, then the interstate.

Top: Route 66, Mojave Desert. A deserted stretch of U.S. 66 west of Interstate 40 and the exit for Fenner, California. Even with today's superior automobiles and modern interstate freeways, the Mojave Desert remains a place to get across as quickly as possible, or avoid altogether. Many early travelers preferred to pay the railroad to ship their vehicles across the desert on flatbed rail cars. This view is looking west toward Essex. *Bottom:* Post Office and Café, Essex. South of Fenner and Interstate 40 are a handful of buildings, which make up the town of Essex. The route through here is a continuation of the National Old Trails Road that followed the Atchison, Topeka and Santa Fe Railroad tracks a mile southeast of this location. The town's handful of buildings lie on the south side of current Route 66 and it appears that the town's post office is the only place still open.

Old Route 66 Marker. On the north side of Highway 66 is a white cement monument dedicated to U.S. 66, built by Billy Holcomb. The monument is near the town of Chambless, which was once on the south side of Route 66 just west of the Marble Mountain Pass. Chambless had one of the few groves of trees along the route through the Mojave Desert, and had a café, cabins and a filling station. Nothing remains of Chambless today.

and motel were filled to capacity, as were the restaurant and garage. With such a tremendous flow of traffic, breakdowns were common, and Burris kept three shifts of mechanics busy around the clock by pulling broken-down cars off the desert highway. After the final link of I-40 was completed just to the north of Amboy in 1972, traffic slowed to a trickle.[237] Despite Burris's investment of several million dollars in the business over the years, the motel and café closed, and the property is currently up for sale. Burris died in the late 1990s, but the buildings have remained untouched, and Roy's Café and Motel still endures.

The railroad crosses U.S. 66 to the north side at Amboy. The next town is Baghdad, a tiny settlement just north of the road; this ghost of a town inspired the cult film *Baghdad Café*, about a female German tourist who became stranded here and opened a café. The plot could easily have been based on the real-life experiences of people who started roadside

National Old Trails Highway, with the original route following the railroad to the south. Isolated pieces of the Old Trails Highway can be found at Cadiz and other places along the route, but traces of the old road are difficult to find.[235]

Route 66 continues west, a lonely two-lane ribbon crossing the parched wilderness. During the heat of the day, mirages start appearing on the roadway and off in the distance at the foothills of the San Gabriel Mountains. Just as driver fatigue starts to set in, Amboy materializes on the horizon. The town once numbered 264 hardy souls, with two cafés, a filling station and garage with a restaurant.[236] In 1938, Buster Burris arrived here to help his father-in-law, Roy Howard, start a new motel business. Burris, a Texas native, moved to California in the 1930s while serving in the U.S. Air Force; he met his first wife, Mary, in San Bernardino. Mary's father had come to the Mojave area in 1925 to work in the salt mines nearby. He convinced Buster to build an auto garage on 50 acres he purchased in Amboy. When the war ended in 1945 and tourism resumed, Burris opened a café, which he named "Roy's" after his father-in-law. Route 66 was a congested highway during the post-war years, and Burris's cabins

businesses on Highway 66 wherever their trips abruptly ended. Baghdad now exists only in the memories of those fortunate travelers who visited the area in the days before the interstate. The highway next bears northwest and passes some lava hills and the Santa Fe tracks to the north. Another series of railroad "towns" were once located along this stretch, spaced at three- or four-mile intervals. The first was called Haynes, followed by Siberia and Klondike (probably named to give some psychological relief to travelers), then Ash Hill. Rittenhouse reported that "skeletons of cars are frequent along the roadside" through this area.[238] The road comes to a railroad signal and crosses north over the Santa Fe tracks, then makes a left turn to continue west toward Ludlow.

Ludlow is the first sizable town after Needles and is just south of the interstate, but contains only a few businesses. The road first passes the vacant Ludlow Café and an abandoned filling station across the road. Ahead are the Ludlow Motel and the Ludlow Coffee Shop, both still in business. The Ludlow Motel has been owned by John Knoll since 1978 and now includes a Dairy Queen and Union 76 station. Highway archeologists can search for the remains of the Ludlow Mercantile/Murphy Brothers,

Top: Santa Fe train crossing Mojave near Danby, California. The Mojave portion of Highway 66 provides timeless landscapes and almost infinite vistas. Danby is several miles south of the current Route 66. Its forerunner, the National Old Trails Road, followed the railroad line across the desert. Traces of the original trail are extremely difficult to find. *Bottom:* Road Runner's Retreat, U.S. 66, Mojave Desert. A shuttered business along Route 66 west of Chambless, California. The Road Runner's Retreat had a short life and was opened during the final years of Route 66. The Road Runner, obviously, has seen its last customer.

Amboy, California. An extinct lava crater is evidence of volcanic activity in the middle of the Mojave Desert near Amboy, California thousands of years ago. Route 66 is a straight stretch of road through the desert, with no services available between the few remaining towns along its route. The town of Amboy appears like an oasis at the crest of the next rise in this view, facing west.

dating to 1908, and the foundation of an old café that was the actual location for the filming of *Baghdad Café*. Ludlow also has a few surviving sections of "plank road" built in the days when this was still the Old Trails Road. The sandy soil in the area ensnared both wagons and motorized vehicles, so discarded railroad ties were placed along the route, forming a suitable path for traffic through the area.[239] Route 66 continues west along the south side of I-40, crosses a lone concrete bridge, and ends in the desert. Interstate 40 must be taken to the exit for Hector Road, where the route resumes. Early maps show a town called Newberry at this location. This route follows the Old National Trails Road (also called the National Trails Highway) and heads toward Daggett.

The town of Daggett dates to the 1880s, and was the first railroad stop for trains traveling to and from the silver and borax mines to the north. The Union Pacific built two rail lines to the mines: a narrow gauge track that hauled silver ore and a three-track line that could be switched between narrow and standard gauges. The Atchison, Topeka and Santa Fe also ran an east–west line

through the area, and a small settlement grew up nearby as traffic gradually increased. A trail ran parallel to the railroad tracks from Needles to Barstow. It was first used by workers building the rail line and later by wagon trains, although many people traveled by train to avoid the hazards of the desert. This trail, which eventually became the National Old Trail and resumes at the exit for National Trails Highway. From here, U.S. 66 and the National Trails Highway continue west along the north side of the interstate and cross a small bridge. In the distance is the Fort Irwin Marine Corps training center, a large facility north of Daggett.

Sixty-six enters Daggett, passing a string of businesses flanking the south side of the road. This road was built in the 1920s to route travelers past the original center of town. The first structure the motorist of the 1930s encountered was an agricultural inspection station erected by the state of California in 1931. The station checked vehicles entering the state from Arizona, and replaced an earlier one built in 1923. (John Ford brought his film crew to Daggett in 1939, and the inspection station

Roy's Motel and Café, Amboy (1938). Established in 1938, Roy's was named after the father-in-law of founder "Buster" Burris. Burris added a café and motel in the early 1940s, and stayed busy around the clock towing disabled vehicles off of the desert, since it was the only garage for miles around. That all changed in 1973, when the final link of Interstate 40 was completed and Amboy became as quiet as it was before the birth of Route 66.

makes a brief appearance in *The Grapes of Wrath* as the Joads are stopped a second time by border inspectors.) Sadly, no trace of the old inspection station can be found today. One of the best-known businesses along this stretch was Kelly's Café, opened during the Depression by the Kelly family. The café was a popular way station for travelers of every type and was particularly frequented by long-haul truckers. During the 1930s and 1940s, a rivalry developed between truck drivers employed with large cartage companies and independents, known as "wild cats." Kelly's was one of many roadside places where the two groups came face-to-face. Kelly's was a Shell station and was once cited for being the top seller of Shell gasoline in the United States, and the café was the pick of the average vacationer.[240] The road comes to an intersection, with a road leading north to Interstate 40 to the left (south) and the original town of Daggett to the right. Just east of the intersection, however, a right turn north to "Old Daggett" takes drivers to the Desert Market, where the Old National Trails Road runs right in front of the store. The Desert Market, turquoise with white trim, is

the only colorful building in town. It first opened in 1908 as Ryerson's General Store; the current structure, made of concrete, replaced the original wooden building, which was consumed in a fire. Next to the Desert Market is the Stone Hotel, built in 1883 when Daggett was still a fledgling settlement. The hotel is made of rocks found in the area and is currently in the process of restoration. Fire often claimed wooden buildings during the days of the Old West, but the sturdy old stone hotel has survived to the ripe old age of 120. Daggett's original railroad depot burned to the ground in the 1960s—another historical loss for U.S. 66. Daggett was incorporated in 1914 and was soon visited by some of the earliest pioneers of auto touring on the National Old Trails Highway.[241] Route 66 continues westbound for a short distance but eventually ends, so drivers should take the interstate to where the old road resumes, on the north side of the interstate outside of Barstow.

U.S. 66 passes under Interstate 40 (which officially ends here) and enters Barstow, following Main Street through the center of town. Barstow was a small city of

Ludlow Café, Ludlow, California. Ludlow, California is 27 miles west of Amboy on the north side of the Atchison, Topeka and Santa Fe Railroad tracks. The Ludlow Café is boarded up and is across the highway from a closed filling station. This location is rich in history, and has a rare section of plank road dating to the days of the National Old Trails Road. The town isn't dead, as the Ludlow Motel and Ludlow Coffee Shop are still open just a short distance to the west.

slightly over 2,000 in the 1940s, when it was a stopping place for travelers destined for Los Angeles. Barstow also sits at the junction of U.S. 66 and U.S. 91 (the Arrowhead Highway), the latter heading north to Las Vegas, following I-15. In the 1800s, Barstow was a supply center for mines in the Mojave area. It is still growing today, despite the harsh desert climate. An abandoned Terrible Herbst gas station is one of the first sites travelers encounter, a dazzling structure with a tile roof and two canopies. In the center is a small building for the attendants, which is crowned by a lighthouse-like tower. The historic Santa Fe depot (1910) and the Fred Harvey House hotel (later, the Casa Del Desierto) are just off Main Street, along with several other historical buildings. The route passes several motels, some old, some new, along with cafés that have withstood both the test of time and the fast-food chains, including the New City Café and the Village Hotel and Cafe. The El Rancho Motel's giant sign directs the motorist toward the south side of the highway at North 2nd Avenue, where a sprawling motel dominates a hillside between Main and Williams streets. The El Rancho was built

in 1944 from railroad ties; the motel's units are in a U-configuration and are terraced up the hillside toward its huge neon sign.[242] The motel has a restaurant — the El Rancho Coffee Shop, built the same year — abutting the highway in front of the motel complex. The old 66 Motel is ahead on the right and the Palm Café (circa 1960) on the left, and farther down the street is the Desert Lodge.[243] As Route 66 leaves town, the road changes course and heads southwest towards its final destination, Los Angeles.

Leaving Barstow, Route 66 makes a wide arc to Victorville, some 40 miles ahead, while Interstate 15, located to the east, takes a more direct route. This downhill stretch follows the Mojave River and the Santa Fe Railroad. It passes Lenwood, just a few miles outside of Barstow, then Hodges, Helendale and Oro Grande, all very small settlements. A line of telephone poles and the railroad follow Old 66, and the ruins of a few filling stations line the route. Just before Victorville, a vintage steel truss bridge crosses the Mojave River, beyond which the road crosses underneath I-15 and enters town. The scenery

(SEE COLOR SECTION C-32.) Desert Market, Daggett, California (1908). Four years before Daggett, California became a municipality, Ryerson's General Store was built on the National Old Trails Highway using a boxcar of cement, since the original structure burned in a fire. A small settlement began here in the early 1880s, because this was the junction of the Union Pacific and Santa Fe Railroads and it was near the silver and borax mines in the northern Mojave Desert. A few other historic structures also remain in Daggett, including the Stone Hotel (circa 1883), which is in the process of renovation.

through this area is rugged and strewn with boulders—an ideal location for filming western movies, which is why many early movie makers came to the Victorville area in the early decades of the twentieth century. Victorville hosted film legends such as William S. Hart, Tom Mix, and Roy Rogers, and the Roy Rogers Museum is appropriately located here. Route 66 makes a right turn in Victorville and heads south out of town. A few older motels are still left in Victorville, including the New Corral Motel, still kept in period condition, its advertising sign topped with a black stallion rearing up on its hind legs. However, the road ends at I-15, so the journey must resume on the interstate.

The interstate arrives at the exit for Hesperia, located four miles west of the freeway. This was the location of Miller's Corners, a filling station recommended by Rittenhouse.[244] The interstate climbs at least 18 miles to the Cajon Summit, 4,257 feet above sea level. The next exit is at the Cajon Pass (Oak Hill Road exit), where U.S. 395 intersects with I-15/U.S. 66. The Summit Inn and Restaurant, south of the highway, dates to 1952. The business was built by Gordon Fields for a Mr. Riley, and the restaurant is still open. After reaching the crest of the summit, the highway makes a long downgrade through the Cajon Pass and heads southeast. The town of Cajon is three miles past the summit. This stretch was once lined with gas stations and was a heavily-traveled route leading into the Los Angeles metropolitan area. Interstate 15 reaches a "Y" with I-215, with I-15 heading toward Los Angeles and I-215 continuing south toward San Bernardino.

Route 66 can be picked up at the exit for the small town of Devore (just past the turnoff for I-15). Route 66 continues southwest as Cajon Boulevard along the south side of I-215. Cajon Boulevard, is a four-lane avenue which passes some aging motels, makes

Village Hotel and Café, Barstow. An old neon sign for one of several businesses in Barstow that survived the advent of the interstates. The city is at the western edge of the Mojave Desert and was a supply center years ago for mines north and west of here. The Village Hotel and Café is on Main Street (U.S. 66) in Barstow's central business district.

Top: Palm Café, Barstow (1960). A more recent addition to Route 66's inventory of vintage businesses is the Palm Café, now one of the oldest restaurants in Barstow, California. The site was originally a filling station but was remodeled into a small café in 1960, where Butch Der worked until he bought the business in 1965. During the ensuing 35 years, Der expanded the café three times to keep up with a steady flow of customers despite U.S. 66 being bypassed in the 1960s. The Palm Café still operates on Barstow's Main Street, although Mr. Der is approaching retirement after dedicating most of his life to serving customers on America's Main Street. *Bottom:* Sands Motel and Cactus Motel, Barstow. Two motels with typical western names in Barstow, California on Route 66. Barstow has a good number of post-war businesses along Main Street and is also the site of several historic buildings, such as the Casa Del Desierto and the Santa Fe railroad depot. Several other old motels, including the Desert Lodge, the Sage Motel, and the Western Motel, as well as the New City Café, are still operating along Highway 66.

El Rancho Motel, Barstow (1944). The El Rancho Motel's giant three-sided neon sign has dominated Barstow's skyline for decades, leaving an indelible impression on generations of Route 66 travelers. The El Rancho Motel, like other buildings in the Mojave area, is constructed of leftover railroad ties due to the scarcity of wood. The motel forms a giant semi-circle that fronts on the south side of U.S. 66, with the El Rancho Coffee Shop ("world famous since 1944") fronting on the highway.

a sharp right turn at the Oasis Motel, and continues south to the intersection with Highland Avenue. The City 66 route headed into San Bernardino by following Highland Avenue east into town, while Alternate 66 continued straight ahead on Vernon Avenue due south. Highway archeologists with time to spare might take a detour into San Bernardino, where the first McDonald's drive-in restaurant was opened in 1948 by Dick and Mac McDonald, on E Street.[245]

Alternate 66 continues south about three miles through Rialto and intersects with Foothill Boulevard. At Foothill Boulevard, the road takes a right turn west and is conveniently marked as California State 66. The next 80 miles of U.S. 66, from here to its end at the Pacific Ocean, pass through continuous urbanized area. Just east of the junction of Pepper Avenue is Wigwam Village #7, built in 1953 (three years after Wigwam #6 in Holbrook, Arizona) by none other than Frank Redford. Redford sold his two Kentucky Wigwam Villages in 1945 and, like many other Americans, migrated west to southern California.[246] Foot-

hill Boulevard continues west through the cities of Fontana and Rancho Cucamonga. At 15395 Foothill Boulevard visitors will find Bono's Restaurant and Deli — originally a small roadside fruit stand catering to tourists and L. A. area residents who passed through this vicinity as they descended from the mountains north of the metro area on weekend excursions.[247] In the town of Rancho Cucamonga is a tiny circa–1920s filling station with Spanish-tile roof, still standing at the northwest corner of the intersection of Foothill with Archibald Avenue. (The Los Angeles area is a virtual graveyard of filling stations from the art deco period, which still remain despite the rapid proliferation of strip malls and other development.) The route passes more old motels, including the 40 Winks, the Rose Motel, the A-1 Trailer Park, and the Mogue Motel. In Rancho Cucamonga, travelers will find the Sycamore Inn, originally a stagecoach stop for the Butterfield Overland Company and dating to 1848. The current structure was built by John Klusman, a local citrus rancher, in 1912, and is styled after quaint country inns

Top: Bridge over Mojave River. A vintage two-lane steel truss bridge crossing the Mojave River a few miles north of Victorville, California on Route 66. The bridge has ornate railings and is angled to accommodate the sharp curve across the river south of Cajon Canyon. Ahead is Victorville, home of the Roy Rogers Museum and the location of many legendary western films.
Bottom: Summit Inn and Restaurant (1952). Route 66's final approach into Los Angeles through Cajon Pass was one the most hazardous stretches of the old road, dropping 2,000 feet on a continuous six-mile descent for those heading into the metropolitan area. The steep climb uphill was no picnic for eastbound traffic either, and a string of filling stations once lined the route to rescue unfortunate drivers. At the top, however, the Summit Inn and Restaurant was ready to greet travelers, beginning in 1952, when Gordon Fields built the business for a Mr. Riley.

Top: Burned-out vintage station, Devore, California. Route 66 heads southeast toward San Bernardino as Cajon Boulevard and passes through the town of Devore. This very early gasoline filling station lies within a wedge-shaped lot at the intersection of State Street and Cajon Boulevard. This portion of U.S. 66 was once a busy highway but sees much less traffic now, as it was by-passed by I-215. *Bottom:* El Cajon and Palms Motels, Cajon Boulevard, Devore. A short distance south of the junction with State Street are a few old motels, such as this pair on the west side of Cajon Boulevard in Devore. This area was once on the fringe of the Los Angeles basin and sometimes weary travelers opted to stop here rather than drive farther to find sleeping quarters.

Top: Wigwam Motel #7, Rialto, California (1953). West of San Bernardino is the city of Rialto and Wigwam Village #7, built in 1953 by the same Frank Redford who owned the two original Wigwams in Kentucky. Redford sold his Kentucky motels in 1945 and died in 1958, after which Wigwam #7 was sold. The 19-unit motel is one block east of Pepper Avenue on Foothill Boulevard and has been rumored for years to be a future victim of new development. The motel has updated its image a bit by changing its slogan to "Do it in a Tee Pee" and adding a brightly-colored paint scheme. *Bottom:* Bono's Restaurant, Fontana, California (1936). Thousands of Americans migrated to southern California during the early decades of the twentieth century to take advantage of the state's temperate climate. Many, like James and Frances Bono, purchased land in the San Bernadino area in the 1920s, hoping to make a living by starting orchards, vineyards and small farms. To supplement their modest income, Frances opened a roadside stand here on July 17, 1936, selling oranges, lemons, and "all the orange juice you can drink for 10 cents," plus wine that tourists could buy in bulk quantities. The Bonos opened a deli and expanded it into a restaurant and added on to the original small building (dating to the late 1800s) several times over the years. Although the founders have both passed away, the business is still operated by their son, Joe Bono.

First Winery in California, Rancho Cucamonga (1839). Located on the north side of Foothill Boulevard is one of California's earliest historic sites. This building is the oldest winery in the state, established in 1839. This structure currently sits behind several retail businesses.

of old Europe. The Inn was remodeled in 1939, and currently is a restaurant featuring fine cuisine (some are original southern recipes handed down from its founder, William "Uncle Billy" Rubottom) and over 600 wines from its three wine cellars. The site of the original inn is marked by a bear, installed in 1932 by the Native Daughters of the Golden West in the Ontario Room of the Sycamore Inn.[248] Also found in Rancho Cucamonga is California's oldest winery, dating to 1839, situated behind some present-day businesses on the north side of Foothill Boulevard.

Next comes Upland, where the statue of the Ma-

donna of the Trail marks the end of the National Old Trails Highway at the intersection of Euclid Avenue. After passing through Claremont and entering La Verne, the road bends northwest and goes under I-210 (the Foothill Freeway) to San Dimas, then Glendora. At Glendora, two alignments can be taken, with the newer route proceeding straight ahead (west) on Alosta Avenue. The older alignment, dating from the 1930s, heads north on Amelia Avenue, then west on Foothill Boulevard until it ends at Citrus Avenue, where the road turns south to meet Alosta Avenue.

Gas station, Foothill Boulevard and Archibald Avenue (1921). This gasoline station is on the north side of Foothill Boulevard in Rancho Cucamonga, a short distance west of the old winery. Dating to 1921, the old station is closed now, its future uncertain.

Continuing west on Alosta Avenue through Azusa, Duarte, and Monrovia, the route heads north on Shamrock Avenue a short distance, then turns west onto Foothill Boulevard. In the 1950s, 66 was rerouted to follow Huntington Drive, which curves around the Los Angeles Arboretum, hugging the south side of I-210, proceeds west through Arcadia and Sierra Madre and eventually becomes Colorado Boulevard (originally Colorado Street). The older alignment takes Foothill Boulevard west through Sierra Madre and jogs south to meet Colorado Boulevard, which heads west through South Pasadena and to the city of Pasadena.[249]

Colorado Boulevard, the main drag in Pasadena, is marked by Historic Route 66 signs. It's a busy thoroughfare, and seems an unlikely place for little old ladies to be racing (at least one driving a shiny red super-stock Dodge). At the intersection with Fair Oaks Avenue, Route 66 continued west across the Colorado Street Bridge — a historic structure just recently restored — and over the Arroyo Seco (Spanish for "dry stream") toward Glendale, then turned south on Figueroa Street and into downtown

Los Angeles. In the early 1930s, the highway was rerouted and turned south from this location onto Fair Oaks Avenue, then west on Huntington Drive. In the '30s, the cities of Los Angeles, Pasadena and South Pasadena collaborated on a highway project to improve traffic between the foothills area around Pasadena and the central Los Angeles business district. The plan for the new highway was based on the limited-access designs of parkways already in use in the eastern U.S. The result was a nine-mile parkway leading from the southern end of Arroyo Parkway (three blocks east of Fair Oaks) to Sunset Boulevard. On December 1, 1940, the Arroyo Seco Parkway (renamed the Pasadena Freeway in 1954) opened for traffic with an inaugural ceremony which included the 1941 Tournament of Roses Queen and California governor Culbert Olson. The Arroyo Seco Parkway was California's first "freeway," with four to six lanes divided by wide medians and limited access from side roads via entrance and exit ramps. The parkway concept rapidly gained acceptance across the country in the years leading up to World War II, and urban areas on U.S. 66 in Chicago, St. Louis and elsewhere

Sycamore Inn, Rancho Cucamonga (1912). William "Uncle Billy" Rubottom emigrated from Arkansas and purchased some land on this site in 1848. Rubottom built a one-room trailside inn that he named the Mountain View House among a grove of sycamore trees in an area known as Bear Gulch. It became a stage stop for the Butterfield Stageline, which carried passengers between San Bernardino and Los Angeles. The original inn burned and the present structure, erected in 1912 by John Klusman, was a social center for the town of Rancho Cucamonga. Today, the Sycamore Inn operates as a first-class restaurant featuring a wide assortment of wines from its three temperature-controlled wine cellars.

were already building four-lane "super-highways." The new parkway was an instant success on the West Coast, and it was designated as U.S. Route 66 soon after its completion.

Following the Pasadena Freeway toward Los Angeles, U.S. 66 and U.S. 99 cross under the Golden State Freeway (I-5), with the Los Angeles River passing underneath the highway. Elysian Park is immediately past the river, and the Pasadena Freeway then approaches an interchange with the Hollywood Freeway (U.S. 101). Just before the interchange, the eastern end of Sunset Boulevard crosses over the freeway on an overpass. Prior to 1952, Route 66 took Sunset Boulevard northwest from this location and turned west onto Santa Monica Boulevard. In the early '50s Route 66 was relocated, and continued past Sunset Boulevard to the interchange where the Pasadena Freeway officially ends and Interstate 110 heads south as the Harbor Freeway, bound for Long Beach. The new route took the Hollywood Freeway (U.S. 101) northwest, then exited off U.S. 101 onto Santa Monica Boulevard. After the decommissioning of Route 66 in 1985 the Pasadena Freeway became California State 11, and is currently designated as California State 110.[250]

Drivers can take at least two alignments that predate the Arroyo Seco Parkway route, beginning in Pasadena at the intersection of Colorado Boulevard and Arroyo Parkway. The first route, U.S. 66's original alignment, continued west on Colorado Boulevard to Eagle Rock, after which it turned south to downtown Los Angeles. The later route also continued west from downtown Pasadena on Colorado, but turned south onto Fair Oaks Avenue to Huntington Drive in South Pasadena. Route 66 turned west onto Huntington Drive, a major thoroughfare heading southwest toward downtown Los Angeles. Huntington Drive becomes Mission Road for a short distance in the Highland Park district; the route then turns west (right) on North Broadway and finally onto South Broadway, where the road crosses the interstate and enters central Los Angeles.[251]

To follow the old alignment on Sunset Boulevard, it is necessary to get off the Hollywood Freeway and backtrack to the beginning of Sunset where it crosses the Pasadena Freeway. The route is easy to follow and is marked with signs commemorating this alignment as a historic highway. Californians are especially hip to Route 66, as the Golden State has become synonymous with

Sunset Boulevard, Los Angeles (1935–1952). This sign, erected by the California Route 66 Association, marks the final leg of U.S. 66 through the Hollywood district of Los Angeles. This alignment was used as Route 66 for almost 20 years until it was moved onto the Hollywood Freeway (U.S. 101) in 1952. This is a view looking west near the eastern end of Sunset Boulevard, near where the Pasadena Freeway ends at U.S. 101.

End of Route 66, Santa Monica Boulevard at Ocean Way, Santa Monica. Although the official end of Route 66 is at the inter-section of Lincoln and Olympic boulevards, the sentimental terminus of U.S. 66 is where Santa Monica Boulevard ends at Pal-isades Park at Ocean Way. A small cement monument and plaque in the park is dedicated to Will Rogers and "The Main Street of America — Highway 66," and was placed there in 1952, the year the film *The Will Rogers Story* was released. For most, this is the real end of U.S. Route 66.

modern freeways and the American "car culture." From 1935 to 1952, U.S. 66 followed Sunset Boulevard north-west through an area whose architecture still has the clas-sic feel of pre–World War II Los Angeles. At Santa Mon-ica Boulevard, the route turned left (west) through the famed Hollywood district. Santa Monica Boulevard has long been one of Los Angeles' main thoroughfares and is lined with hundreds of shops and businesses, some of which have survived decades of changing consumer trends and urban redevelopment. The route heads south-west through fashionable West Hollywood and Beverly Hills. U.S. 66 passes Century City, Westwood and West Los Angeles as California State Highway 2. The route con-tinues southwest toward the Pacific Ocean and enters the city of Santa Monica. However, just seven blocks before reaching the Pacific Ocean at Ocean Way, Route 66 makes a left turn at Lincoln Boulevard, heading southeasterly. Three blocks later, U.S. 66 officially ends at a nondescript intersection at Lincoln and Olympia boulevards. How-

ever, few people followed this route and continued straight ahead on Santa Monica Boulevard, bound for the ocean sunset. Santa Monica Boulevard finally ends at Ocean Way and Palisades Park, with the Pacific Ocean within visual range. A restaurant called the Bell Vu was at this location from 1937 until its closure some decades ago.[252] The words "Bell Vu" painted on the side of a brick building on the final block of Santa Monica Boulevard is the only reminder of the Bell Vu. Within Palisades Park is a cement monument and plaque dedicated to Will Rogers and Highway 66 dating to 1952, the year the movie *The Story of Will Rogers* was released. At this peaceful spot, where warm sea breezes sweep in from the Pacific and up the cliff to the park, the 2,448-mile journey of Route 66 ends. The Will Rogers memorial is perhaps just one more reason for choosing this location as the stopping point for Route 66, a true legend of the Great American Road.

Notes

1. Dave Bartholomew, "Route 66, The Man and the Song," *Route 66 Magazine*, Summer 1994.
2. Helene Thanas, Chicago, IL.
3. "Historic Route 66 in Illinois," Illinois DOT.
4. Larry Hassert, White Fence Farm, Lemond, IL.
5. "Historic Route 66 in Illinois," Illinois DOT.
6. Ibid.
7. Ibid.
8. Mike Russi, Lucenta Tire, Braidwood, IL.
9. "Historic Route 66 in Illinois," Illinois DOT.
10. Ibid.
11. Old Log Cabin Inn, Pontiac, IL.
12. Michael Wallis, *Route 66, The Mother Road*, St. Martin's Press, 1990.
13. Dixie Trucker's Home, McLean, IL.
14. Wallis, 1990.
15. Tom Snyder, *The Route 66 Traveler's Guide and Roadside Companion*, St. Martin's Press, 1990.
16. Wallis, 1990.
17. Edwin Waldmire III and Sue Waldmire, Springfield, IL.
18. Stacia Seaton, Waggoner, IL.
19. Nicholas Adams, Litchfield, IL.
20. Karen Soulsby, Mount Olive, IL.
21. Quinta Scott and Susan Croce Kelly, *Route 66*, University of Oklahoma Press, 1988.
22. Robert Earnhart, Hamel, IL.
23. Jack D. Rittenhouse, *A Guide Book to Highway 66*, University of New Mexico Press, 1988.
24. Larry Wofford, Mitchell, IL.
25. James E. Easterly, Illinois DOT and Christopher Schwarberg, "The Old Chain of Rocks Bridge."
26. Illinois DOT.
27. C. H. Curtis, *The Missouri Route 66 Tour Book*, Curtis Enterprises, 1994.
28. Travis Dillon, St. Louis, MO.
29. Shellee Graham, "Museum of Transportation Unveils Coral Court Facade," Society for Commercial Archeology News, Summer 2000.
30. Snyder, 1990.
31. Rittenhouse, 1988.
32. Cassie Hombs, "A Quieter Time," *The Joplin Globe*, 2001.
33. Curtis, 1994.
34. Ibid.
35. Wes Karna, Pacific, MO.
36. Rittenhouse, 1988.
37. Betty Thomure and L'la Merle Daub, Villa Ridge, MO.
38. Meramec Caverns, Stanton, MO.
39. Curtis, 1994.
40. Ibid.
41. Pauline Armstrong, Cuba, Mo.
42. The Rosati Winery, Rosati, MO.
43. George Piazza, Rosati, MO.
44. Curtis, 1994.
45. Russ Bullock, St. James, MO.
46. Curtis, 1994.
47. Ibid.
48. Ibid.
49. Ibid.
50. Ibid.
51. Nye Goodridge, Vernelle's Motel, Newber, MO.; John Bradbury, University of Missouri, Rolla, MO.
52. Rittenhouse, 1988.
53. Curtis, 1994.
54. Ibid.
55. Ibid.
56. Ramona Lehman, Lebanon, MO.
57. Rittenhouse, 1988.
58. Glenn Wrinkle, Jr., Lebanon, MO.
59. Curtis, 1994.
60. Julie Turner, "75 Years of Kicks on Route 66," *The Lebanon Daily Record*, September 2, 2001.
61. Ramona Lehman, Lebanon, MO.
62. Curtis, 1994.
63. Ibid.
64. Rittenhouse, 1988.
65. Rittenhouse, 1988.
66. Curtis, 1994.
67. Steak and Shake Restaurant, Springfield, MO.
68. Wally Kennedy, "Motel Was a Travel Court for Motorists on the Mother Road," *The Joplin Globe*, July 30, 2001.
69. Scott Meeker, "Drive-In Theater Back in Business," *The Joplin Globe*, July 30, 2001.
70. Curtis, 1994.
71. Scott Nelson, Eisler's Old Riverton Store, Riverton, KS.
72. Ibid.

73. Wanda Murphey, Baxter Springs, KS.
74. Annie Stewart, "The Haunting of Spooklight," *Route 66 Magazine*, Summer 1994.
75. David Rayburn, Oklahoma Department of Transportation.
76. Scott Meeker, "Still Showing; Memories Rerun Daily at Miami's Grand Theater," *The Joplin Globe*.
77. Francis Maloney, Afton, OK.
78. Robert Waldmire and Oklahoma Tourism and Recreation Department, Discover Oklahoma, 1990.
79. Wallis, 1990.
80. Wanda Derosia, Foyil, OK.
81. Ann De Frange, "Legacy of a Dreamer," *Route 66 Magazine*, Summer 1994.
82. Waldmire and Oklahoma Tourism and Recreation Department, 1990.
83. Barbara Pool, Claremore, OK.
84. Waldmire and Oklahoma Tourism and Recreation Department, 1990.
85. Ann De Frange, "Tale of a Whale," *Route 66 Magazine*, Fall 1994.
86. "Official Oklahoma Route 66 Association Trip Guide, 2002–2003," Oklahoma Route 66 Association, 2002.
87. Boston Avenue Methodist Church, Tulsa, OK.
88. Waldmire and Oklahoma Tourism and Recreation Department, 1990.
89. Jerry McClanahan and Jim Ross, *Here It Is, Route 66, The Map Series*, Ghost Town Press, 1990.
90. Rittenhouse, 1988.
91. Fred Welch, Stroud, OK.
92. "Official Oklahoma Route 66 Association Trip Guide, 2002–2003," Oklahoma Route 66 Association, 2002.
93. Michael Patel, Lincoln Motel, Chandler, OK.
94. "Official Oklahoma Route 66 Association Trip Guide, 2002–2003," Oklahoma Route 66 Association, 2002.
95. Ibid.
96. Ibid.
97. *World Almanac*, Funk and Wagnall, 1995.
98. Andy Lefkowitz, "Barn Comes Full Circle," *The Joplin Globe*, August 27, 2001.
99. "Official Oklahoma Route 66 Association Trip Guide, 2002–2003," Oklahoma Route 66 Association, 2002.
100. Jim Powell, "Route 66, An American Adventure," *Route 66 Magazine*, Summer 1994.
101. David Rayburn, Oklahoma Department of Transportation.
102. Waldmire and Oklahoma Tourism and Recreation Department, 1990.
103. Scott Meeker, "Route 66 Grocer Sacks Up Nostalgia," *The Joplin Globe*, 2001.
104. Rittenhouse, 1988.
105. Waldmire and Oklahoma Tourism and Recreation Department, 1990.
106. "Official Oklahoma Route 66 Association Trip Guide, 2002–2003," Oklahoma Route 66 Association, 2002.
107. Rittenhouse, 1988.
108. Waldmire and Oklahoma Tourism and Recreation Department, 1990.
109. Walter Mason, Clinton, OK.
110. Rittenhouse, 1988.
111. "Official Oklahoma Route 66 Association Trip Guide, 2002–2003," Oklahoma Route 66 Association, 2002.
112. Rittenhouse, 1988.
113. Ibid.
114. Ibid.
115. "Official Oklahoma Route 66 Association Trip Guide, 2002–2003," Oklahoma Route 66 Association, 2002.
116. Rittenhouse, 1988.
117. Ibid.
118. Scott and Kelly, 1988.
119. Rittenhouse, 1988.
120. Tonya Detten, Texas DOT.
121. Rittenhouse, 1988.
122. Mike Head, Amarillo, TX.
123. Linda Drake, Vega, TX.
124. Ibid.
125. Ibid.
126. Fran Hauser, Adrian, TX.
127. Rittenhouse, 1988.
128. Jim Powell, "Route 66, An American Adventure," *Route 66 Magazine*, Summer 1994.
129. McClanahan and Ross, 1994.
130. Joann Harwell, Adrian, TX.
131. Rittenhouse, 1988.
132. Ibid.
133. Wallis, 1990.
134. "Welcome to Tucumcari, the Legendary City," Tucumcari-Quay County Chamber of Commerce.
135. Dale Bakke, Tucumcari, NM.
136. Mike and Betty Callens, Tucumcari, NM.
137. Snyder, 1990.
138. "Santa Rosa, New Mexico," Santa Rosa Chamber of Commerce.
139. Ibid.
140. Mike Gallegos, Santa Rosa, NM.
141. Rittenhouse, 1988.
142. Johnny Martinez, Santa Rosa, NM.
143. Ibid.
144. Wallis, 1990.
145. Jerry McClanahan, "The Lost Highway," *Route 66 Magazine*, Winter 1994-1995.
146. Jerry McClanahan, "The Lost Highway," *Route 66 Magazine*, Spring 1995.
147. Ibid.
148. McClanahan and Ross, 1994.
149. Snyder, 1990.
150. Susan Bohannan Mann, "Irate Governor Paved Way for Route 66," *Route 66 Magazine*, Spring 1994.
151. Wallis, 1990.
152. Rittenhouse, 1988.
153. Wallis, 1990.
154. Ibid.
155. Rittenhouse, 1988.
156. Albuquerque New Mexico's Historic Route 66 Tour Guide and Map, New Mexico Department of Tourism, 1993.
157. Steve Vaatoseow, Albuquerque, NM.
158. Glen W. Driskell, "The Passing Parade," *Route 66 Magazine*, Spring 1995.
159. Albuquerque New Mexico's Historic Route 66 Tour Guide and Map, New Mexico Department of Tourism, 1993.
160. Sam Kassam, Albuquerque, NM.
161. Rittenhouse, 1988.
162. Albuquerque New Mexico's Historic Route 66 Tour Guide and Map, New Mexico Department of Tourism, 1993.
163. Ibid.
164. Wallis, 1990.

165. Rittenhouse, 1988.
166. Wallis, 1990.
167. Ibid.
168. Betty DeSoto, Villa de Cubero Trading Post, Cubero, NM.
169. Rittenhouse, 1988.
170. Ibid.
171. Johnny Callahan, Uranium Café, Grants, NM.
172. Rittenhouse, 1988.
173. Sam Soohoo, Gallup, NM.
174. Wallis, 1990.
175. Rittenhouse, 1988.
176. Yellowhorse Trading Post, Lupton, AZ.
177. Rittenhouse, 1988.
178. McClanahan and Ross, 1994.
179. Rittenhouse, 1988.
180. Kimberly Gallegos, Holbrook, AZ.
181. Elinor Lewis, Holbrook, AZ.
182. Cindy Jaquez, Joseph City, AZ.
183. Rittenhouse, 1988.
184. Ibid.
185. Gilbert Lopez, Arrowhead Bar, Winslow, AZ.
186. Steve and Cathy Machie, "Don't Forget Winona," *Route 66 Magazine*, Winter 1994-1995.
187. Rittenhouse, 1988.
188. Bob Moore, "The Meteor Crater Observatory," *Route 66 Magazine*, Fall 1994.
189. Wallis, 1990.
190. Paul Taylor, "Two Guns, Arizona," *Route 66 Magazine*, Winter 1993-1994.
191. Rittenhouse, 1988.
192. Steve and Cathy Machie, "Don't Forget Winona," *Route 66 Magazine*, Winter 1994-1995.
193. Rittenhouse, 1988.
194. Ibid.
195. Fred Wong, Flagstaff, AZ.
196. Jim Powell, "Route 66, An American Adventure," *Route 66 Magazine*, Fall 1994.
197. Rittenhouse, 1988.
198. Stella Sanchez, Williams, AZ.
199. Teri Cleeland, "Motorist, What of the Night," *Route 66 Magazine*, Fall 1995.
200. Rittenhouse, 1988.
201. Ibid.
202. Angel Delgadillo, Seligman, AZ.
203. Michelle Rushlo, "Grand Canyon Caverns Survives on Legends," St. Paul Pioneer Press, September 10, 2000.
204. Ralph Goldstein, Peach Springs, AZ.
205. Mildred Barker, Truxton, AZ.
206. Chuck Radcliffe, Truxton, AZ.
207. Wallis, 1990.
208. Rittenhouse, 1988.
209. Bob Waldmire.
210. Jim Pritchard, Hackberry, AZ.
211. Rittenhouse, 1988.
212. Linda Terrin, Mojave Museum of History and Arts, Kingman, AZ.
213. Ibid.
214. Ibid.
215. "Kingman, Arizona," *Route 66 Magazine*, Summer 2000.
216. Linda Terrin, Mojave Museum of History and Arts, Kingman, AZ.
217. Ibid.
218. Nancy Carmody, Yucca, AZ.
219. Rittenhouse, 1988.
220. Rob Morris, Charles Crisman, and Mary Walker Crisman, "Cool Springs," *Route 66 Magazine*, Summer 2000.
221. Jim Powell, "Route 66, An American Adventure," *Route 66 Magazine*, Fall 1994.
222. Rittenhouse, 1988.
223. Ibid.
224. Paul Taylor, "Oatman, Arizona," *Route 66 Magazine*, Spring 1994.
225. Rittenhouse, 1988.
226. Linda Terrin, Mojave Museum of History and Arts, Kingman, AZ.
227. Lucia Knudson, "Arizona's Route 66 Fun Run Ends at Topock," *Kingman Miner*, April 1997.
228. McClanahan and Ross, 1994.
229. Linda Terrin, Mojave Museum of History and Arts, Kingman, AZ.
230. Maggie McShan, Needles, CA.
231. Ibid.
232. Dave Deenick, Needles, CA.
233. McClanahan and Ross, 1994.
234. Rittenhouse, 1988.
235. Jerry McClanahan and Jerry Ross, "Mojave Gold," *Route 66 Magazine*, Fall 1995.
236. Rittenhouse, 1988.
237. Michael Balter, "The Romance of Route 66," *National Geographic Traveler*, 1996.
238. Ibid.
239. Ludlow Motel, Ludlow, CA.
240. Beryl Bell, Daggett, CA.
241. Ibid.
242. El Rancho Motel, Barstow, CA.
243. Butch Der, Barstow, CA.
244. Rittenhouse, 1988.
245. McClanahan and Ross, 1994.
246. Elinor Lewis, Holbrook, AZ.
247. Joseph Bono, Fontana, CA.
248. Reggie Sellas, Rancho Cucamonga, CA.
249. Snyder, 1990.
250. Ibid.
251. Ibid.
252. Ibid.

Index